A POPULAR TREATISE

<small>ON THE</small>

# ART OF PHOTOGRAPHY,

<small>INCLUDING</small>

## DAGUERRÉOTYPE,

<small>AND</small>

## ALL THE NEW METHODS OF PRODUCING PICTURES

<small>BY THE CHEMICAL AGENCY OF LIGHT.</small>

<small>BY</small>

### ROBERT HUNT,

<small>SECRETARY OF THE ROYAL CORNWALL POLYTECHNIC SOCIETY.</small>

<small>ILLUSTRATED BY ENGRAVINGS.</small>

ROBERT HUNT

# A POPULAR TREATISE ON THE ART

# OF PHOTOGRAPHY

A FACSIMILE EDITION

WITH INTRODUCTION AND NOTES

BY JAMES YINGPEH TONG

OHIO UNIVERSITY PRESS: ATHENS

Introduction and Notes © 1973 by James Yingpeh Tong
Library of Congress Catalog Card Number: 72-96395
ISBN 8214-0127-0
Manufactured in the United States of America.

# TABLE OF CONTENTS

INTRODUCTION TO ROBERT HUNT     *ix*

Early Life     *x*

The First Manufacturer of Direct-positive Photographic
Paper     *xiii*

Correspondence with Herschel     *xvi*

Tenure as Secretary of the Polytechnic Society     *xviii*

*A Popular Treatise on the Art of Photography*     *xx*

APPENDICES:

    A.   Robert Hunt's Genealogy     *xxvi*

    B.   Compositions of Solutions in the *Treatise*     *xxix*

    C.   Chemical Index to the *Treatise*     *xxxi*

    D.   Name Index to the *Treatise*     *xl*

    E.   Subject Index to the *Treatise*     *xlii*

    F.   Abbreviations Used in Citations     *xlvi*

    G.   Notes and References     *xlix*

A POPULAR TREATISE ON THE ART OF
PHOTOGRAPHY: Facsimile Edition

# ACKNOWLEDGMENTS

MY sincere appreciation goes to the numerous individuals, libraries, museums, and societies which permitted me to use their collections. In particular I wish to thank Dr. B. H. Vawdrey for lending me important materials on Hunt; the Royal Society of London and the International Museum of Photography in the George Eastman House, Rochester, N. Y., for permission to publish correspondence between Hunt and Herschel; Dr. D. B. Thomas of the Science Museum, London, for allowing me to copy letters between Herschel and Talbot in the Science Museum collection, and for information on the whereabouts of other Talbot material; Mr. J. D. North of the Museum of History of Science, Oxford, for a copy of Hunt's "Directions for Using the Photographic Drawing Papers"; and Mr. Anthony Burnett-Brown for making available for public study microfilm copies of letters to Talbot and other pertinent manuscripts.

I also wish to thank Mr. Richard W. Ryan, Miss Anne Braxton, and Mr. J. Timothy Daum of Ohio University Library for interesting me in this project; Mrs. Ann T. Johnson and Mrs. Anne Contant Gusmano of the Interlibrary Loan Department for borrowing quantities of books and periodicals for me; Mr. K. J. Spencer and Mr. John Thackray of the Institute of Geological Science, London, for their thoughtful assistance when I was using their library and archives; Mr. Eric Bunt for searching the naval records at the Public Record Office and part of the Stoke Damerel Registers; Miss Sylvia Brackell, London, for her invaluable and continuing help on my project; Mr. T. R. Harris, Camborne, for information on Cornwall Polytechnic Society and Miners' Association of Cornwall and Devon; Mr. James R. Griffin for information on Griffin & Co.; Mr. Colin McGregor and Mr. Howard Purdie, London, for their generous donation of time; Mr. Peter Bunnell for checking the publication plans of several publishers in the United States and for his interest in the project; Mr. Beau-

mont Newhall and Mr. R. A. Sobieszek for their interest and encouragement; and Dr. Harriet P. Tong for her most helpful suggestions.

February 14, 1973

# INTRODUCTION TO ROBERT HUNT

ROBERT HUNT,[1-22] Sir John Frederick William Herschel,[23] and William Henry Fox Talbot[24] are probably the three most important English pioneers in photography. While both Herschel and Talbot had excellent formal education, Hunt was a self-taught chemist. After nearly twenty years of struggle, he established a druggist business of his own in his native town of Devonport and began chemical experiments in his spare time. His first scientific paper appeared in 1838,[25] followed by a series of twenty-eight research papers[26-63] and several editions of two books[64-74] on light and photography. He also wrote numerous papers, books, and articles for nonscientific periodicals on a wide range of subjects.[75] His contemporaries recognized his achievements by electing him a Fellow of the Royal Society of London in 1854. In 1873 he and Talbot were elected the first two honorary members of the Royal Photographic Society of Great Britain.[76] After his death, there were numerous tributes,[6-16,21] and a museum was named in his memory.[77] And, in 1965, he and Herschel and Talbot were among the one hundred twelve inventors selected by an international committee to be honored as photography's great inventors.[78] Yet Robert Hunt is unknown except by historians of photography.[79-86] The published biographies of Hunt[3,4,5,19,20] are generally mere chronicles of his positions and his publications, there were very few contemporary critical reviews of his work,[1,87,88] and there was little recognition of his work after his death.

The early photographic processes, a number of which were invented by Hunt,[58] are of intense interest to photographers today. Art photographers have become interested in the various unique qualities of daguerreotypes and the results of early paper processes which cannot be obtained with present-day commercial photographic material. Photographic scientists are exploring nonsilver processes and thermography suggested by the observations of the pioneers. Hunt's *A Popular Treatise on the Art of Photography*[64] was the first general manual on photography ever published in

English. It was also the nucleus from which his later books on photography and light[65-74] were to evolve. This book should also be recognized as the first general history of photography and Hunt's evaluation of the known processes. In addition it contains his unpublished research and observations on photography.

## EARLY LIFE

ROBERT HUNT was born on September 6, 1807, at Plymouth Dock, now Devonport, England.[89,90] He was the only child of Robert Hunt, a ship's carpenter of the Royal Navy,[94] and Honour Thomas Hunt. The boy never saw his father, who died when the war sloop *Moucheron* on which he was serving apparently foundered at sea in April, 1807,[95] while carrying dispatches to Admiral Duckworth[96] in the Dardenelles.[1] No trace of the vessel was ever found. Rumors[4] that the *Moucheron* had been captured by Algerian pirates, who sold the sailors into slavery, and that the sailors had been liberated after the bombardment of Algiers in 1816[97] proved false. On June 30, 1808,[98] Honour Hunt was officially declared a widow and was granted a meager Naval pension of twenty-five pounds a year[95] to support herself and her son.

Robert Hunt first attended an ordinary country school[4] in Plymouth Dock, where his remarkable memory attracted attention. At eight he could allegedly repeat Pope's complete translation of the *Iliad* without error.[1] In about 1816[2] his mother moved to Penzance to be near her relatives. There Hunt attended a school taught by a Wesleyan preacher.[1] He became the second ranking student, surpassed only by a boy two or three years his senior. This rival stimulated his natural love for poetry, and Hunt wrote verses on the death of George III and other events of the day.

"I was launched upon the world at the age of twelve, and [from] that age, almost without a guide, I struggled among the difficulties and dangers of the Metropolis," said Hunt.[99] Friends found him an apprenticeship with a Paddington surgeon, and he set off alone for London.[1] Although he worked chiefly as an errand boy, he learned to dispense medicine. With pocket money from his uncle, he paid an usher from a neighboring school to teach him Latin so that he could read prescriptions. He also[5] attended some of the last anatomy lectures of the distinguished Joshua Brookes.[100] According to the rules of the College of Surgeons his apprenticeship was to last four years,[4] but he left after eighteen months be-

cause of the master's harsh treatment.[1] After several months his uncle found him temporary employment as junior clerk to a wharfinger on the Paddington Canal.[5]

Six months later, Dr. Charles Smith, a Scotch physician practicing in Hatton Garden, accepted Hunt as a pupil on very advantageous terms.[5] Dr. Smith's brother, Richard, was a partner in a firm of chemists in Fleet Street where Dr. Smith came each evening to give free medical treatment to the poor.[101] He also had many patients in the Old Fleet Prison, and all his prescriptions were prepared at the Fleet Street firm. Hunt was allowed to spend a good deal of his time there learning to dispense drugs. In his spare time he pursued his favorite literary studies.[1] At the age of 16 or 17, he wrote[1] several tales for the *Gleaner*[102] and some poems for the *Imperial Magazine*.[103] Richard Smith's close friend Henry Hunt,[104] a liberal MP often known as "the Radical" Hunt, was a frequent visitor at Fleet Street.[5] Henry Hunt, no relation to Robert Hunt, became interested in the gifted young man and carefully directed his studies.[105] Meanwhile, two new friends, clerks to barristers with chambers in the Temple, furthered Hunt's self-education by lending him books.

A series of unfortunate circumstances brought the Fleet Street firm, and Robert Hunt's connection with it, to an abrupt end.[5] His mother, who had moved to London to be with him,[1] could hardly support herself on her limited pension. It was urgent that he find immediate employment. Through the introduction of Mrs. Elizabeth Fry, the famed prison reformer,[106] the philanthropist William Allen[107] secured for Hunt the management of a dispensing business in the West End.[5] The job paid a small salary which enabled him to help his mother and to pursue some scientific studies.[1] This business career was interrupted by illness resulting from an accident on the night of January 20, 1827. While struggling to get a better view[1] of the Duke of York's funeral procession,[108] he fell into the icy Thames River at Dachet.[4] At the time of his recovery he inherited a small property on the banks of the Fowey River from his paternal grandfather,[5] who died at the age of 78 and was buried on March 17, 1827. From the sale of elm trees from the estate,[5] Hunt realized enough profit to vacation for ten months, in 1829, in the West of England. In the introduction,[112] which he wrote in September, 1864, to his *Popular Romances of the West of England*,[109] Hunt reminisced about the tour:

Having spent about a month on the borders of Dartmoor, and wandered over that wild region of Granite Tors, gathering up its traditions,—ere yet Mrs. Bray[113] had thought of doing so,—I resolved on walking through Cornwall. Thirty-five years since, on a beautiful spring morning, I landed at Saltash, from the very ancient passage-boat, which in those days conveyed men and women, carts and cattle, across the river Tamar, where now that triumph of engineering, the Albert Bridge, gracefully spans its waters. Sending my box forward to Liskeard by a van, my wanderings commenced; my purpose being to visit each relic of Old Cornwall, and to gather up every existing tale of its ancient people. Ten months were delightfully spent in this way; and in that period a large number of the romances and superstitions which are published in these volumes were collected, with many more, which have been weeded out of the collection as worthless.

In a footnote to the introduction, Hunt speaks of the many wild tales of Cornwall which he heard. The tales, traditions, and superstitions he collected on that tour were rapidly disappearing by 1864. Thus the book has had a lasting value for students of Cornish folklore; it was the first of Hunt's books to be reprinted unabridged in the twentieth century.[111]

It is likely that he reached Penzance in the middle of his tour and stayed with his uncle while he explored the areas around Mount's Bay. The vacation gave him his first opportunity to write poetry at his leisure. He wrote a long descriptive poem *The Mount's Bay*, which was published by subscription in 1829 together with five shorter poems.[116] Two hundred fifty-four copies were sold on subscription to two hundred twenty-six people, among them a number of prominent Cornwall residents.[117] Although *The Mount's Bay* shows that Hunt had a love for highly colored verse, a sensitivity to the beauty of nature, and a romantic nostalgia for the past, it was critically undistinguished. More aware of his shortcomings as a poet, he turned earnestly to science.

Returning to London, Hunt managed a druggist business in Tottenham Court Road[1] and devoted himself to studying chemistry.[5] His mother remained in Penzance, probably with her brother James Thomas. James Thomas married Ann Davy on May 30, 1831, at Madron. Ann Davy was the daughter of William Davy,[118] brother of Edmund Davy,[119] who was an assistant to the renowned

chemist of Penzance, Sir Humphry Davy.[120,121] Hunt's mother soon remarried. On July 5, 1831, in Madron, she became the wife of Stephen Weaver,[124] a seller of musical instruments on Market Jew Street in Penzance.[125] Hunt soon joined his family in Penzance, where he and his uncle opened a chemist and druggist's shop.[1] There was a public dispensary on Chapel Street,[126,130] and Thomas and Hunt had their shop on the same street in 1833 and 1834.[19,127] Business temporarily prospered. On March 16, 1834, at Madron, Hunt married Harriet Swanson of Stoke Damerel. Harriet was probably a year younger than Robert as she was baptized on December 4, 1808. For many years her father, William Swanson, was a cordwainer or shoemaker on George Street, Plymouth Dock,[131,132] later Devonport,[133,134] and the Hunt and Swanson families might have known each other. The couple's first son was born on Christmas Day, 1834, and was baptized Robert on January 18, 1835, in Madron.

During this period in Penzance, Hunt first became involved in adult education, assisting in the formation of the Mechanics' Institution,[135] and giving the first of its lectures.[5] As its curator, he lectured on poetry as well as science and became well known as a stimulating speaker.[1] When family disputes and lawsuits between James Thomas's relatives brought their business to an end,[1,136] Hunt advertised a course of lectures on chemistry in Devonport.[1] These lectures were well attended, enabling him to go to London in 1836 to look for another position[137] while his wife and son stayed with his father-in-law in Devonport.[138] Hunt worked as the assistant to a druggist in Newgate Street[138] for about one year.[1] During that time he indulged his literary inclinations by writing two plays. He submitted one of them, a tragedy called *Geraldine of Aspin*, to William Macready, manager of the Covent Garden Theatre,[139] who politely rejected it.[1] Hunt's second son, Charles, was born on September 30, 1837, in Devonport.[138] Shortly thereafter, Hunt returned to Devonport where he ventured once more into business by opening a small druggist's shop.[1] He offered his services to the public as an analytical chemist, began a series of original experiments, and published his first paper in the January 1838 issue of *Philosophical Magazine*.[25]

## THE FIRST MANUFACTURER OF DIRECT-POSITIVE PHOTOGRAPHIC PAPER

IN January, 1839, Arago's first announcement of Daguerre's invention[201] and the rival claims by Talbot[316] stirred the imagina-

tion of scientists and laymen everywhere, including Robert Hunt, and stimulated widespread experimentation in photography. Since details of Daguerre's procedures were not made public until August, 1839,[203] most of the early efforts in England were directed toward processes on paper. Although Talbot was very guarded in announcing his specific method, the paper processes were relatively easy to work out from the few details Talbot disclosed. By March, 1839, John Thomas Cooper,[140] Resident Chemist of the Polytechnic Institution on Regent Street, London, was manufacturing photogenic paper on a large scale; he first advertised his paper for sale on the front page of the March 16 issue of the *Athenaeum* at five shillings for one dozen sheets of octavo paper.[141] Three weeks later, Ackermann & Co., 96 Strand, advertised "Ackermann's Photogenic Drawing-box," containing all the supplies and instructions for "copying objects by means of the sun."[142] By May 18, E. Palmer, Chemical and Philosophical Instrument Maker, 103 Newgate Street, was advertising "photogenic paper of very superior kind, fixing liquids," as well as portable field cameras, the first camera advertised in London.[143]

Since Talbot's process produced a paper negative, and a positive print had to be obtained by "transfer" (now known as contact printing), Robert Hunt devoted his efforts to producing a direct-positive process on paper. In a paper[26] dated January 2, 1840, he wrote: "My first endeavours in the photographic art were directed to restoring the natural order of light and shadow; and I fortunately succeeded in effecting this very early in the summer of 1839."

Consequently, he decided to prepare his direct-positive paper for sale. When he wrote Sir John Herschel on December 9, 1839, he mentioned,[144] "For six months I have devoted very much attention to Photogenic drawing and I have prepared for sale a very sensitive paper of my own devising which preserves the natural order of the lights and shadows."

Herschel replied on the 14th:[145]

> Your letter dated the 9th reached me here only yesterday a delay I cannot explain. The experiments you relate are curious and interesting. I am acquainted at present with only one photographic paper which whitens by exposure to light. As you say you prepare yours for sale, I shall be very glad to be furnished with a specimen of half a dozen sheets which if enclosed to me by post . . . will reach me

securely. If at the same time you will state the amount
which it will render me your debtor, how I shall remit it,
I will not be tardy in doing so.

Hunt sent the paper on December 18 but refused to receive "any
price for the paper."[146] In a letter dated April 23, 1840, to Her-
schel, Hunt inquired:[147] "I imagine you [to] be aware if Da-
guerre's patent[148] would interfere with the sale of my new papers
—perhaps if you are so you will be so kind as to inform me."
Herschel's reply, if there was one, is not preserved. We do not
know how long Hunt continued to manufacture his paper; how-
ever, one package of Hunt's papers, both exposed and unexposed,
is among Herschel's experimental photographic papers in the
Museum of the History of Science, Oxford, and was mentioned
by Schultze in 1965.[149]

While J. T. Cooper was the first manufacturer of photogenic
paper, Hunt was the first manufacturer of direct-positive paper.
It seems that neither was a commercial success. Cooper adver-
tised his paper for only a little over one month, his last advertise-
ment appearing in the April 20 issue of the *Athenaeum*.[150] He also
submitted his method to the Society of Arts, which awarded him
a silver medal, and published his method in its *Transactions*.[226]
Hunt disclosed his direct-positive process in a very detailed paper
published in two parts in September and October of 1840.[28] This
paper was reprinted in his *A Popular Treatise on the Art of Pho-
tography*.[151]

According to the very brief "Directions for using the Photo-
graphic Drawing Papers,"[152] which is preserved with Hunt's
papers at Oxford, the paper required an exposure of thirty min-
utes to one hour in the camera obscura. A "fixing fluid" was to
to be brushed on both sides of the paper immediately before
use.[152,153,154] Hunt's letter dated December 18, 1839, to Herschel[146]
details the "fixing fluid" he was using:

I mentioned the Muriate of Baryta[155] as the fluid with
which the paper was first washed. For some weeks I pre-
pared my papers with *that salt*—but I then found the
*muriate of Ammonia* gave more sensitiveness—and I have
ever since, and do at the present moment prepare my
papers with it— When I made Barytic Papers I found
the Hydriodate of Potassa the best bleaching fluid— But
with the Ammonia the *Hydriodate of Baryta* answers
much better and is the fluid I send out with my packets.

As I cannot send a bottle through the Post Office I am
under the necessity of leaving you to procure that prepa-
ration.[156]

The fixing fluid depended on how the paper was prepared. If the
paper was prepared with barium chloride (muriate of baryta)
and silver nitrate, the fixing fluid was an aqueous solution of
potassium iodide (hydriodate of potassa). If the paper was pre-
pared with ammonium chloride (muriate of ammonia) and silver
nitrate, the fixing fluid was an aqueous solution of barium iodide
(hydriodate of baryta). Hunt found that the second combination
produced a more sensitive paper. He coated his paper with silver
chloride and reduced the silver chloride to metallic silver by light.
The fixing fluid, when applied to the paper just before the paper
was used, made the metallic silver sensitive to the bleaching
action of light. The term "bleaching fluid" used by Hunt in his
letter is more accurate than the term "fixing fluid." Other suppliers
had been selling "fixing liquids," which were used to prevent
finished photographs from being affected by light.[157] Hunt's call-
ing his reagent "fixing fluid" was, therefore, misleading to the
public. That Hunt could not send bottles through the post office
undoubtedly limited his sales to local customers since the printed
directions did not give instructions on how to prepare the "fixing
fluid."

## CORRESPONDENCE WITH HERSCHEL

THE first letter[144] Hunt wrote to Herschel, on December 9, 1839,
initiated a lively and open exchange of letters and photographic
specimens[159] during Hunt's most productive period of scientific
endeavor. This relationship between Herschel, one of the most
popular and honored scientists of his time, and Hunt, the obscure
self-taught chemist, greatly influenced the scientific as well as the
personal life of Hunt. Hunt's first letter was mostly concerned
with his experimental observations:

> Having just read your communication[268] to the British
> Association—and having some weeks since observed
> some of the peculiarities of the red ray you have there
> mentioned and some others which appear to [have] been
> unnoticed by you, is the inducement for writing—I would
> respectfully direct your attention to the following facts.

The observations Hunt reported to Herschel were on the unexplained effects of light transmitted through colored media. Herschel was writing a paper on that very subject, and he wrote to Hunt on December 14, 1839,[145]

> The properties of paper washed with muriate of Baryta in so far as they are peculiar to these salts are new to me but the general tenor of the results of the action of coloured media on the chemical rays has for some time been familiar to me and I have a great mass of experiments on them which I have been only prevented from publishing hitherto by its having been pointed to me by a friend that it would be desirable to delay doing so that the period allowed for the specification of Daguerre's patent shall have elapsed. As that time is now at hand I am drawing up a memoir for speedy publication (of which when printed I shall take care to forward you a copy) and you will therefore pardon me, and attribute it to no other than a right motive, if I express a wish that you would defer until I have done so, make me the depository of any other results you may have arrived at or may arrive at in the interim (however under other circumstances I should feel gratified and instructed by their communication) Perhaps you would not object to my mentioning in the paper alluded to those properties of muriate of baryta which refer to the action of light on it under coloured media (of course in connection with your name) as illustrating in a remarkable manner (as they do) some general conclusions I have arrived at as well as other phenomena of a similar nature (some indeed identical) which I have observed and which depend on the same principles.

When Herschel's paper, his most important paper on photography and photochemistry, was published in the *Philosophical Transactions* of 1840,[270] Hunt's observations were quoted verbatim and credited to him.[160] In the rough draft[161] of the same letter[145] Herschel was going to propose to Hunt that if he preferred to write up his own work as a communication to the Royal Society, Herschel would gladly present it. Apparently Herschel changed his mind. But when Hunt wrote him[162] on April 15, 1840, to tell him about the daguerreotype process on paper, a process which he invented, and to send him two specimens of the paper, Herschel was enthusiastic enough to offer to present a communi-

cation on Hunt's invention to the Royal Society for him if he wished to write one.[163] Hunt gratefully acknowledged[147] this generous offer on April 23 and sent Herschel a paper on May 9[164] which Herschel presented to the Royal Society on June 18, 1840, the only paper of Hunt's which was presented to the Royal Society and published in the *Philosophical Transaction.*[29]

Herschel, who knew Talbot well, tried to interest him in Hunt's work and to acquaint Hunt with Talbot's work. On April 19, 1840, when Herschel wrote to Hunt,[163] he also wrote to Talbot[165] and sent him Hunt's specimens, which he thought very promising.[165] In a subsequent letter to Talbot on May 3, Herschel gave him Hunt's address.[165] On May 12, 1840, Herschel sent Hunt four of Talbot's photographs:[166] "I enclose 4 specimens out of many, on every variety of objects sent me by Mr. Talbot that you may see what *is* doing with the Camera obscura in this country."

Hunt replied on May 16:[167] "They are of rich promise—but I fear for their permanence. I am not certain as to Mr. Talbot's preparation—but I have produced somewhat similar pictures—by acting on the bromide of silver by hydrochloric acid."

Hunt's statements show first that even by May 16, 1840, he did not know what Talbot's process involved. Secondly, he feared for the permanence of Talbot's photographs because Talbot apparently had not yet used sodium thiosulphate for fixing. Thirdly, Hunt had produced similar pictures by using a mixture of silver bromide and silver chloride. In spite of all Herschel's effort, there is no evidence that Hunt and Talbot corresponded with one another until February, 1841.[168]

## TENURE AS SECRETARY OF THE POLYTECHNIC SOCIETY

ROBERT HUNT's ability as a lecturer and his growing reputation in science led to his appointment in 1840 by the Royal Cornwall Polytechnic Society as its Secretary,[169] a key position in the Society.[170] In addition to general administration, the secretary was responsible for delivering a variety of lectures. Some of these lectures were given during the year for the enlightenment of its members. Caroline Fox,[171] who first suggested the forming of the Society and who conceived the word "Polytechnic,"[173] recorded in her famous diary two lectures by Hunt which she attended: an evening lecture on August 12, 1841, on "The Influence of Poetry

and Painting on Education" and, on October 5, 1841, a chemistry lecture which she described as "very pretty, popular, explosive, and luminous."[174] Beginning in 1840, the secretary was requested, for the purpose of furnishing general information of the Society's progress, to visit various parts of the country after each exhibition, and to lecture on the most striking subjects which might annually come before the Society.[175]

Sir Charles Lemon, President of the Royal Cornwall Polytechnic Society from its inception in 1833 until his death in 1868, was a pioneer for miners' education.[176,177] After two unsuccessful attempts to organize an experimental school in Truro in 1839 and 1840, he asked Hunt to try to establish a class for young miners in a school conducted by John Phillips[178] at Tuckingmill near Camborne, the very center of extensive tin and copper mines of that time.[179] Three teachers, including Hunt, were engaged and Hunt lectured weekly on chemistry.[178] Sir Charles Lemon and his older sister Lady Basset[180] shared equally for one year the expense of this experiment of taking the school to the miners, instead of expecting them to go a long distance to the school. This was the only successful attempt at a mining school in Cornwall until Hunt helped to institute the Miners' Association of Cornwall and Devon in 1859.[182] The establishment of a mining school is Hunt's lasting gift to Cornwall.

Hunt was Secretary of the Royal Cornwall Polytechnic Society from 1840 until 1845.[183] His predecessors held the position on a part-time basis. Beginning with Hunt, the Society made the secretariat a full-time position.[169] Although the salary was small and Hunt did occasional analysis[184] and contemplated doing professional photography to supplement his income, the position gave him leisure for research.[185] Partly through the influence of Robert Were Fox,[186] he became interested in the electricity of mineral veins. Through his contact with miners, he became concerned with their welfare. During his five years in Falmouth, he did research in these areas.[2] And, as a result of his familiarity with mines and miners' education, he was chosen by Sir Henry Thomas De la Beche as Keeper of Mining Records at the Museum of Economic Geology in London in 1845.[187] He was elected a member of the British Association for the Advancement of Science in 1840 and remained an active member for forty years.[188] During his tenure as the Secretary of the Royal Cornwall Polytechnic Society he presented eleven reports[30,31,34,36-38,41-43,47,48] on his research on

light and photography at meetings of the British Association. He also wrote two of his most important books on these subjects. The first of them is *A Popular Treatise on the Art of Photography.*

## A POPULAR TREATISE ON THE ART OF PHOTOGRAPHY

HUNT mentioned his intention of writing a popular treatise on photography in his first letter to Herschel written from Falmouth.[185] On January 17, 1841, he wrote:

> Would you favour me with an opinion on the probable success of a popular treatise on photography— I have an idea, that a work of a very interesting character may be written thereon— But that I doubted my powers I should without hesitation attempt it— The probability is that I may yet be rash enough to make the attempt.

Herschel's reply to this letter is not preserved. In a letter dated February 20, 1841, however, Herschel told Hunt,[189] "I shall be very glad to see your history of photography which cannot but be interesting. . . ."

According to the dates given in his *Treatise* (pages 93, 96), Hunt completed his "Conclusion" on March 17, 1841, and added the supplementary chapter on April 19.[190] The book was probably published in May, 1841, and Herschel wrote to Hunt on May 21, 1841, acknowledging a copy of the book:[191] "Allow me to thank you for your extensive and instructive view of the present state of photography as well as to congratulate you on the beautiful process at the end which is a very important step indeed." Herschel was here referring to the process of developing silver bromide paper with mercury vapor invented by Hunt and described in the supplementary chapter of the *Treatise.*

Historians of photography have called Hunt's *Treatise* "the first real textbook"[192] as well as "the first general treatise" of photography.[193] If we consider the tremendous stimulation of research by the discovery of photography, it is suprising that a general treatise did not appear earlier. Because the early daguerreotype pictures were superior to pictures made by the paper processes, numerous editions and translations of Daguerre's original manual were published in 1839 and 1840.[237] But because of Daguerre's patent in England, the English interest in daguerreo-

type was considerably restrained until March 23, 1841, when Richard Beard opened his first daguerreotype portrait studio in London.[194] Consequently, most of the early experiments in England were on paper processes; however, many of the early experimenters such as Ponton,[195,292] Cooper,[140,226] and Taylor[196,197] quickly lost interest. As result, there were very few active investigators of paper processes. The most diligent investigators during the first two years were unquestionably Talbot, Herschel, and Hunt.

Of these three men, Hunt was ideally suited to write the first general treatise on photography. Recognition and financial rewards accorded Daguerre in the first years of photography were denied Talbot, who was reluctant to disclose prematurely his key observations for fear that others might first discover how to employ his process. He realized that as the patentee of a commercially viable photographic process he would receive recognition as well as money. His decision to patent his processes and to guard the patent rights zealously is therefore understandable. Herschel's research was scientifically more disciplined, but photography was only one of his many interests. Hunt, however, devoted all of his investigation to photography, and published all of his findings. He also was well informed on the most important contemporary work in photography published in English and French. Popular magazines such as the *Literary Gazette* and the *Athenaeum* vied with one another to report discoveries and improvements in photography. Journals such as the *Chemist* translated articles in foreign journals within one or two months of the original publication.[198] From the comments Hunt made about the processes of other experimenters reported in his *Treatise*, it appears that he tested most of these processes and often tried to improve on them.

Historians have not recognized that Hunt's *Treatise* is also a record of his own unpublished research in photography. Judging from the relative space he devoted to this research in the *Treatise*, we can conclude that he spent more time on paper processes than on daguerreotype on metal. Perhaps writing about his own research in the *Treatise* enabled him to publish observations which would not satisfy a full-length scientific article. Hunt generously reported preliminary observations of his incomplete experiments, such as the three methods of "darkening the shadows,"[199] or intensification, and the detection of sulfur compounds in unexposed paper which spontaneously darkens.[200] Publication of these ex-

periments and some of his more extensive experiments on paper processes in the *Treatise* obscures the fact that all these were his own original work.

Hunt's *Treatise* is the first general history of the photographic processes. Daguerre's original manual was more specifically the delineation of a process. It was probably not Hunt's intention to write a history of light and photochemistry prior to Daguerre's and Talbot's inventions, and there is only a brief chapter on these inventions at the beginning of the *Treatise*. Hunt explored the early history of light and photo chemistry much more extensively when he wrote his *Researches on Light* in 1844.[65] Hunt's *Treatise* is a comprehensive record of the principal contributions[201-345] to photographic processes from 1839 up to the time of its publication in 1841.

Hunt mentions fifty-six persons in his *Treatise*.[346] Of these, twenty were contributors to the knowledge of light or early photochemistry (including Davy and Wedgwood), four had roles in the history of Daguerre and Niepce (Arago, Biot, Duchâtel, and Isidore Niepce), and the remainder were all contributors to the photographic processes.

The major obstacle Hunt encountered in writing his *Treatise* was the secrecy shrouding the works of Daguerre and Talbot. Hunt attempted to discover the truth by writing Daguerre and Talbot directly. At the January 4, 1841, meeting of the Académie des Sciences Arago announced that Daguerre had developed a more sensitive process.[207] The announcement was reported in England in the *Athenaeum* on January 30.[347] Hunt wrote Daguerre to inquire about the new development, and Daguerre replied[235] evasively in English on February 19. Hunt reprinted the essential part of Daguerre's reply in his *Treatise*.[348] On June 28, 1841, Arago at last reported Daguerre's innovation, which consisted of subjecting the iodized plate to an electric spark inside the camera.[349] When, after waiting three years, Hunt heard of no additional improvement or application of this discovery, he commented, ". . . but, up to the present time, some great obstacle appears to have interfered with the successful practical use of this new and important discovery. . . ."[350] Arago's first announcement of Daguerre's more sensitive process, however, might have prompted Talbot to announce his improved paper process in a letter dated February 5, 1841, to the editor of the *Literary Gazette*:[336]

I shall confine myself in this letter to a single subject, viz. the discovery which I made last September of a chemical process by which paper may be made far more sensitive to light than by any means hitherto known. . . . The production of the image is accompanied with some very extraordinary circumstances, to which I will advert in a subsequent letter. . . . The new kind of photographs, . . . I propose to distinguish by the name of Calotype."

Talbot's letter was published on February 13, 1841. A week later, Herschel wrote Hunt:[189] "Mr. Talbot I understand has got some considerable improvement in his paper but I do not know the particular. . . ."

Since Talbot's letter in the *Literary Gazette* did not give any particulars, Hunt decided to inquire of Talbot directly on February 26.[168] Hunt reported in his *Treatise*[351] that Talbot wrote him and sent him "some most exquisite specimens of this new photographic art." There is no indication that Talbot gave Hunt any technical information on the Calotype process. Meanwhile, Talbot had already written a second letter[337] dated February 19 to the editor of the *Literary Gazette* in which he reported his accidental discovery that the "picture had unexpectedly *developed itself* by a spontaneous action." This letter was published the day after Hunt had written Talbot but contained no description of the new process. Talbot was not yet ready to divulge his secret since he had sealed his patent[352] as recently as February 8. Consequently Hunt was restricted to mentioning only the accidental nature of Talbot's discovery.[351]

Herschel, on the other hand, was willing to let Hunt quote from his letter[189] of February 20, 1841, and Hunt cited two of Herschel's observations verbatim.[353,354] Hunt's *Treatise*, however, does not make it clear that Herschel had kept for one year the specimens of paper on which he made one of the observations.[353]

Hunt's *Treatise* was published by Richard Griffin & Co. as part of the first series of "Griffin's Scientific Miscellany, an Occasional Publication of Treatises Relating to Experimental Science"[355,356] edited by John Joseph Griffin.[357] The series included translations of works by Liebig[358] and von Kobell[359] and original works by John J. Griffin,[360] Thomas Spencer,[310] and Andrew C. Ramsay.[361] As a separate volume, Hunt's *Treatise* sold for three shillings and twopence.[356] A combined volume of all six treatises bound in cloth was priced at twenty shillings.[356]

Henry Hunt Snelling published *The History and Practice of the Art of Photography*[362] in 1849 and openly acknowledged his indebtedness to Hunt. Hunt's name appeared on twelve pages of the one hundred twenty-nine page book.[363] In chapter 2 Snelling told his reader,[364]

> In the next chapter, however, I shall give a synopsis of Mr. Hunt's treatise on the "Influence of the Solar Rays on Compound Bodies, with special reference to their Photographic application"—a work which should be in the hand of every Daguerreotypist, and which I hope soon to see republished in this country.

The treatise he referred to is Part I of Hunt's *Researches on Light.*[65] From other passages[365] in Snelling's 1849 treatise, it would appear that he also copied or paraphrased material from the 1841 edition of Hunt's *Treatise.*

When J. J. Griffin planned to publish the second edition of the "Encyclopaedia Metropolitana; or System of Universal Knowledge," Hunt was asked to prepare a revised version of his treatise to be included. This revised version, retitled *Photography, a Treatise on the Chemical Changes Produced by Solar Radiation, and the Production of Pictures from Nature by the Daguerreotype, Calotype, and Other Photographic Processes,'* appeared in 1851 as volume sixteen of the encyclopaedia[66] and sold for five shillings.[366] The new edition was more than twice the size of the 1841 edition and had an index. In the preface dated July 1851, Hunt wrote:

> It is now ten years since the Popular Treatise on the Art of Photography was published. . . . A reprint of the "Popular Treatise" was at first intended, with such additions as might be necessary from the improved state of our knowledge. It was, however, found impracticable to do justice to the subject in this way; therefore, an entirely new arrangement has been adopted, and only so much of the original work retained as represented the history of one of the most beautiful of the applications of Physical Science to Art.

From these statements, it appears that a second edition printed in 1847 mentioned in Epstean's translation[367] of Eder's *History of Photography* never existed.

When Snelling began to publish his *Photographic Art Journal* in 1851, he serialized Hunt's *Researches on Light*,[65,368] followed by Hunt's *The Poetry of Science*,[91,369] and the 1851 edition of Hunt's *Treatise*.[66,370] The three books occupied one-tenth of the pages of the journal in 1851 and 1852. In December, 1851, Samuel D. Humphrey, publisher of the *Daguerrian Journal*, had already issued an "American edition" of Hunt's *Treatise* with five additional chapters by the "American Editor."[67] He advertised the book in his journal and wrote a review:[371]

> This work is just out of press in England, as well also in America. It is a reprint from the London edition, with additions by the American editor, and probably has a more comprehensive view of our science than any publication hitherto upon the American catalogue. The Daguerrian operator will here find a very complete statement of the past and present position of the Daguerreotype art, together with all improvements both in Europe and America up to the present date.

Both the *Photographic Art Journal* and the *Daguerrian Journal* serialized photographic books[372] and reprinted articles from European publications,[373] including many of Hunt's articles from the *Art Journal*.[374,375,376] These publications made Hunt's work familiar to American photographers of the mid-nineteen century.

# APPENDIX A

## ROBERT HUNT'S FAMILY

| Name<br>Date, Source* | Relationship to Robert Hunt,<br>Event, notes |
|---|---|
| Robert Hunt<br>July 12, 1777 (SD) | Grandfather.<br>Married Ann Prevo.<br>They had five children:<br>Robert, Mary Ann, William,<br>Richard, and Mary Ann. |
| March 17, 1827 (SD) | Buried, having died at the age of 78 at Tamar Street. |
| Robert Hunt<br>January 24, 1781 (SD)<br>June 30, 1805 (SD)<br>April (?), 1807 | Father.<br>Baptized.<br>Married Honour Thomas.<br>Died at sea. |
| Mary Ann Hunt<br>February 20, 1783 (SD) | Aunt.<br>Baptized.<br>She probably died before 1790. |
| William Hunt<br>December 30, 1784 (SD) | Uncle.<br>Baptized. |
| Richard Hunt<br>April 25, 1786 (SD) | Uncle.<br>Baptized. |
| Mary Ann Hunt<br>July 16, 1790 | Aunt.<br>Baptized. |

---

* (M): Madron Parish Registers.
(S): Somerset House, London.
(SL): St. Levan Parish Registers.
(SD): Stoke Damerel Parish Registers.

| Name<br>Date, Source* | Relationship to Robert Hunt,<br>Event, notes |
|---|---|
| Joseph Thomas, Jr. | Maternal grandfather.<br>Married Mary Gwennap.<br>They had six children: Mary,<br>Joseph, Thomas, James, Honour,<br>and Honour. |
| Mary Thomas<br>February 23, 1771 (SL) | Maternal aunt.<br>Baptized. |
| Joseph Thomas<br>July 26, 1772 (SL)<br>July 28, 1772 (SL) | Maternal uncle.<br>Born.<br>Baptized. |
| Thomas Thomas<br>August 6, 1774 (SL)<br>August 7, 1774 (SL) | Maternal uncle.<br>Born.<br>Baptized. |
| James Thomas<br>July 27, 1776 (SL)<br>July 29, 1776 (SL)<br>May 30, 1831 (M) | Maternal uncle.<br>Born.<br>Baptized.<br>Married Ann Davy of Penzance. |
| Honour Thomas<br>April 12, 1779 (SL)<br>May 23, 1780 (SL) | Maternal aunt.<br>Baptized.<br>Died. |
| Honour Thomas<br>July 13, 1781 (SL)<br>June 30, 1805 (SD)<br>July 5, 1831 (M)<br>August 27, 1842 (S) | Mother.<br>Baptized.<br>Married Robert Hunt.<br>Married Stephen Weaver.<br>Died at Rosevean Row, Penzance,<br>at the age of 58 [sic]. |
| William Swanson | Father-in-law. |
| Charlotte Sophia Swanson<br>January 2, 1824 (SD) | Mother-in-law.<br>Buried, having died at the age of<br>39 at George Street. |
| Harriet Swanson<br>December 4, 1808 (SD) | Wife.<br>Baptized. |

| *Name*<br>*Date, Source\** | *Relationship to Robert Hunt,*<br>*Event, notes* |
|---|---|
| March 16, 1834 (M)<br>November 28, 1896 (S) | Married Robert Hunt.<br>Died at 37 Gleneldon Road, Streatham, Surrey. |
| Robert Hunt<br>September 6, 1807 (SD)<br>August 2, 1809 (SD)<br>March 16, 1834 (M) | <br>Born in Plymouth Dock.<br>Baptized.<br>Married Harriet Swanson.<br>They had six children: Robert, Charles, Charlotte Fisher, Harriet, Emma Jane, and Elizabeth. |
| October 17, 1887 (S) | Died at 26 St. Leonard's Terrace, Chelsea. |
| Robert Hunt<br>December 25, 1834 (M)<br>January 18, 1835 (M) | Son.<br>Born in Penzance.<br>Baptized. |
| Charles Hunt<br>September 30, 1837 (S) | Son.<br>Born at 65 George Street, Devonport. |
| Charlotte Fisher Hunt<br>April 26, 1841 (S)<br>January 9, 1932 (S) | Daughter.<br>Born at Berkeley Vale, Falmouth.<br>Died at 70 Streathbourne Road, Balham, Surrey. |
| Harriet Hunt<br>December 3, 1842 (S)<br>April 4, 1926 (S) | Daughter.<br>Born at Berkeley Vale, Falmouth.<br>Died at 70 Streathbourne Road, Balham, Surrey. |
| Emma Jane Hunt<br>June 18, 1844 (S)<br>January 20, 1884 (S) | Daughter.<br>Born at Berkeley Vale, Falmouth.<br>Died at 26 St. Leonard's Terrace, Chelsea. |
| Elizabeth Hunt<br>March 31, 1846 (S) | Daughter.<br>Born. |

*Name*
*Date, Source**

*Relationship to Robert Hunt,*
*Event, notes*

October 15, 1868 (S)    Married William Vawdrey in
                        St. Jude's Church, Chelsea.
February 27, 1921 (S)   Died at 70 Streathbourne Road,
                        Balham, Surrey.

# APPENDIX B

## COMPOSITIONS OF SOLUTIONS

In Hunt's *Treatise*, the compositions of solutions are expressed in one of four ways: (1) grains of the solute (the substance dissolved, usually a solid) and fluid ounces[377] or fluid drachms[378] of the liquid solvent (usually water), (2) weight ratios[379] of the solute and the solvent, (3) S.G.[380] or specific gravity of the solution, and (4) volume ratios[382] of two liquids.

The grain was the least ambiguous of the English weight units in Hunt's time, because it was the common denominator of the two systems of units in use, the troy units and the avoirdupois units.[385] Both units employed the terms pound, ounce, drachm, and grain. While one troy grain equals one avoirdupois grain, all the other quantities are different. The accompanying table gives the subdivision of the English troy and avoirdupois pounds. In the 1840's, one grain equaled 0.06475 grams.[383] At the same time, volumes were measured in Imperial gallons similar to the British gallon in use today. One British gallon divides into 160 fluid ounces. One British fluid ounce is approximately 0.961 U.S. fluid ounce, or 28.41 cc.

The compositions of aqueous solutions of solid solutes are often expressed in weight ratios of solute and water, because the weight of water can be easily calculated from its volume. One Imperial fluid ounce of water at 62°F weighs one avoirdupois ounce.[385] One cc. of water at the same temperature weighs 0.999 gram. For example, a silver nitrate solution[379] made up of one part of silver nitrate to four parts of water can be prepared by dissolving ten grams of silver nitrate in forty cc. of water or one avoirdupois ounce of silver nitrate in four British fluid ounces of water.

## ENGLISH WEIGHTS AND MEASURES, 1841[386]

*Troy weights:*[383]

| Pound | Ounces | Drachms | Scruples | Grains | Grams |
|-------|--------|---------|----------|--------|-------|
| 1 | 12 | 96 | 288 | 5760 | 372.96 |
|  | 1 | 8 | 24 | 480 | 31.08 |
|  |  | 1 | 3 | 60 | 3.885 |
|  |  |  | 1 | 20 | 1.295 |
|  |  |  |  | 1 | 0.06475 |

*Avoirdupois weights:*[383]

| Pound | Ounces | Drachms | Grains | Grams |
|-------|--------|---------|--------|-------|
| 1 | 16 | 256 | 7000 | 453.25 |
|  | 1 | 16 | 437.5 | 28.328 |
|  |  | 1 | 27.34375 | 1.7705 |
|  |  |  | 1 | 0.06475 |

*Imperial measures:*[385]

| Gallon | Pints | Fluid ounces | Fluid drachms | Minims |
|--------|-------|--------------|---------------|--------|
| 1 | 8 | 160 | 1280 | 76800 |
|  | 1 | 20 | 160 | 9600 |
|  |  | 1 | 8 | 480 |
|  |  |  | 1 | 60 |

Occasionally the S.G., or specific gravity, of a solution is given.[380,381] Specific gravity is the ratio of the weight of a material to the weight of an equal volume of water.[390] For precise measurements it is necessary to specify the temperature associated with the specific gravity value. According to current definition of specific gravity as the ratio of the mass of a material to the mass of an equal volume of water at 4°C, the specific gravity of the material is numerically equal to its density in grams per milliliter. For an aqueous solution containing a single solute such as silver nitrate,[380] tables listing weight percent of solute vs. the density of the solution can be found in chemical handbooks. For more complex solutions, a hydrometer should be used to determine the specific gravity of the solution as substances are added to the solution.[381]

Volume ratios are most commonly used to express compositions of solutions made up of two liquids.[382] The reader should keep in mind that when two or more substances are brought together to form a solution, the volume of the solution is not necessarily the sum of the volumes of the substances used.

The vagueness of the compositions of solutions or the amounts of substances used were typical of the articles on photography published during 1839 and 1840. Frequently no composition is given in the original articles which Hunt quoted. Variations in the chemical composition of the commercial papers and in the impurities in chemicals contributed significantly to the uncertainties in the recipes of all the early processes. In reading and testing these early works, we should take the attitude that they are only approximate guidelines and avoid the mistake of jumping to unfavorable conclusions if our first experiments with any early process fail.

# APPENDIX C

## CHEMICAL INDEX AND NOTES[397]

**Hunt's names, page references, with current names, formulas, and notes in italics.**

Acetate of lead, 17, 37—*Lead(II) acetate*, $Pb(C_2H_3O_2)_2$. See sugar of lead.

Acetate of silver, 21, 22—*Silver acetate*, $AgC_2H_3O_2$.

Acid nitrate of mercury, 46—*See* acid nitrate of quicksilver.

Acid nitrate of quicksilver, 24, preparation of, 24—*A saturated solution of mercury (II) nitrate*, $Hg(NO_3)_2$, *in nitric acid*, $HNO_3$.

Albumen, 11.

Alcohol, 24, 39, 46, 51, 61, 78, 79, 90—*Common alcohol or spirit of wine was prepared by distilling whiskey or some 'ardent' spirit and had a specific gravity of about 0.87. Rectified spirit of wine was obtained by a second distillation and had a specific gravity of about 0.84. Proof spirit used for making tinctures had a specific gravity of 0.93. Regular proof spirit was 50 percent by weight alcohol. All are aqueous solutions of ethanol or ethyl alcohol,* $C_2H_5OH$.[399]

Alkali, 44—*See hartshorn.*

Alkaline carbonate, 22—*Sodium carbonate*, $Na_2CO_3$, *or potassium carbonate*, $K_2CO_3$.

Alkaline solutions, 17—*Solutions of sodium hydroxide*, NaOH, *potassium hydroxide*, KOH, *or other hydroxides.*

Alum, 17—*Potassium alum*, $KAl(SO_4)_2 \cdot 12H_2O$, *or ammonium alum*, $NH_4Al(SO_4)_2 \cdot 12H_2O$.

Alumina, 17—*Alumina or aluminum(III) oxide*, $Al_2O_3$.

Amalgam— of gold, 62, of silver, 60, 71—*Mercury alloy of other metals.*

Amalgamated copper, 67.

Ammonia, 22, 31, 39, 79—*Aqueous solutions of ammonia*, $NH_3$.

Ammoniaco-sulphate of copper, 64—*Tetramminecopper(II) sulphate*, $Cu(NH_3)_4SO_4$, *prepared by adding ammonia to a solution of copper sulphate*, $CuSO_4$.

Animal glutens, 36—*Gums of animal origin.*

Animal oil of Dippel, 50—*Volatile oil obtained by attenuating animal oil by successive distillation.*

Argentine salt, 70—*Silver salt.*

Argentine wash, 13—*Silver nitrate wash.*

Asphaltum, 3, 48, 49, 62—*Asphalt.*

Baryta, barytes, barytic—*Barium.*

Barytic salts, 83—*Barium salts.*

Basic hyponitrate of the protoxide of quicksilver, 46—*Mercury(I) hydroxide nitrite*, $Hg_2(OH)NO_2$.

Bichloride of mercury, 46, 75, 76, 78, 84—*Mercury(II) chloride*, $Hg_2Cl_2$. *See* corrosive sublimate.

Bichromate of potash, 9, 32, 76, 77, 78, 83—*Potassium dichromate*, $K_2Cr_2O_7$.

Bitumen, 51—*Asphalt.*

Bitumen of Judea, 48, 50—*Jew's pitch, asphalt.*

Borate of lead, 17—*Lead(II) metaborate monohydrate*, $Pb(BO_2)_2 \cdot H_2O$.

Borax, 87—*Borax or sodium tetraborate decahydrate*, $Na_2B_4O_7 \cdot 10H_2O$.

Brine, 31—*A concentrated solution of sodium chloride*, NaCl.

Bromide of potassium, 9, 10, 20, 94—*Potassium bromide*, KBr. *See* hydrobromate of potash.

Bromide of silver, 19, 20, 21, 45, 72, 73, 94, 95—*Silver bromide*, AgBr.

Bromide of sodium, 39, 45—*Sodium bromide*, NaBr.

Bromine, 69, 94—*Bromine*, $Br_2$.

Burnt lime, 90—*Calcium oxide*, CaO.

Calomel, 75—*Mercury(I) chloride*, $Hg_2Cl_2$. *See* chloride of mercury.

Canada Balsam, 25—*Turpentine from balsam fir*.

Carbonaceous earth, 80.

Carbonate of ammonia, 31—*Ammonium carbonate monohydrate*, $(NH_4)_2CO_3 \cdot H_2O$.

Carbonate of barytes, 41—*Barium carbonate*, $BaCO_3$.

Carbonate of silver, 21, 22—*Silver carbonate*, $Ag_2CO_3$.

Carbonate of soda, 68—*Sodium carbonate*, $Na_2CO_3$.

Caustic silver, 2—*Silver chloride*, AgCl.

Caustic soda, 90—*Sodium hydroxide*, NaOH.

Chalk, 62, 68—*Calcium carbonate*, $CaCO_3$

Charcoal, 80, 85.

Chlorate of potash, 10, 15, 39—*Potassium chlorate*, $KClO_3$.

Chloride of gold, 37, 61, 85, 86—*Gold(III) chloride*, $AuCl_3$.

Chloride of lime, solutions of—*Commercial bleaching solutions made from chlorine and slaked lime*, $Ca(OH)_2$. *The solution contains one mole calcium hypochlorite*, $Ca(ClO)_2$, *per mole of calcium chloride*, $CaCl_2$.

Chloride of mercury, 75—*Mercury(I) chloride*, $Hg_2Cl_2$. *See* calomel.

Chloride of platina, 37—*Platinum(IV) chloride*, $PtCl_4$.

Chloride of silver, 2, 3, 7, 12, 14, 18, 19, 20, 23, 24, 31, 32, 45, 61, 67, 68, 71, 73, 76, 84, 87—*Silver chloride*, AgCl. *See* muriate of silver.

Chloride of soda, solutions of, 10, 16, 39—*Commercial bleaching or disinfecting solutions made from chlorine and sodium hydroxide*, NaOH. *The solution contains one mole of sodium hypochlorite*, NaClO, *per mole of sodium chloride*, NaCl. *See* Labarraque's disfecting soda liquid.

Chloride of sodium 38, 61—*Sodium chloride*, NaCl. *See* muriate of soda, common salt, salt.

Chloride of strontium, 45—*Strontium chloride*, $SrCl_2$. *See* muriate of strontia.

Chlorine, 2, 69, 75, 85, 89, 90, 94—*Chlorine*, $Cl_2$.

Chlorine, aqueous solution of, 10, 16, 63—*Chlorine water.*

Chloruret of lime, 63—*Calcium chloride,* $CaCl_2$. *See* muriate of lime.

Chromate of mercury, 78—*Mercury(II) chromate,* $HgCrO_4$, *or mercury(II) dichromate,* $Hg_2Cr_2O_7$.

Chromate of silver, 21, 22, 32, 78—*Silver chromate,* $Ag_2CrO_4$, *or silver dichromate,* $Ag_2Cr_2O_7$.

Chromic acid, 78—*Chromic acid,* $H_2CrO_4$.

Citrate of silver, 21, 22—*Silver citrate,* $Ag_3C_6H_5O_7$.

Common Salt, 10, 12, 59—*Sodium chloride,* NaCl. *See* chloride of sodium, muriate of soda, salt, and table salt.

Copal varnish, 35—*Varnish made from resins from various tropical trees.*

Copper, 3, 49, 53, 54, 60, 62, 67-70, 79, 83, 87.

Corrosive sublimate, 75, 76, 84—*Mercury(II) chloride,* $HgCl_2$ *See* dichloride of mercury.

Cream of tartar, 67—*Potassium hydrogen tartrate,* $KHC_4H_4O_6$.

Cyanide of silver, 31—*Silver cyanide,* AgCN.

Dahlia, 79.

Deal, 89.

Dextrine, 61—*Soluble carbohydrate from starch.*

Diacetate of lead, 10—*Lead(II) acetate,* $Pb(C_2H_3O_2)_2$. *See* acetate of lead, sugar of lead.

Egg white, 11.

Emery, 51.

Etching ground, 35.

Ether, 51, 85—*Ethyl ether,* $(C_2H_5)_2O$.

Ferrocyanate of potash, 31, 37—*Potassium hexacyanoferrate(II) more commonly known as potassium ferrocyanide,* $K_4Fe(CN)_6$. *See* ferroprussiate of potash, prussiate of potash.

Ferroprussiate of potash, 72—*Same as above.*

Fluoride of silver, 72—*Silver fluoride,* AgF.

Fulminate of silver, 22, 23—*Silver fulminate,* $Ag_2C_2N_2O_2$.

Glass, iv, 3, 7, 10, 21, 24, 26, 28, 29, 35, 42, 49, 50-52, 60, 64, 70-72.

Gold, 61, 62, 74, 80, 85-87.

Gum, 33, 36, 61, 62.

Gum acacia, 36—*Gum from* acacia arabica. *See* gum arabic.

Gum arabic, 62, 78—*Gum from* acacia arabica *or* acacia vera.

Gum guaiacum, 2, 79—*Gum from* guaiacum officinale.

Gum lac, 60, 61—*Gum-lac, an inferior kind of lac from a scale insect* gascardia madagascariensis.

Gum tragacanth, 36—*Gum from* astragalus tragacantha.

Hartshorn, 44—*Spirit of hartshorn, an aqueous solution of ammonia*, $NH_3$.

Heart-ease, 79—*Heartsease or heart's-ease, the wild pansy.*

Horn silver, 2—*Cerargyrite, native silver chloride*, AgCl.

Hydrate of alumina, 17—*Aluminum hydroxide*, $Al(OH)_3$.

Hydrate of oxide of lead, 17—*Lead(II) hydroxide*, $Pb(OH)_2$.

Hydriodate of: ammonia, 40—*Ammonium iodide*, $NH_4I$; baryta, 40, 41—*Barium iodide*, $BaI_2$; iron, 40—*Iron(II) iodide*, $FeI_2$; lead, 17—*Lead(II) iodide*, $PbI_2$. *See* iodide of lead; manganese, 40—*Manganese(II) iodide*, $MnI_2$; potash, 10, 22, 34, 35, 40, 44, 68, 83, 86—*Potassium iodide, KI. See* iodide of potassium; soda, 40—*Sodium iodide*, NaI. *See* iodide of sodium.

Hydriodic: acid, 37, 40, 41, 89—*Hydroiodic acid*, HI; saline solution, 19—*A solution of an iodide*; salt, 36, 37, 39, 42, 47, 75, 79, 83—*Any iodide*; solution, 41, 86—*An iodide solution*; wash, 38—*An iodide wash.*

Hydrobromate of potash, 10—*Potassium bromide*, KBr. *See* bromide of potassium.

Hydrochloric acid, 2, 10, 45, 74, 89—*Hydrochloric acid*, HCl. *See* muriatic acid and spirits of salts.

Hydrochloric ether, 10, 16, 39—*Ethyl chloride*, $C_2H_5Cl$.

Hydrofluoric acid, 72—*Hydrofluoric acid*, HF.

Hydrogen, 2, 43, 74—*Hydrogen*, $H_2$.

Hydrosulphate of ammonia, 62—*Ammonium sulphide*, $(NH_4)_2S$.

Hydruret of carbon, 79—*Components of pitch insoluble in alcohol.*

Hyposulphite of soda, 5, 8, 18, 30, 32, 34, 44, 59, 61, 62, 70-72, 76, 79, 84, 90, 95—*Sodium thiosulphate pentahydrate*, $Na_2S_2O_3$·$5H_2O$. It was called sodium hyposulphite or "Hypo."

Iodated silver, 61—*Silver surface of daguerreotype plate which was converted to silver iodide or "iodized."*

Iodidated solution, 45—*A solution of an iodide. In this case, a potassium iodide solution.*

Iodide of: lead, 37—*Lead(II) iodide*, $PbI_2$. *See* Hydriodate of lead; potassium, 10, 19, 31, 32, 39, 45—*Potassium iodide*, KI. *See* hydriodate of potash; silver, 18, 19, 20, 31, 37, 42-44, 62, 72, 73, 76, 94—*Silver iodide*, AgI. *See* ioduret of silver; sodium, 45—*Sodium iodide*, NaI. *See* hydriodate of soda.

Iodine, 34, 40, 41, 43, 44, 50, 55, 56, 59-62, 67-70, 73-75, 78, 83, 84, 86, 89, 90, 94—*Iodine*, $I_2$.

Ioduret of silver, 53, 68, 70, 71—*Silver iodide*, AgI. *See* iodide of silver.

Isinglass, 11—*Gelatin made from air bladders of fish*.

Labarraque's disinfecting soda liquid, 10—*See* chloride of soda, solutions of.

Lamp black, 27.

Lichen Rocellus, 79—*Litmus is the dye obtained from an alkaline extract of this lichen*.

Lime, 60—*Calcium oxide*, CaO.

Linseed oil, 90.

Magnesia, 62—*Magnesium oxide*, MgO.

Manganese, 90—*Manganese(IV) oxide*, $MnO_2$, *commonly called manganese dioxide*.

Mercury, 34, 58, 59, 60-62, 67-71, 73, 75, 76, 84, 94-96—*Mercury*, Hg. *See* quicksilver.

Mordant, 15, 17, 18, 85.

Muriate of: ammonia, 9, 10, 15, 38, 45, 46, 74—*Ammonium chloride*, $NH_4Cl$; baryta, 10, 15, 39, 46, 83—*Barium chloride*, $BaCl_2$; barytes, 8, 85—*Barium chloride*, $BaCl_2$; copper, 37—*Copper(II) chloride*, $CuCl_2$; iron, 15, 37, 39—*Iron(II) chloride*, $FeCl_2$; lead, 17—*Lead(II) chloride*, $PbCl_2$; lime, 10, 15—*Calcium chloride*, $CaCl_2$; peroxide of iron, 10, 15—*Iron(III) chloride*, $FeCl_3$; potash, 15—*Potassium chloride*, KCl; silver, 2—*Silver chloride*, AgI. *See* chloride of silver; soda, 8, 10, 12-15, 18, 31, 68, 69—*Sodium chloride*, NaCl. *See* chloride of sodium, common salt, salt; strontia, 10, 15, 17, 38, 46—*Strontium chloride*, $SrCl_2$. *See* chloride of strontium.

Muriated wash, 37—*A chloride solution*.

Muriatic acid, 2, 23, 24, 44-46, 75, 79, 90—*Hydrochloric acid*, HCl. *See* hydrochloric acid, spirits of salts.

Muriatic salts of earthy bases, 18—*Chlorides of beryllium, mag-*

*nesium, calcium, strontium, and barium*, $BeCl_2$, $MgCl_2$, $CaCl_2$, $SrCl_2$, $BaCl_2$.

Nitrate of: copper, 37, 62—*Copper(II) nitrate*, $Cu(NO_3)_2$; copper (cuprous salt), 10—*Copper(I) nitrate*, $CuNO_3$; lead, 17, 37—*Lead(II) nitrate*, $Pb(NO_3)_2$; mercury, 24, 67—*Mercury(II) nitrate*, $Hg(NO_3)_2$; potash, 15—*Potassium nitrate*, $KNO_3$; silver, 3, 5, 6, 10-23, 30-32, 36-39, 43-45, 62, 71, 72, 74, 75, 77-79, 83-85, 87, 95—*Silver nitrate*, $AgNO_3$; soda, 15—*Sodium nitrate*, $NaNO_3$.

Nitric acid, iv, 22, 24, 50, 53, 54, 62, 63, 68, 70, 85—*Nitric acid*, $HNO_3$.

Nitric ether (sweet spirits of nitre), 10, 39—*Ethyl nitrate*, $C_2H_5$-$NO_3$.

Nitromuriate of gold, 85—*A solution of gold in* aqua regia, *a mixture of nitric acid and hydrochloric acid.*

Oil of lavender, 3, 48, 49, 51—*Oil from the flowering spike of the* lavandula spica.

Oil of petroleum, 52.

Oil of white petroleum, 49.

Olive oil, 53, 54, 60.

Organic matter, 7, 16-18, 78, 84, 85.

Organized matter, 17—*Probably misprint of organic matter.*

Oxalate of: lead, 17—*Lead(II) oxalate*, $PbC_2O_4$; silver, 21, 22—*Silver oxalate*, $Ag_2C_2O_4$.

Oxide of gold, 2—*Gold(III) oxide*, $Au_2O_3$.

Oxide of: lead, 17, 37—*Lead(II) oxide*, PbO; black, 2—*Lead(I) oxide*, $Pb_2O$; puce coloured, 2—*Lead(IV) oxide*, $PbO_2$; red, 2—*Lead(III) oxide*, $Pb_2O_3$.

Oxide of: mercury, green, 2—*Mercury(I) oxide*, $Hg_2O$; red, 2—*Mercury(II) oxide*, HgO.

Oxide of silver, 2, 31, 34, 39, 43, 68, 70, 73, 74, 77—*Silver(I) oxide*, $Ag_2O$. Hunt's designation of the metallic silver image on photographs as silver oxide (as on pp. 31, 34, 43, 70, 73, 74, 77) can be traced to Berthollet's erroneous hypothesis.[400]

Oxygen, 43, 90—*Oxygen*, $O_2$.

Paper, 7-9, 11, 13, 17, 18, 20, 23, 24, 32, 38, 43, 60, 70, 78, 79, 94.

Phosphate of: barytes, 41—*Barium phosphate*, $Ba_3(PO_4)_2$; lead, 17—*Lead(II) phosphate*, $Pb_3(PO_4)_2$; silver, 21, 31, 74—*Silver*

phosphate, $Ag_3PO_4$; soda, 10, 21, 39—*Sodium phosphate*, $Na_3$-$PO_4$.

Phosphoric acid, 41—*Phosphoric acid*, $H_3PO_4$.

Phosphorus, 41, 74—*Yellow phosphorus*, $P_4$.

Phosphuretted hydrogen, 74—*Phosphine*, $PH_3$.

Pitch, 79.

Plaster of Paris, 7—*Calcium sulphate hemihydrate*, $CaSO_4 \cdot \frac{1}{2}H_2O$. *See* sulphate of lime.

Platina, 43, 44, 60—*Platinum*, Pt.

Protoxide of silver, 74—Insufficient description.

Prussiate of potash, 31—*See* ferrocyanate of potash.

Pumice, 53, 54, 59, 60.

Pumice stone, 67.

Quicksilver, 24, 75—*Mercury*, Hg. *See* mercury.

Resins, 3, 51.

Rochelle salt, 10, 22—*Potassium sodium tartrate tetrahydrate*, $KNaC_4H_4O_6 \cdot 4H_2O$. *See* tartrate of potash and soda.

Rotten-stone, 67.

Rouge, jeweller's, 67.

Saline, 13, 14, 38, 39, 59—*An aqueous salt solution*.

*Salt*, 71, 95—*Sodium chloride*, NaCl. *See* common salt, chloride of sodium, muriate of soda, table salt.

Salts of protoxide of silver, 74—Insufficient description.

Salts of silver, 21, 22, 32, 77, 82.

Silver, iv, 2, 3, 10, 22, 34, 38-41, 43, 44, 49, 50, 53-56, 59-62, 67-74, 79, 80, 83, 85-87, 94—*Silver*, Ag.

Silver solution, 37, 38—*Silver nitrate solution*.

Silvering powder, 67.

Size, 7, 11, 27, 28, 36, 84.

Snake stone, 67.

Soda, 67, 90—*Sodium carbonate*, $Na_2CO_3$.

Spirit, 67—*See* alcohol.

Spirits of: salts, 10—*Hydrochloric acid*, HCl. *See* hydrochloric acid and muriatic acid; turpentine, 25—*Oil of turpentine or gum spirit*; wine, 2, 10, 11, 20, 22, 50—*See* alcohol.

Starch, 60, 78.

Stone, 49.

Subchloride of silver, 45—*Not knowing the chemical nature of darkened material, Lassaigne*[280] *called silver chloride darkened by exposure to sun light* sous-chlorure d'argent *which was translated as sub-chloride of silver in the* Chemist.[281]

Sugar of lead, 10, 17, 35—*Lead(II) acetate trihydrate*, $Pb(C_2H_3O_2)_2\cdot 3H_2O$. See acetate of lead, diacetate of lead.

Sulphate, 90.

Sulphate of: baryta, 40—*Barium sulphate*, $BaSO_4$; barytes, 4—*Barium sulphate*, $BaSO_4$; indigo, 77—*Sodium indigotin disulphonate*, $C_{16}H_8N_2Na_2O_8S_2$ (soluble indigo); iron, 37, 40—*Iron (II) sulphate*, $FeSO_4$; lead, 17—*Lead(II) sulphate*, $PbSO_4$; lime, 7—*Calcium sulphate*, $CaSO_4$. See plaster of Paris.

Sulphite, 85.

Sulphur, 74, 85, 87, 90.

Sulphuret, 90—*Sulphide*.

Sulphuret of: antimony, 74—*Antimony(III) sulphide*, $Sb_2S_3$; silver, 32, 34, 75, 85, 86—*Silver sulphide*, $Ag_2S$.

Sulphureted hydrogen, 34, 74, 75, 76, 86—*Hydrogen sulphide*, $H_2S$.

Sulphuric acid, 40, 41, 68, 90—*Sulphuric acid*, $H_2SO_4$.

Sulphurous acid gas, 90—*Sulphur dioxide*, $SO_2$.

Sweet spirit of nitre, 39—*See* nitric ether.

Table salt, 67—*Sodium chloride*, NaCl. See common salt, chloride of sodium, muriate of sodium, salt.

Tartrate of: potash and soda, 10, 22—*See* Rochelle salt; silver, 21, 22—*Silver tartrate*, $Ag_2C_4H_4O_6$; soda, 39—*Sodium tartrate dihydrate*, $Na_2C_4H_4O_6\cdot 2H_2O$.

Tin, 3—*Tin*, Sn.

Tincture of: gum guaiacum, 79; iodine, 67— *An alcohol solution of.*

Tripoli, 61.

Urate of soda, 39—*Sodium urate monohydrate*, $Na_2C_5H_2N_4O_3\cdot H_2O$.

Varnish, 25, 49, 50.

Vegetable colours, 79, 91.

Violet tricolor, 79—*Wild pansy.*

Water: distilled, 10, 39, 41, 95; soft, 41.

Wax, 49.

White lead, 35—*Lead(II) dihydroxide dicarbonate*, $Pb_3(OH)_2$-$(CO_3)_2$.

Willow, 89.

Zinc, 68—*Zinc*, Zn.

# APPENDIX D

## NAME INDEX TO THE *TREATISE*

Since Hunt generally gave neither first names nor references for his quotations and his *Treatise* had no index, this index supplies the complete names, the dates of birth and death, the pages of Hunt's *Treatise* on which the name appeared, and the reference numbers (in parentheses) of the person's publications quoted by Hunt and notes on the names.

Arago, Dominique François Jean (1786-1853), 3, 92, 93, (201-207).

Backhoffner, 69, see Bachhoffner
Bachhoffner, George Henry (1810-1879), 69, (208-213).
Bayard, Hippolyte (1801-1887), 5, 45, (214).
Beard, Richard (1802-1885), 66, (215).
Becquerel, Alexandre Edmond (1820-1891), 5, 78, (216).
Bérard, Jacques Étienne (1789-1869), 2, (217, 220).
Berres, Joseph Edler von (1796-1844), 62, 63, (218, 219, 278).
Berthollet, Claude Louis (1748-1822), 2, (220).
Berzelius, Jöns Jakob (1748-1822), 2, (221).
Biot, Jean Baptiste (1774-1862), 4, 21, 82, (222, 223, 434).

Choiselat, Charles, 62, (224).
Configliachi, Pietro (1777-1844), 2, (225).
Cooper, John Thomas (1790-1854), 14, 15, (226, 227).

Daguerre, Louis Jacques Mandé (1789-1851), iii, 3, 4, 22, 27, 50-53, 57, 60, 62, 66, 69, 70, 75, 82, 94, (201-205, 207, 228-237).
Daubeny, Charles Giles Bridle (1795-1867), 88, (238).
Davy, Sir Humphry (1778-1829), 1-3, (239-241).
Donné, Alfred (1801-1878), 5, 63, (242).
Draper, John William (1811-1882), 5, 27, 29, 56, 63, 66, (243).
Duchâtel, Charles Marie Tenneguy, Comte (1803-1867), 4, (244).

Englefield, Sir Henry Charles (1752-1822), 2, (245).

Fizeau, Hippolyte Louis (1819-1896), 61, (206, 246).
Fulhame, Mrs., 74, (247).
Fyfe, Andrew, the younger (1792-1861), 5, 21, 35, (248, 249).

Harris, Sir William Snow (1791-1867), 2, (250).
Havell, John F. (?-1841), 34, 35, (251-259, 341).
Havell, William (1782-1857), 34, 35, (251-259, 341).
Herschel, Sir John Frederick William (1792-1871), iv, 5, 7, 8, 14, 16-18, 29, 30, 35, 37, 71, 72, 80, 82, 83, 84, 87, 88, 91, (260-271).
Herschel, Sir William (1738-1822), 2, (272-274).

Jordan, Thomas Brown (1807-1890), 87-89, (275, 276).

Knox, George James, 2, (277).
Knox, Rev. Thomas, 2, (277).
Kratochwila, Franz, 62, (219, 278, 279).

Lassaigne, Jean Louis (1800-1859), 35, 45, (280, 281).
Lubeck, 2, see Seebeck, (282-284).

Malaguti, Faustino Jovita (1802-1878), 30, (285).
Morichini, Domenico Pini (1773-1836), 2, (286, 287).

Newton, Sir Isaac (1642-1727), 70, (288).
Niepce, Joseph Nicéphore (1765-1833), 1, 3, 4, 48, 50, (289-291).
Niepce, Isidore (1805-1868), 4

Ponton, Mungo (1801-1880), 5, 9, 76, 78, (292).
Prechtl, Johann Joseph Ritter von (1778-1854), 62, (293, 294).
Preschot, 62, see Prechtl, (294).

Ritter, Johann Wilhelm (1776-1810), 2, (295).
Rumford, Benjamin Thompson, Count, (1753-1814), 2, 80, 85, (296, 297).

Schafhaeutl, 16, 23, 24, 46, 79, 85, see Schafhäutl
Schafhäutl, Karl Franz Emil (1803-1890), 16, 23, 24, 46, 79, 85, (298).
Scheele, Karl Wilhelm (1742-1786), 2, (299).
Seebeck, Thomas Johann (1770-1831), 2, (300-303).
Seguier, Baron Armand Pierre (1803-1876), 60, (304-306).
Soleil, Jean-Baptiste François (1798-1878), 5, 61, (307, 308).
Somerville, Mary (Mrs. William Somerville, née Fairfax) (1780-1872), 2, (309).
Spencer, Thomas, 72, (310-315).

Talbot, William Henry Fox (1800-1877), iii, iv, 4, 5, 11, 12, 14, 18, 20, 27, 30, 34, 35, 45, (316-337).

Towson, John Thomas (1804-1881), 22, 23, 29, 66, (338).

Vérignon, 45, (340).

Wedgwood, Thomas (1771-1805), 1-3, (240).
Wellmore, 34, see Willmore
Willmore, James Tibbits (1800-1863), 34, (251-259, 341).
Wolcott, Alexander Simon (1804-1844), 66, (345).
Wollaston, William Hyde (1766-1828), 2, 80, (342-344).
Woolcott, 66, see Wolcott

# APPENDIX E

## SUBJECT INDEX

Actinograph, 88
Alchemists, 2

Bichromate of potash processes, 76-79; with iodine and starch, 78-79; with silver and mercury salts, 78; with sulphate of indigo, 77
Blue demy process, 79
Bromidated papers (silver bromide papers), 9, 19-21, 94-96; effect of paper on sensitivity of, 9; preparation and properties of, 19-21; use of mercury in bringing out pictures on, 94-96

Calotype, 4
Camera, 18, 26, 42, 48, 61, 64, 67, 71, 96; Cigar box, 27; Daguerre's, 57; Draper's, 27, 66; Hunt's, 27, 67, 80-82; Obscura, 1, 3, 11-13, 20, 21, 26, 27, 41, 42, 49, 53, 77, 86, 94; With mirrors, 66
Carbonized plate process (Schafhaeutl), 79
Chemicals, for making negative photographic papers, 10.
Colorific: agent, 17; effect of barytic salts, 83; effect of gluten, 36
Colour: of thin films, 70; photographs, 82-83; produced by different coloured lights, 29
Contrast, increase of, 33. *See also* darkening the shadows
Copying: botanical specimens, 24-25; by juxtaposition, 86-87; engravings, 11, 25, 34, 35; lace and feathers, 10; profiles, 1

Daguerre: history of, 3-4; letter of, to Hunt, 69-70. *See* Name Index.

Daguerreotype, 5, 53-71, 72, 74, 92; apparatus, 34, 53-56, 58-61, 67, 95; bringing out the picture, 58-59; bromine in, 69; camera, 57, 66, 67; chemistry, 70-71; cleaning and polishing the plates, 53, 54, 61, 67, 70; engraving and etching of, iv, 62-63, 69; experiments on, 69; exposure of, 58, 61; fixing of, 59-62; focusing, 57-58; improvements, 60-70; invisible, 84; iodizing the plate, 54-56, 60, 61; keeping quality of unexposed, 56; miscellaneous observations, 68; original process, 53-60; portraits, 63-66; reusing the plate, 60; reversal of, 84; sensitivity of, 55, 69-70; silvering copper plate for, 63, 67-68; simplifications, 67-69
Daguerreotype on paper (Hunt), 73-76
Darkening the shadows, 34
Developing, 95. See also "bringing out the picture" under each process.
Direct-positive photographic papers. See positive photographs.
Drawing by application (printing), 41. See also transfer.

Electroplating. See galvanic agency.
Etching on glass plate, 34-35
Exposure, 12, 27, 58, 61

Fixing, 5, 8, 11, 18, 24, 30-32, 34, 42, 44, 46, 59, 61, 62, 70-72, 79, 95
Fixing agents: alcohol, 46; ammonia, 31; bichromate of potash, 32; carbonate of ammonia, 31; chloride of gold, 61-62; ferrocyanate of potash, 31; gum, 62; hydrosulphate of ammonia, 62; hyposulphite of soda, 5, 8, 18, 30, 32, 34, 44, 59, 61, 62, 70-72, 79, 95; iodide of potassium, 31, 32; muriate of soda, 31, 59; muriatic acid and acid nitrate of quicksilver, 24; nitric acid and nitrate of silver or copper, 62; water, 11, 31, 42
Focusing, 26, 29, 57; chemical, 29, 66; luminous, 29

Galvanic agency: in silvering copper, 68; in thickening silver image, 72
Glass: effect of, on darkening of nitrate of silver, 7, 29; heliography on, 3, 49-52; Herschel's process on, iv, 71-72; phosphate of silver process on (Fyfe), 21
Gold: revival of, 2, 74, 80, 85; salts as photographic agents, 85-86

Heliograph (Jordan's light recorder), 88, 89
Heliography, 3, 48-52
Herschel, Sir John, letter to Hunt, 82, 91
History of photography, 1-5
Hydriodic acid solutions, preparations of, 40-41
Hydriodic salts as photographic agents, 36-45

Intensification. See contrast, increase of, *and* darkening the shadows.

Invisible photographs, 84

Iodidated papers (silver iodide papers), 18-19

Jugglers of India copying profiles, 1

Lens, 26, 27, 29, 57, 64, 66, 80-82; achromatic, 29, 82; achromatic and periscopic, 57; acromatic glasses for, 29; achromaticity of, 80; double convex, 29, 64, 66; periscopic, 81

Light: absorption of, by air and water, 30; calorific influences of, 2, 91; chemical influences of, 1, 2, 30, 91: maximum, on photographic papers, 29; on bleaching of silver by hydriodate of potash, 35; on coloured bodies, 1; on darkening of silver salts, 1, 2, 5, 11, 17-18, 20, 21, 79, 84; on gum guaiacum, 2; on oxides of lead and mercury, 2; on precious stones (amethyst and opal), 1; on reaction between hydrogen and chlorine, 2; on revival of gold and silver from oxides, 2; colours produced by different coloured, 29; effectiveness in darkening of photographic papers by different, 28-29; effectiveness in darkening of photographic papers by sunlight at different hours, 30; focal distances of different, 29; infrared (rays of a deeper red), 28; luminous influences of, 2, 91; luminous influences of, on vegetable colour papers, 91; magnetic induction by violet, 2; permeated through coloured media, 83; refraction of, 28; refrangibility, 2, 29, 45, 70, 83; registering of variation of, with photographic paper, 30, 88-89 (*see* actinograph *and* heliograph), spectrum, 28; theories, 91; ultraviolet (beyond the violet), 2, 28

Metal, photographic processes on: carbonized plate process, 79; daguerreotype, 53-71; heliography, 49-52; phosphate of silver process, 21

Mirror: camera for daguerreotype portraits, 66; in camera obscura, 26; to provide reflected light for portraiture, 64; to reverse image on daguerreotype, 57

Muriated papers (silver chloride papers), 11-18, 31, 84; fixing, 31; preparation of, 11-18; using, 24-27

Negative photographs, 9-32, 94-96; apparatus for preparing, 9; fixing, 30-32, 95; preparation of papers for, 10-29, 94-95; using, 24-27, 95

Nitrated papers (silver nitrate papers), 10, 11, 31; fixing, 31; preparation of, 10-11

Non-silver processes. *See* bichromate of potash processes, gold salts as photographic agents, *and* vegetable colour processes.

Organic matter, effect of: on darkening of silver salts, 7, 11, 16-18, 20, 84-85; on permanence of positive photographs, 36

Paper: bank post, 8, 9, 23; bath drawing cards, 8, 9; bibulous (filter

SUBJECT INDEX *xlv*

paper), 9; blotting, 9, 13, 32, 78; card board, 60; demy, 7, 20; demy, blue, 79; demy, smooth, 18; demy, superfine, 8, 9; metallic, Penny's improved patent, 23; post, blue wove, 17; post, thick, 8, 9; post, thick wove, 8, 9; post, thin, 7, 9; post, writing, 24; satin post, double glazed (J. Whatman), 38; satin post, superfine, 8, 9; satin post, well glazed, 94; tissue, 8, 9; unsized, 9; writing, superfine, 11

Paper, photographic processes on, iv, 1, 6-47, 73-79, 94-96; acetate of silver, 21, 22; apparatus for preparing, 9; apparatus for using, 24, 25; bichromate of potash, 9, 76-79; bromidated papers (bromide of silver), 9, 19-21, 94-96; carbonate of silver, 21, 22; chromate of silver, 21, 22; citrate of silver, 21, 22; daguerreotype on paper (Hunt), 73-76; effect of: excess silver nitrate on the sensitivity of, 14, 19; glass on the darkening of, 7, 29; heat on (thermography), 19 (*see* copying by juxtaposition); humidity on, 15, 43; moisture on, 29, 30, 95; organic matter on, 7, 11, 16-18, 20, 36, 84, 85; sulphur and sulphite on, 85; fulminate of silver, 22, 23; hydriodated (*see* positive photographs); invisible photographs, 84; iodidated papers (iodide of silver), 18, 19, 84, 86; muriated papers (chloride of silver), 3, 11-18, 31, 84; negative photographs, 9-32; nitrated papers (nitrate of silver), 3, 10, 11, 31; oxalate of silver, 21, 22; phosphated papers (phosphate of silver), 21; positive photographs, 35-46; relative sensitivities of bromidated, iodidated, and muriated papers, 19, 20; reversal of, 84; selection of paper for, 6-9; spontaneous darkening of, 84, 85; tartrate of silver, 21, 22; vegetable colour, 79, 91

Patents: Beard, 66; Daguerre, 4; Talbot, 4; Wolcott, 66

Photogenic drawings, iii, 11

Positive photographs, 32-47; by transfer, 32-34; from etching on glass, 34, 35; of Bayard, 45; of Hunt, 35-46: bringing out the picture with alkali and acid, 44; chemistry of, 42-44; colour of, 38, 39, 45; directions for taking photographs with, 41, 42; effects of coating the paper with metallic solutions, 36, 37; fixing, 42, 44; preparation of, 37-39; of Lassaigne, 45; of Schafhaeutl, 46; of Verignon, 45, 46

Printing. *See* transfer.

Silver. *See* silver and various salts of silver in the Chemical Index.

Silvering copper, with: galvanic agency, 68; silvering powder, 67

Solar microscope, 1, 5

Solarized (exposed to the sun), 21, 64, 83

Specific gravity, 18, 22, 72

Spectrum, 1, 28, 70

Talbot's letter to Hunt, 4

Thermography, 19

Transfer, 24, 31, 32, 33, 94. *See also* drawing by application.

Vegetable colour processes, 79, 91

Wood made light sensitive, 89, 90

# APPENDIX F

## ABBREVIATIONS USED IN CITATIONS

*Abhandl. Konig. Akad. Wiss. Berlin—Abhandlungen der Königlichen Akademie der Wissenschaften zu Berlin.*

*Academy—Academy, London.*

*Ann. Chem. Pharm.—Annalen der Chemie und Pharmacie. (Liebig)*

*Ann. Chim.—Annales de Chimie, ou Recueil de Mémoires concernant la Chimie et les Arts qui en dépendent, Paris.*

*Ann. Phil.—Annales of Philosophy; or Magazine of Chemistry, Mineralogy, Mechanics, Natural History, Agriculture, and the Arts. (Thomson)*

*Ann. Physik—Annalen der Physik. (Gilbert)*

*Ann. Physik Chem.—Annalen der Physik und Chemie. (Poggendorff)*

*Ann. Sci.—Annals of Science.*

*Art Union—Art Union, London.*

*Art J.—Art Journal, London.*

*Athenaeum—Athenaeum, London.*

*B.C.—Bibliotheca Cornubiensis* by George Clement Boase and William Prideaux Courtney, Longmans, Green, Reader, & Dyer, London, 1874-1882, 3 vols.

*Biog. Rev.—Biograph and Review, London.*

*Brit. J. Phot.—British Journal of Photography, London.*

*C.C.—Collectanea Cornubiensia; Collection of Biographical and Topological Notes Relating to the County of Cornwall,* by George Clement Boase, Netherton & Worth, Truro, 1890.

*Chemist—The Chemist; or Reporter of Chemical Discoveries and Improvements and Protector of the Rights of the Chemist and Chemical Manufacturer, London.*

*Compt. Rend.—Comptes Rendus Hébdomadaires des Séances de l'Académie des Sciences,* Paris.

*D.N.B.—Dictionary of National Biography,* ed. by Leslie Stephen and Sidney Lee, Smith Elder & Co., London, 1908-1909.

*Dag. J.—Daguerreian Journal,* Philadelphia. First issued as Humphrey's *Journal of the Daguerreotype and the Photographic Arts and the Sciences and Arts Pertaining to Heliography.*

*Edinb. J. Sci.—Edinburgh Journal of Science.*

*Edinb. New Phil. J.—Edinburgh New Philosophical Journal.*

*Edinb. Phil. J.—Edinburgh Philosophical Journal.*

*Elec. Mag.—Electrical Magazine,* London and Paris. (Walker)

*Gleaners—Gleaners; or Weekly Historical Register,* London.

*Imp. Mag.—Imperial Magazine; or Compendium of Religious, Moral and Philosophical Knowledge,* London.

*J. Chem. Physik—Journal für Chemie und Physik,* Nurnberg. (Schweigger)

*J. Frankl. Inst.—Journal of the Franklin Institute of the State of Pennsylvania,* Philadelphia.

*J. Nat. Phil. Chem. Arts—Journal of Natural Philosophy, Chemistry, and the Arts,* London. (Nicholson)

*J. Phot. Sci.—Journal of Photographic Science,* London.

*J. Phys. Chim. Hist. Nat.—Journal de Physique, de Chimie, et de l'Histoire Naturelle,* Paris.

*J. Roy. Inst.—Journal of the Royal Institution of Great Britain,* London.

*J. Sci. Arts—Journal of Science and the Arts,* London. Continued as *Quarterly Journal of Science, Literature, and Arts.*

*J. Soc. Arts—Journal of Society of Arts,* London.

*Lit. Gaz.— Literary Gazette,* London.

*M.E.B.—Modern English Biography,* by Frederic Boase, Netherton & Worth, Truro, 1892-1921.

*Mém. Phys. Chim. Soc. Arcueil—Mémoires de Physique et de Chimie de la Société d'Arcueil,* Paris.

*Mem. Proc. Chem. Soc.—Memoirs and Proceedings of the Chemical Society of London.*

*Nature—Nature,* London.

*N. Brit. Rev.—North British Review.*

*Phil. Mag.—Philosophical Magazine,* or *Annals of Chemistry, Mathematics, Astronomy, Natural History, and General Science,* London, 1827-1832. Continued as the *London and Edinburgh Philosophical Magazine and Journal of Science,* Lon-

don, 1832-1840; *The London, Edinburgh, and Dublin Philo-
sophical Magazine and Journal of Science,* 1840-1850.

*Phil. Trans.—Philosophical Transactions of the Royal Society of
London.*

*Phot. Art J.—Photographic Art Journal,* New York.

*Phot. J.—Photographic Journal,* London.

*Phot. Quart.—Photographic Quarterly,* London.

*Proc. Geol. Polytech. Soc. W. Yorks.—Proceedings of the Geologi-
cal and Polytechnic Society of the West Riding of Yorkshire,*
Leeds.

*Proc. Roy. Irish Acad.—Proceedings of the Royal Irish Academy,*
Dublin.

*Proc. Roy. Soc.* (London)*—Proceedings of the Royal Society,* Lon-
don.

*Proc. Roy. Soc. Med.* (London)*—Proceedings of the Royal Society
of Medicine,* London.

*Redruth Independent—Redruth Independent,* Redruth, Cornwall.

*Rept. Brit. Assoc.—Reports of the British Association for the Ad-
vancement of Sciences,* London.

*Rept. Miners' Assoc. Cornwall Devon—Reports of the Miners' As-
sociation of Cornwall and Devon.*

*Rept. Roy. Cornwall Polytech. Soc.—Reports of the Royal Corn-
wall Polytechnic Society,* Falmouth, Cornwall.

*Times—Times,* London.

*Trans. Roy. Geol. Soc. Cornwall—Transactions of the Royal Geo-
logical Society of Cornwall,* Penzance.

*Trans. Roy. Soc. Edinb.—Transactions of the Royal Society of
Edinburgh.*

*Trans. Soc. Arts—Transactions of the Society of Arts,* London.

*W. Antiq.—Western Antiquary;* or *Devon & Cornwall Notebook,*
Plymouth.

*Western Morning News,* Devonport ed.*—Western Morning News,*
Devonport edition.

# APPENDIX G

## NOTES AND REFERENCES

1. Sir David Brewster, *N. Brit. Rev.*, **13**, 117-158 (1850).
2. *B.C.*, **1**, 259-260 (1874); **3**, 1238-1239 (1882).
3. Thompson Cooper, "Men of the time," G. Routledge, London, 1879. pp. 548-549.
4. Lovell Augustus Reeve, "Portraits of Men of Eminence in Literature, Science and Art, with Biographical Memoirs. The Photographs from Life by Ernest Edwards," L. Reeve & Co., London, **2**, No. 15, 119-122 (Aug. 1864).
5. *Biog. Rev.*, **6**, 115-120 (Aug. 1881).
6. *Times*, No. **32208**, 5 (Oct. 20, 1887).
7. *J. Soc. Arts.*, **35**, 980 (Oct. 21, 1887).
8. *Brit. J. Phot.*, **34**, 661 (Oct. 21, 1887).
9. *Athenaeum*, No. **3130**, 541-542 (Oct. 22, 1887).
10. *Academy*, **32**, No. **807**, 272-273 (Oct. 22, 1887).
11. *Rept. Roy. Cornwall Polytech. Soc.*, **55**, 15-16 (1887).
12. *Nature*, **37**, 14 (Nov. 3, 1887).
13. T. W. Newton, *W. Antiq.*, **7**(7), 147-149 (Dec. 1887).
14. *Phot. J.*, **12**, 77-78 (Feb. 24, 1888).
15. *Proc. Geol. Polytech. Soc. W. Yorks.*, **10**, 243-244 (1889).
16. Sir Archibald Geikie, *Proc. Roy. Soc.* (*London*), **47**, i-ii (1890).
17. *C.C.*, 400, 733, 1133, 1206, 1727 (1890).
18. Andrew Lang, "The Photographic Work of Robert Hunt," *Phot. Quart.*, **3**, 229-239 (1892).
19. F. Boase, "Robert Hunt," *M.E.B.*, **1**, 1592-1593 (1892).
20. R. E. Anderson, "Robert Hunt (1807-1887)," *D.N.B.*, **10**, 277-278 (1908).
21. *Trans. Roy. Geol. Soc. Cornwall*, **11**, 69-72 (1895).
22. A. G. K. Leonard, "Devonport-born Scientist Collected Folklore of Old Cornwall, Robert Hunt—'Poet of Science'," *Western Morning News* (Devonport ed.), (Oct. 15, 1954).
23. Miss A. M. Clerke, "Sir John Frederick William Herschel (1792-1871)," *D.N.B.*, **9**, 714-719 (1908).
24. G. C. Boase, "William Henry Fox Talbot (1800-1877)," *Ibid.*, **19**, 339-341 (1909).
25. R. Hunt, "On Tritiodide of Mercury," *Phil. Mag.*, ser. 3, **12**, 27-28 (Jan. 1838).
26. R. Hunt, "On the Permeability of Various Bodies to the Chemical Rays," *Ibid.*, ser. 3, **16**, 138-142 (Feb. 1840).
27. R. Hunt, "On Light which has Permeated Coloured Media,

and on the Chemical Action of the Solar Spectrum," *Ibid.*, 267-275 (Apr. 1840); *J. Frankl. Inst.*, 30, 266-272 (1840).

28. R. Hunt, "On the Use of Hydriodic Salts as Photographic Agents," *Phil. Mag.*, ser. 3, 17, 202-211, 260-268 (Sept.-Oct., 1840).

29. R. Hunt, "On the Influence of Iodine in Rendering Several Argentine Compounds, Spread on Paper, Sensitive to Light, and on a New Method of Producing with Greater Distinctness the Photographic Image," *Phil. Trans.*, 130, 325-334 (1840); *Phil. Mag.*, ser. 3, 17, 381 (Oct. 1840).

30. R. Hunt, "On the Influence of the Ferrocyanate of Potash on the Iodide of Silver, Producing a Highly Sensitive Photographic Preparation," *Rept. Brit. Assoc.*, 11, pt. 2, 47 (1841); *Chemist*, 2, 257-258 (1841).

31. R. Hunt, "Researches on the Influence of Light on the Germination of Seeds and the Growth of Plants," *Rept. Brit. Assoc.*, 12, pt. 1, 75-80 (1842).

32. R. Hunt, "On Thermography, or the Art of Copying Engravings, or any Printed Characters from Paper on Metal Plates; and on the Recent Discovery of Moser, Relative to the Formation of Images in the Dark" *Phil. Mag.*, ser. 3, 21, 462-468 (1842).

33. R. Hunt, "On a Light of a Peculiar and Unknown Character Emanating from the Outer Edge of the Sun," *Rept. Roy. Cornwall Polytech. Soc.*, 10, 31-32 (1842).

34. R. Hunt, "On the Changes which Bodies Undergo in the Dark," *Rept. Brit. Assoc.*, 13, pt. 2, 10-11 (1843).

35. R. Hunt, "Some Experiments and Remarks on the Changes which Bodies are Capable of Undergoing in the Darkness, and on the Agent Producing These Changes," *Phil. Mag.*, ser. 3, 22, 270-279 (1843).

36. R. Hunt, "On Chromatype, a new Photographic Process," *Rept. Brit. Assoc.*, 13, pt. 2, 34-35 (1843).

37. R. Hunt, "On the Influence of Light on the Growth of Plants," *Ibid.*, 35.

38. R. Hunt, "On the Influence of Light on a Great Variety of Metallic and Other Compounds," *Ibid.*, 35-36.

39. R. Hunt, "On the Spectral Images of M. Moser," *Phil. Mag.*, ser. 3, 23, 415-426 (1843).

40. R. Hunt, "Energiatype," *Athenaeum*, No. 866, 500-501 (June 1, 1844); *Ibid.*, No. 869, 575 (June 22, 1844).

41. R. Hunt, "Researches on the Influence of Light on the Germination of Seeds and the Growth of Plants," *Rept. Brit. Assoc.*, 14, pt. 1, 29-32 (1844).

42. R. Hunt, "On the Influence of Light on Chemical Compounds and Electro-chemical Action," *Ibid.*, 14, pt. 2, 35-36 (1844).

43. R. Hunt, "On the Ferrotype, and the Property of Sulphate of Iron in Developing Photographic Images," *Ibid.*, 36.

44. R. Hunt, "On the Chemical Changes Produced by the Solar Rays," *Rept. Roy. Cornwall Polytech. Soc.*, 12, 102-104 (1844).

45. R. Hunt, "Influence of Light on Plants," *Phil. Mag.*, ser. 3, 24, 96-97 (1844).

46. R. Hunt, "On Chromo-cyanotype," *Ibid.*, 435-439.

47. R. Hunt, "Report of the Actinograph," *Rept. Brit. Assoc.*, 15, pt. 1, 90-91 (1845).

48. R. Hunt, "Contributions to Actino-chemistry.—On the Chemical Changes Produced by the Solar Rays, and the Influence of Actinism in Disturbing Electrical Forces," *Ibid.*, 15, pt. 2, 29 (1845).

49. R. Hunt, "Contribution to Actino-chemistry," *Mem. Proc. Chem. Soc.*, 2, 311-320 (March 3, 1845 meeting); *Phil. Mag.*, ser. 3, 27, 25-35 (1845).

50. R. Hunt, "Contribution to Actino-chemistry.—The Chemical Changes Produced by the Solar Rays on Some Photographic Preparations Examined," *Phil. Mag.*, ser. 3, 27, 276-286 (1845).

51. R. Hunt, "Report on the Actinograph," *Rept. Brit. Assoc.*, 16, pt. 1, 31-33 (1846).

52. R. Hunt, "Notices on the Influence of Light on the Growth of Plants," *Ibid.*, 33-34.

53. R. Hunt, "Electrolysis Affected by Solar Light," *Elec. Mag.*, 2, 231-232 (1846).

54. R. Hunt, "Researches on the Influence of the Solar Rays on the Growth of Plants," *Rept. Brit. Assoc.*, 17, pt. 1, 17-30 (1847).

55. R. Hunt, "On the Coloured Glass Employed in Glazing the New Palm House in the Royal Botanic Garden at Kew," *Ibid.*, 17, pt. 2, 51-52 (1847).

56. R. Hunt, "Report of Progress in the Investigation of the Action of Carbonic Acid on the Growth of Plants Allied to Those of the Coal Formation," *Ibid.*, 18, pt. 1, 84 (1848).

57. R. Hunt, "On the Influence of Light in Preventing Chemical Action," *Ibid.*, 18, pt. 2, 54-55 (1848).

58. R. Hunt, "On the Present State of Our Knowledge of the Chemical Action of the Solar Radiation," *Ibid.*, 20, pt. 1, 137-159 (1850).

59. R. Hunt, "On the Chemical Action of the Solar Radiations," *Ibid.*, 22, pt. 1, 262-272 (1852).

60. R. Hunt, "On the Chemical Action of the Solar Radiations," *Ibid.*, 23, pt. 1, 68-81 (1853).

61. R. Hunt, "On a Method of Accelerating the Germination of Seeds," *Ibid.*, 23, pt. 2, 63 (1853).

62. R. Hunt, "On the Principles upon which the Construction of Photographic Lenses should be Regulated," *Phot. J.*, 1, 14-20 (1854).

63. R. Hunt, "On Methods for Measuring the Variations in the Chemical Action of the Solar Rays," *Ibid.*, 81-84.

64. R. Hunt, "A Popular Treatise on the Art of Photography, Including Daguerreotype, and all the New Methods of Producing Pictures by the Chemical Agency of Light," Richard Griffin & Co., Glasgow, 1841. 96 p.

65. R. Hunt, "Researches on Light; an Examination of all the Phenomena Connected with the Chemical and Molecular Changes Produced by the Influence of the Solar Rays; Embracing all the Known Photographic Processes and New Discoveries in the Art," Longman, Brown, Green, and Longman, London 1844. 303 p.

66. R. Hunt, "Photography: a Treatise on the Chemical Changes Produced by Solar Radiation, and the Production of Pictures from Nature by the Daguerreotype, Calotype, and Other Photographic Processes," E. Smedley's Encyclopaedia Metropolitana; or System of Universal Knowledge, 2d ed. rev., 2d div., Applied Science v. 16, J. J. Griffin & Co., London, and Richard Griffin & Co., Glasgow, 1851. 234 p.

67. R. Hunt, "Photography: a Treatise on the Chemical Changes Produced by Solar Radiation, and the Production of Pictures from Nature by the Daguerreotype, Calotype, and Other Photographic Processes," with additions by the American Editor, S. D. Humphrey, New York, 1852. 290 p.

68. R. Hunt, "A Manual of Photography," 3d ed., enlarged, J. J. Griffin & Co., London, and Richard Griffin & Co., Glasgow, 1853. 321 p.

69. R. Hunt, "A Manual of Photography," 4th ed., Richard Griffin & Co., London & Glasgow, 1854. 329 p.

70. R. Hunt, "Researches on Light in its Chemical Relations; Embracing a Consideration of all the Photographic Processes," 2d ed., Longman, Brown, Green, and Longman, London, 1854. 396 p.

71. R. Hunt, "A Manual of Photography," 5th ed., Richard Griffin & Co., London & Glasgow, 1857. 342 p.

72. R. Hunt, "The Practice of Photography," Richard Griffin & Co., London & Glasgow, 1857. 126 p.

73. R. Hunt, "The Practice of Photography," Henry Carey Baird, Philadelphia, [1857]. 126 p.
74. R. Hunt, "Researches on Light," 3rd ed., H. Bohn, London, 1862.
75. Other selected works of Hunt may be found listed elsewhere in the References. A bibliography, compiled by the author, of Hunt's published works, unpublished manuscripts, letters, photographs taken by Hunt, and photographs and portraits of Hunt and his family will be published separately.
76. *Phot. J.*, **15**, 178 (1873).
77. *Redruth Independent* (October 27, 1891).
78. Louis Walton Sipley, "Photography's Great Inventors, Selected by an International Committee for the International Photography Hall of Fame," American Museum of Photography, Philadelphia, 1965. pp. 5, 14, and 23.
79. Josef Maria Eder, "Geschichte der Photographie," 4th ed., Verlag von Wilhelm Knapp, Halle, 1932. 2 v.
80. Josef Maria Eder, "History of Photography," trans. from the 4th German ed.[79] by Edward Epstean, Columbia University Press, New York, 1945.
81. George Potonniée, "The History and the Discovery of Photography," trans. from the French by Edward Epstean, Tennant and Ward, New York, 1936.
82. Wolfgang Baier, "Quellendarstellungen zur Geschichte der Fotografie," Veb Fotokinoverlag, Leipzig, 1966.
83. Helmut Gernsheim and Allison Gernsheim, "The History of Photography, from the Camera Obscura to the Beginning of the Modern Era," McGraw-Hill Book Co., New York, 1969.
84. R. Derek Wood, "J. B. Reade, F.R.S., and the Early History of Photography," *Ann. Sci.*, **27**, 13-45, 47-83 (March 1971).
85. R. Derek Wood, "The Involvement of Sir John Herschel in the Photographic Patent Case, *Talbot* v. *Henderson*, 1854," *Ibid.*, 239-264 (Sept. 1971).
86. Beaumont Newhall, private communication 1972. Mr. Newhall first called to my attention that three of Hunt's books were reprinted in the *Phot. Art J.*
87. Sir David Brewster, *N. Brit. Rev.*, **7**, 465-504 (1847).
88. Sir David Brewster, *Ibid.*, **29**, 177-210 (1858).
89. J. E. B. Gover, A. Mawer, and F. M. Stenton, "The Place-names of Devon," University Press, Cambridge, England, 1931. pt. 1, p. 240. Plymouth Dock became Devonport in 1824.
90. The earliest published biography of Robert Hunt was written by Sir David Brewster in 1850 in a review[1] of three of

Hunt's books.[65,91,92] Brewster met Hunt at the meetings of
the British Association for the Advancement of Science[1] and
might have learned about Hunt's background in conversa-
tion. Later biographies differ from Brewster's only in minor
details and are generally vague or erroneous on dates of
Hunt's early life.

    Hunt reciprocated Brewster's service by writing Brew-
ster's biography in the *D.N.B.*[93] Hunt wrote forty-three
biographies for the *D.N.B.* before he died.

91.  R. Hunt, "The Poetry of Science, or Studies of the Physical
Phenomena of Nature," 2d ed., Reeve, Benham, & Reeve,
London, 1849. 478 p.

92.  R. Hunt, "Panthea, the Spirit of Nature," Reeve, Benham, &
Reeve, London, 1849. 358 p.

93.  R. Hunt, "Sir David Brewster (1781-1868)," *D.N.B.*, 2,
1207-1211 (1908).

94.  Admiralty Documents, Public Record Office, London.
ADM/6/29, Commission and Warrant Books, 1805, War-
rant dated January 28, 1805.

95.  *Ibid.* ADM/6/345, Widow Pension Papers, 1808, X.1,4355.
". . . Robert Hunt, late Carpenter of His Majesty's sloop the
Moucheron, who lost his life when the said sloop foundered
at sea, and which is supposed to have happened in the
month of April, one thousand eight hundred and seven and
has left the Bearer Honour Hunt a Widow; . . . she is not
possessed of a clear Annual Income to double the Value of
Twenty five pounds and therefore she appears to us to be
intitled to the Benefit of the said Charity . . ." (dated June
15, 1808). There is also a certified copy of the entry in the
Register Book of Marriage of the parish of Stoke-Damerel
which reads: ". . . Robert Hunt, Carpenter of the Moucheron
Sloop of war, Bachelor, and Honour Thomas of this Parish,
Spinster, were married in the Parish Church of Stoke Dam-
erel aforesaid, by License on the Thirtieth Day of June in
the year One Thousand Eight Hundred and Five. . . ."

96.  Sir John Knox Laughton, "Sir John Thomas Duckworth
(1748-1817)," *D.N.B.*, 6, 92-96 (1908).

97.  Sir John Knox Laughton, "Edward Pellew, First Viscount
Exmouth (1757-1833)," *Ibid.*, 15, 711-715 (1909).

98.  Probated Wills, Public Record Office, London. Prob II,
1481, C/876. Robert Hunt's will made on New Year's Day,
1807 was proved at London on June 30, 1808.

99.  Letter from Hunt to Herschel dated March 22, 1844, Royal
Society of London HS.10.108.

100.  W. E. A. Axon, "Joshua Brookes (1754-1821)," D.N.B., 2,

1342-1343 (1908). Hunt went to London when he was about twelve-and-a-half,[5] or 1820. He probably attended some of the last lectures of Brookes since Brookes died in 1821.

101. Ref. 5 gives the most detailed description of Robert Hunt's association with the Smith brothers. Richard Smith was a native of Somersetshire and owned property next to the manor of Henry Hunt. No other biographical material has been found for the Smith brothers.

102. Almost all the tales in *Gleaners* were published anonymously. Two tales which may have been written by Hunt are:
    (a) "The Land's End of Cornwall," 1(17), 261-264 (August 20, 1823); 1(18), 285-287 (Aug. 27, 1823); 1(19), 293-295 (Sept. 3, 1823); 1(20), 312-314 (Sept. 10, 1823).
    (b) "St. Michael's Mount, Cornwall," 1(21), 321-322 (Sept. 17, 1823).

103. No poem signed by Hunt is found in the *Imp. Mag.* from 1822 to 1832. There are five poems signed "H":
    (a) "Sonnet.-Thought," 5, 927 (1823).
    (b) "A Promise," 6, 1046 (1824). (dated Birmingham, Sept. 1824.)
    (c) "Birthday Lines," 7, 743 (1825). (dated March 1, 1825.)
    (d) "Lines on Seeing the Beautiful Ruins of Slaugham-Place, Sussex. The Remains of a Noble Mansion of a Family named 'Covert,' who flourished in the Reign of King Henry the Third," 7, 936-937 (1825). (addressed Woolwich.)
    (e) "A Scottish Chief to the Ruined Mansion of his Ancestors," 8, 563 (1826). (dated Belgrave, near Leicester, 1826.)
    A number of poems were published anonymously or with apparent pen names. There is no clue to show which poems, if any, were written by Hunt.

104. J. A. Hamilton, "Henry Hunt (1773-1835)," *D.N.B.*, 10, 264-266 (1908).

105. Henry Hunt was imprisoned from 1820 to 1822.[104] He was relatively inactive from 1822 to 1826. His visits to Richard Smith's establishment and his education of Robert Hunt probably took place during that period. Brewster[1] also mentioned Henry Hunt's part in educating Robert Hunt and commented: "It is pleasing to record this anecdote of one of those public characters whom society often proscribes, because their political opinions are more liberal than their own."

106. W. G. Blaikie, "Elizabeth Fry (1780-1845)," *D.N.B.*, 7, 734-736 (1908).

107. Leslie Stephens, "William Allen (1770-1843)," *D.N.B.*, 1, 322-323 (1908).

108. *Times*, No. 13182, 2-3 (Jan. 22, 1827).

109. R. Hunt, "Popular Romances of the West of England; or the Drolls, Traditions, and Superstitions of Old Cornwall," J. C. Hotten, London 1865, 2 v.

110. R. Hunt, "Popular Romances of the West of England; or the Drolls, Traditions, and Superstitions of Old Cornwall," 2d ed., J. C. Hotten, London, (1871). 475 p.

111. R. Hunt, "Popular Romances of the West of England; or the Drolls, Traditions, and Superstitions of Old Cornwall," 3d ed., Chatto and Windus, London, 1881, 480 p. Reprinted by B. Bloom, New York, 1968.

112. Ref. 109, pp. vii-viii.

113. Mrs. Edward Atkyns Bray, neé Anna Eliza Kemp,[114,115] "Traditions, Legends, Superstitions, and Sketches of Devonshire on the Borders of the Tamar and the Tovy, Illustrative of its Manners, Customs, History, Antiquities, Scenery, and Natural History, in a Series of Letters to Robert Southey, Esq. by Mrs. Bray," J. Murray, London, 1838. 3 v.

114. W. P. Courtney, "Anna Eliza Bray (1790-1883)," *D.N.B.*, 2, 1142-1143 (1908).

115. "Anna Eliza Bray," *M.E.B.*, 1, 385 (1892).

116. R. Hunt, "The Mount's Bay; a Descriptive Poem, in Three Books, and Other Pieces," J. Downing and T. Matthews, Penzance, 1829. 90 p.

117. *Ibid.*, subscription list on unnumbered pages.

118. *C.C.*, 194, 196.

119. R. Hunt, "Edmund Davy (1785-1857)," *D.N.B.*, 5, 635 (1908).

120. R. Hunt, "Sir Humphry Davy (1778-1829)," *Ibid.*, 5, 637-643 (1908).

121. Brewster[1] mentioned that Hunt's maternal uncle married a member of Sir Humphry Davy's family. Boase[118] noted that Anne Davy married Mr. Thomas, a clerk. Ann and Anne were often recorded interchangeably in early nineteen-century registers. Robert Hunt wrote the biographies of Edmund Davy,[119] Sir Humphry Davy,[120] and John Davy[122] in the *D.N.B.* Hunt used information furnished by the Davy family when he wrote Sir Humphry's biography, which contains previously unpublished details of Sir Humphry's childhood. When Sir Harold Hartley wrote Sir Humphry's biography,[123] Professor McKie verified for him Hunt's remarks

on Robert Dunkin who helped Sir Humphry by building scientific equipment for him.

122. R. Hunt, "John Davy, M.D. (1790-1868)," *D.N.B.*, 5, 645-646 (1908).

123. Sir Harold Hartley, "Humphry Davy," Thomas Nelson & Son Ltd., London 1966.

124. The Marriage Register in Madron shows that Stephen Weaver married three times: (a) Stephen Weaver of Penzance married Sarah Tapley of Penzance on October 7, 1812, at Madron by License, (b) Stephen Weaver, widower of Penzance, married Elizabeth Russell of Penzance on March 22, 1814, at Madron by Banns, with consent of parents, witnessed by Richard Edmonds and Phoebe Weaver, and (c) Stephen Weaver, widower of Penzance, married Honour Hunt, widow of Robert Hunt, on July 5, 1831, at Madron. The accounts of Stephen Weaver's marriages given by G. C. Boase (*C.C.* 400 and 1206) contain some obvious errors.

125. "Pigot & Co.'s National Directory, 1830," p. 158.

126. The archives of the St. Mary's Chapel, Penzance, preserve a copy of a printed letter dated August 8, 1828, requesting the local churches to preach a sermon asking for contribution to the public dispensary on Chapel Street.

127. Ann Symons was known to be a "Chymist and druggist" on Chapel Street in 1823[128] and in 1830.[129] It cannot be established whether Thomas and Hunt bought her business or opened their own shop in competition. By 1844, Ann Symons was no longer a chemist and druggist and there was no chemist and druggist on Chapel Street, although the public dispensary was still on Chapel Street.[130]

128. "Pigot & Co.'s London and Provincial New Commercial Directory for 1823-4," p. 193, lists five druggists in Penzance.

129. "Pigot & Co's National Directory, 1830," p. 157 lists seven druggists in Penzance.

130. "Pigot & Co.'s Royal National and Commercial Directory and Topography of the County of Cornwall, 1844," pp. 30 and 33.

131. "The Picture of Plymouth being a Correct Guide to the Public Establishments, Charitable Institutions, Amusements and Remarkable Objects in the Towns of Plymouth, Plymouth Dock, Stonehouse, Stoke, and their Vicinity," Rees and Curtis, Plymouth, 1812. p. 224: "William Swanson, Cordwainer, George Street [Dock]."

132. N. Taperell, "The Plymouth, Plymouth Dock, Stonehouse, Morice-Town and Stoke Directory," N. Taperell, Plymouth, 1822. p. 75.

133.  Robert Brinkley, "The Plymouth, Stonehouse, and Devon-port Directory," W. Byers, Fore Street, Devonport, 1830. p. 170: "William Swanson, Boot and shoemaker, 60 George Street."

134.  "Flintoff's Directory and Guidebook to Plymouth, Devon-port, Stonehouse, and their Vicinity," G. Flintoff, Plymouth, [c. 1844]. p. 117. William Swanson's address was 59 George Street.

135.  Ref. 1 and 5 call the organization "Mechanics' Institution." Ref. 4 calls it "Penzance Literary and Scientific Institution." Ref. 16 and 17 call it "Mechanics' Institute."

136.  Hunt wrote Herschel on March 22, 1844, ". . . about five and twenty I succeeded in placing myself in a position (in business) which promised me competence, . . . From this position in a few years, having in the mean time married, I was thrown by the cruel persecution of a relative, penni-less upon the world. . . ."[99]

137.  The 1835 List of Members in the *Rept. Roy. Cornwall Poly-tech. Soc.* gives Hunt's address as Penzance. The 1836 List shows Hunt was in London. There is no further mention of him until 1840.

138.  According to the Birth Registration No. 41, 1837, Registra-tion District Stoke Damerel, Subdistrict of Clowance, Devon County, Charles Hunt was born on September 30, 1837, at about two o'clock in the morning at No. 65 George Street, Devonport. The informant was "Harriet Hunt, mother, the wife of Robert Hunt, Chemist and Druggist, Newgate Street, London." The birth was registed October 11, 1837. William Swanson, Hunt's father-in-law, occupied different houses on George Street from 1812 to 1844.[131-134]

139.  Joseph Knight, "William Charles Macready (1793-1873)," *D.N.B.*, **12**, 721-727 (1909). Macready made his debut as manager of Covent Garden on September 30, 1837, appear-ing in "Winter's Tale."

140.  F. Boase, "John Thomas Cooper," *M.E.B.*, **4**, 748 (1908).

141.  *Athenaeum*, No. **594**, 193 (March 16, 1839).

142.  *Ibid.*, No. **597**, 249 (April 6, 1839).

143.  *Ibid.*, No. **603**, 361 (May 18, 1839).

144.  Royal Society of London, Herschel Letters HS.10.80.

145.  International Museum of Photography, George Eastman House, Rochester, N. Y., Herschel Letters No. 1.

146.  Royal Society of London, Herschel Letters HS.10.82.

147.  *Ibid.*, HS.10.84.

148.  Miles Berry, "Spontaneous Reproduction of all the Images Received in the Focus of the Camera Obscura," English Patent No. 8194, sealed August 14, 1839.

149. R. S. Schultze, *J. Phot. Sci.*, **13**, 65-66 (1965).
150. *Athenaeum*, No. **599**, 289 (April 20, 1839).
151. Ref. 64, pp. 36-45.
152. R. Hunt, "Directions for Using the Photographic Drawing Paper, and for Taking Views with the Camera Obscura," W. Richards, Printer (Telegraph Office), Devonport.
153. Ref. 28, p. 209, § 28.
154. Ref. 64, p. 41, pt. D.
155. For current names of chemicals mentioned in Hunt's *Treatise* and letters, see the Chemical Index, pp. xxxi-xl.
156. In the original letter, "that salt," "muriate of Ammonia," and "Hydriodate of Beryta" were underlined.
157. Cooper advertised a "Preserving Liquid, for fixing the drawings" on April 20, 1839.[150] The May 11, 1839, issue of the *Athenaeum* has an anonymous, unaddressed advertisement for "photogenic paper of highly sensitive quality" and a fixing liquid, whereby they may afterwards be rendered so permanent, that the sun's ray will not destroy their beauty or accuracy."[158] Palmer also advertised fixing liquids in bottles.[143]
158. *Athenaeum*, No.**602**, 345 (May 11, 1839).
159. The Royal Society of London has fifty-seven letters exchanged by Hunt and Herschel (Herschel Letters HS.10.80 to HS.10.136); The Internationaal Museum of Photography, George Eastman House, Rochester, New York, has seventeen letters from Herschel to Hunt.
160. Ref. 270, p. 43.
161. Royal Society of London, Herschel Letters HS.10.81.
162. *Ibid.*, HS.10.83.
163. International Museum of Photography, George Eastman House, Herschel Letter No. 2.
164. Royal Society of London, Herschel Letters HS.10.85.
165. Letters exchanged between Herschel and Talbot from 1823 to 1868 in the Photographic Collection of the Science Museum, London.
166. International Museum of Photography, George Eastman House, Herschel Letter No. 3.
167. Royal Society of London, Herschel Letters HS.10.86.
168. Letter from Hunt to Talbot dated February 26, 1841, in the Lacock Abbey Collection. Two microfilm copies are available for public study through the generosity of the owner. One copy is kept in the Science Museum Library, London, and the other in the Smithsonian Institution, Washington, D.C.
169. *Rept. Roy. Cornwall Polytech. Soc.*, **8**, xi (1840).
170. Michael D. Stephens and Gordon W. Roderick, "The Royal

Cornwall Polytechnic Society, a History of the Origins, Aims and Development of the Society in Relation to 19th Century Adult Education," Earles Press, Redruth, Cornwall. pp. 10-11.

171. Richard Garnett, "Caroline Fox (1819-1871)," *D.N.B.*, 7, 531 (1908).

172. Wilson Lloyd Fox, "Historical Synopsis of the Royal Cornwall Polytechnic Society," *Rept. Roy. Cornwall Polytech. Soc.*, 50, 3-76 (1882).

173. Ref. 172, p. 3.

174. Caroline Fox, "Memories of Old Friends, being Extracts from the Journals and Letters of Caroline Fox, of Penjerrick, Cornwall, from 1835 to 1871," edited by Horace N. Pym, 2d ed., to which are added fourteen original letters from J. S. Mill never before published, J. B. Lippincott & Co., Philadelphia, 1882. pp. 148 and 155.

175. Ref. 172, pp. 10-11.

176. F. Boase, "Sir Charles Lemon[1784-1868]," *M.E.B.*, 2, 386 (1897).

177. *B.C.*, 314-315, 1267.

178. *C.C.*, 733.

179. R. Hunt, "British Mining, a Treatise on the History, Discovery, Practical Developments and Future Prospects of Metalliferous Mines in the United Kingdom," Crosby Lockwood & Co., London, 1884. p. 874.

180. *C.C.*, 490. (Lady Basset, neé Harriet Lemon, was the second wife of Baron Francis Basset.[181])

181. W. H. Tregellas, "Francis Basset, Baron de Dunstanville of Tehidy and Baron Basset of Stratton (1757-1835)," *D.N.B.*, 1, 1297-1298 (1908).

182. J. H. Collins, "Remarks on the Successive Mining Schools of Cornwall," *Rept. Miners' Assoc. Cornwall Devon*, 10, 20-24 (1871).

183. *Rept. Roy. Cornwall Polytech. Soc.*, 13, xii (1845).

184. Letter from Hunt to Herschel dated January 26, 1844, Royal Society of London, Herschel Letters HS.10.106: ". . . Our Society although popular is very poor, and the small sum of 80 pounds per annum is all it can afford to the Secretary. I of course add by analysis, a little, but it is indeed very little to this. . . ."

185. Letter from Hunt to Herschel dated January 17, 1841, Royal Society of London, Herschel Letters HS.10.89: ". . . The duties of my office will leave me abundant leisure for the exercise of my industry—which I trust I shall direct to pursuit of usefulness. . . ."

186. W. Jerome Harrison, "Robert Were Fox (1789-1877)," *D.N.B.*, **7**, 573 (1908).

187. Sir John Smith Flett, "The First Hundred Years of the Geological Survey of Great Britain," His Majesty's Stationery Office, London, 1937. p. 46.

188. The membership list of 1867 Report of the British Association shows that Hunt was elected in 1840. He was still listed as a member in the 1880 *Report* but not in the 1881 *Report*.

189. International Museum of Photography, George Eastman House, Rochester, N. Y., Herschel Letter No. 5.

190. A week later, Hunt's first daughter, Charlotte Fisher Hunt, was born.

191. International Museum of Photography, George Eastman House, Rochester, N. Y., Herschel Letter No. 7.

192. Erich Stenger, "The March of Photography," English translation of "Siegeszug der Photographie in Kultur, Wissenschaft, Technik" by Edward Epstean with additional material translated by H. W. Greenwood, Focal Press Ltd., 1958. p. 266.

193. Ref. 83, p. 80.

194. *Times*, No. **17626**, 6 (March 24, 1841).

195. R. B. Prosser, "Mungo Ponton (1802-1880)," *D.N.B.*, **16**, 95-96 (1909).

196. Major W. W. Webb, "Alfred Swaine Taylor (1806-1880)," *D.N.B.*, **19**, 402-403 (1909).

197. A. S. Taylor, "On the Art of Photogenic Drawing," Jeffrey, London, 1840. 37 p.

198. *Chemist* began publication in January 1840. All seventeen French articles from *Comptes Rendus* which Hunt quoted were translated in the *Chemist*. See Ref. 205, 206, 214, 216, 223, 224, 234, 242, 246, 281, 293, 304, 305, 306, 307, 308, and 340.

199. Ref. 64, p. 34.

200. *Ibid.*, p. 85.

201. D. F. J. Arago, "Fixation des images qui se forment au foyer d'une chambre obscure," *Compt. Rend.*, **8**, 4-7 (Jan. 7, 1839). (First announcement of Daguerre's invention.)

202. D. F. J. Arago, "Procédé de M. Daguerre," *Compt. Rend.*, **8**, 170-172 (Feb. 4, 1839). (Comments on Talbot's first letter to the Académie dated January 29, 1839.)

203. D. F. J. Arago, "Le Daguerréotype," *Compt Rend.*, **9**, 250-267 (Aug. 19, 1839). (First complete description of Daguerre's process.)

204. D. F. J. Arago, [Report to the Chamber of Deputies] in

"Historique et Description des Procédés du Daguerréotype et du Diorama" by L. J. M. Daguerre, Alphonse Giroux et Cie., Paris, 1839. pp. 9-29.

205.  D. F. J. Arago, *Compt. Rend.*, **9**, 284 (Dec. 23, 1839); *Chemist*, **1**, 120 (April 1840). (Daguerre's method of iodizing silver.)

206.  D. F. J. Arago, "Fixation des images photogéniques sur métal," *Compt. Rend.*, **10**, 488 (Mar. 23, 1840); *Chemist*, **1**, 187 (1840). (Fizeau's method of fixing daguerreotypes.)

207.  D. F. J. Arago, *Compt. Rend.*, **12**, 23 (Jan. 4, 1841). (Daguerre's new rapid process.)

208.  Backhoffner was probably George Henry Bachhoffner,[209,210] a founder of the Polytechnic Institution of London which gave daguerreotype demonstrations to the public. Bachhoffner made and etched daguerreotypes himself.[211] However, it was John F. Goddard who first published the use of bromine as accelerator for daguerreotype.[212] Hunt mistakenly attributed Goddard's invention to Bachhoffner. In the second edition of his *Treatise*, Hunt credited Goddard as "the first to employ bromine in combination with iodine."[213]

209.  "George Henry Bachhoffner (1810-1879)," *D.N.B.*, **1**, 790 (1908).

210.  "George Henry Bachhoffner," *M.E.B.*, **1**, 118-119 (1892).

211.  *Athenaeum*, No. **657**, 436 (May 30, 1840).

212.  *Lit. Gaz.*, No. **1247**, 803 (Dec. 12, 1840).

213.  Ref. 66, p. 163.

214.  H. Bayard, "Procédé pour obtenir sur papier des images photogéniques," *Compt. Rend.*, **10**, 337 (Feb. 24, 1840); *Chemist*, **1**, 119 (Apr. 1840).

215.  Richard Beard, "Apparatus for Taking Likenesses, Representations of Nature, Drawings, and Other Objects," English Patent No. 8546, sealed June 13, 1840.

216.  A. E. Becquerel, "Note sur un papier impressionable à la lumière, destiné à reproduire les dessins et les gravures," *Compt. Rend.*, **10**, 469-471 (Mar. 16, 1840); *Chemist*, **1**, 151-152 (1840).

217.  J. E. Bérard, "Mémoire sur les propriétés des différentes espèces de rayons qu'on peut séparer au moyen du prisme de la lumière solaire," *Mém. Phys. Chim. Soc. Arcueil*, **3**, 1-47 (1817); *J. Sci. Arts*, **5**, 77-81 (1818).

218.  J. E. von Berres, "Ueber die Vervielfältigung der daguerre'schen Lichtbilder durch den Druck," *Ann. Chem. Pharm.*, **36**, 337-343 (1840).

219.  J. E. von Berres, "A Method of Permanently Fixing, Engraving, and Printing from Daguerreotype Pictures," trans.

by Dr. Mackenzie, *Athenaeum*, No. **656**, 418-419 (May 23, 1840); *Lit. Gaz.*, No. **1218**, 331-332 (May 23, 1840).

220. C. L. Berthollet, J. A. Chaptal, and J. P. Biot, "Rapport sur un Mémoire de M. Bérard relatif aux propriétés physiques et chimiques des divers rayons qui composent la lumière solaire," *Ann. Chim.*, **85**, 309-325 (1813); *J. Nat. Phil. Chem. Arts*, **35**, 250-259 (1813); *Ann. Phil.*, **2**, 161-167 (Sept. 1813).

221. J. J. Berzelius, "Traité de Chimie," trans. into French by A. J. L. Jourdan, Paris, 1829. v. 1, p. 46.

222. J. P. Biot, *Compt. Rend.*, **8**, 409-412 (Mar. 18, 1839). (Talbot's letter dated March 15, 1839, and Biot's remarks. Talbot translated Biot's remarks and published them in the *Lit. Gaz.*[334])

223. J. P. Biot, "Note sur les dessins photogéniques de M. Talbot," *Compt. Rend.*, **10**, 483-488 (Mar. 23, 1840); *Chemist*, **1**, 184-187 (1840).

224. C. Choiselat, "Fixation des images photogéniques," *Compt. Rend.*, **10**, 767 (May 11, 1840); *Chemist*, **1**, 211 (July, 1840).

225. P. Configliachi, "Mémoire sur la force magnétisante du bord le plus reculé du rayon violet du spectre solaire," *J. Phys. Chim. Hist. Nat.*, **78**, 212-235, 293-316 (1813); *Ann. Physik*, **46**, 337-366 (1814).

226. J. T. Cooper, "Preparation of photogenic paper," *Trans. Soc. Arts*, **52**, 193-196 (1839); *J. Soc. Arts*, **87**, 823-824 (1939). Cooper's original paper has no illustration. Figure 3 in Hunt's *Treatise*[227] was probably made by Hunt from Cooper's description.

227. Ref. 64, p. 14.

228. L. J. M. Daguerre, "Historique et Description des Procédés du Daguerréotype et du Diorama," Alphonse Giroux et Cie., Paris, 1839. 79 p. The first edition has been reprinted with the official English translation[229] with an introduction by Beaumont Newhall by Winter House, Ltd., New York, 1971.

229. L. J. M. Daguerre, "An Historical and Descriptive Account of the Various Processes of the Daguerreotype and the Diorama," McLean, London, 1839.

230. L. J. M. Daguerre, "History and Practice of Photogenic Drawing on the True Principles of the Daguerreotype, with the New Method of Dioramic Painting," trans. by J. S. Memes, Smith, Elder, & Co., London, and Adam Black & Co., Edinburgh, 1839.

231. Robert Hunt probably had Menes' translation[230] of Daguerre's manual. In a paper dated February 29, 1840, Hunt gave Memes' translation as a reference.[27]

232. L. J. M. Daguerre, "Des procédés photogéniques consi-

dérés comme moyens de gravure," *Compt. Rend.*, 9, 423-429 (Sept. 30, 1839).

233. L. J. M. Daguerre, "Sur la substitution du tripoli à la ponce, pour le polissage des plaques destinées à recevoir les images du Daguerréotype," *Compt. Rend.*, 9, 512-513 (Oct. 21, 1839).

234. L. J. M. Daguerre, "Sur le rôle que jouent les bandes de plaqué dont on entoure la lame destinée à recevoir une image photographique avant de l'exposer à la vapeur d'iode," *Compt. Rend.*, 10, 116-117 (Jan. 20, 1840); *Chemist*, 1, 81-82 (Mar., 1840).

235. Daguerre's letter in English to Robert Hunt, dated February 19, 1841, is preserved in the miscellaneous French autograph collection of the Pierpont Morgan Library, New York City. The complete text of the letter has been published by the Gernsheims[236] who pointed out that Hunt changed "battle" to "cattle," cattle being more likely to be found in marketplaces.

236. Helmut Gernsheim and Alison Gernsheim, "L. J. M. Daguerre (1787-1851), the World's First Photographer," The World Publishing Co., Cleveland and New York, 1956. p. 116.

237. Beaumont Newhall, "Bibliography of Daguerre's Instruction Manuals," *Ibid.*, pp. 191-196. A bibliography of 31 items, with notes by the Gernsheims on pp. 196-197. It is also reprinted on pp. 267-277 of the 1971 reprint of Daguerre's manuals.[228]

238. C. G. B. Daubeny, "On an Apparatus for Obtaining a Numerical Estimate of the Intensity of Solar Light, at Different Periods of the Day, and in Different Parts of the Globe," *Rept. Brit. Assoc.*, 9, pt. 2, 6 (1839).

239. H. Davy, "An Essay on Heat, Light, and the Combinations of Light, with a New Theory of Respiration," in "Contributions to Physical and Medical Knowledge, Principally from the West of England" collected by Thomas Beddoes, M.D., Biggs and Cottle, Bristol, 1799, pp. 4-147. Reprinted in "The Collected Works of Sir Humphry Davy" edited by John Davy, London, 1839, v. 2, pp. 3-86.

240. H. Davy, "An Account of a Method of Copying Paintings upon Glass, and of Making Profiles, by the Agency of Light upon the Nitrate of Silver. Invented by T. Wedgwood, Esq. With Observations by H. Davy," *J. Roy. Inst.*, 1, 170-174 (1802).

241. H. Davy, "Elements of Chemical Philosophy," London, 1812. Reprinted in "The Collected Works of Sir Humphry

Davy," edited by John Davy, London, 1840, v. 4, div. 2, pp. 155-156.

242. A. Donné, "Procédés de gravure des images photogéniques sur plaque d'argent," *Compt. Rend.*, 10, 933-934 (June 15, 1840); *Chemist*, 1, 244-245 (Aug., 1840).

243. J. W. Draper, "On the Process of Daguerreotype, and its Application to Taking Portraits from the Life," *Phil. Mag.*, 17, 217-225 (1840).

244. Comte C. M. T. Duchâtel, "Exposé des Motifs et Projet de Loi présentés par M. le Ministre de l'intérieur à la Chambre des Députés, Séance du 15 juin 1839," in "Historique et Description des Procédés du Daguerréotype et du Diorama" by L. J. M. Daguerre, A. Giroux et Cie, Paris, 1839, pp. 1-4.

245. Sir H. Englefield, "Experiments on the Separation of Light and Heat by Refraction," *J. Roy. Inst.*, 1, 202-208 (1802).

246. H. Fizeau, "Note sur un moyen de fixer les images photographiques," *Compt. Rend.*, 11, 237-238 (Aug. 10, 1840); *Chemist*, 1, 342-343 (Nov. 1840).

247. Mrs. Fulhame, "An Essay on Combustion, with a View to a New Art of Dying [sic] and Painting, wherein the Phlogistic and Antiphlogistic Hypotheses are proved Erroneous," London, 1794. 182p.

248. A. Fyfe, "On Photography," *Edinb. New Phil. J.*, 27, 144-155 (1839).

249. A. Fyfe, "On the Daguerreotype," *Ibid.*, 28, 205-211 (1840).

250. Sir W. S. Harris, "On the Influence of the Sun's Ray on the Oscillations of the Magnetic Needle," *Proc. Roy. Soc.* (London), 3, 175-176 (1833).

251. According to Hunt[252] Havell's death had been announced while his *Treatise* was being printed. John F. Havell's obituary appeared in the February 15, 1841, issue of the *Art Union*.[253] The procedures Hunt attributed to Havell[254] was first published by William Havell.[255]

At the March 21, 1839, meeting of the Royal Society, Talbot first reported his method of making a negative by scratching with a needle on glass coated with a solution of resin in turpentine and blackened by candle smoke.[256] At the March 22, 1839 meeting at the Royal Institution, Faraday called attention to "several specimens of Messrs. Havell and Wilmore's [sic] application of Mr. Talbot's discovery."[257] Both events were reported in the March 30, 1839, issue of the *Lit. Gaz.* Havell and Willmore could not have known Talbot's method. The same issue also contained a letter from Talbot describing a completely different method of making negatives by painting on glass with transparent

varnishes of different colours.[334] There followed the letter
from William Havell which Hunt quoted.[255] Talbot's letter
was prompted by an anonymous article which had appeared
a week earlier,[258] and an attempt by several engravers to
patent the process.[341] The article described a method of
scratching designs on glass covered with etching ground
and smoke. The method was attributed to "Mr. J. F. Havell
and Mr. Willmore." The attempt to secure a patent was
instigated by J. T. Willmore with two other artists.[341] Will-
more explained that their motive was self-protection, be-
cause the "new art" threatened them with the loss of their
occupation. William Havell disclaimed any connection with
Willmore's activities.[259]

252. Ref. 64, p. 34, fn.
253. "Obituary of Mr. John Havell," *Art Union*, 3, 34 (February 15, 1841).
254. Ref. 64, p. 35.
255. William Havell, *Lit. Gaz.*, No. 1158, 203-204 (March 30, 1839). (Letter dated March 28, 1839.)
256. *Ibid.*, 201-202.
257. *Ibid.*, 201.
258. "Photogenic Drawing," *Ibid.*, No. 1157, 187 (March 23, 1839).
259. William Havell, *Ibid.*, No. 1160, 236 (April 13, 1839). (Letter dated April 11, 1839.)
260. Sir J. F. W. Herschel, "On the Hyposulphurous Acid and its Compounds," *Edin. Phil. J.*, 1, 8-29 (1819).
261. Sir J. F. W. Herschel, "Additional Facts Relative to the Hyposulphurous Acid," *Ibid.*, 396-400.
262. Sir J, F. W. Herschel, "Some Additional Facts Relating to the Habitudes of the Hyposulphurous Acid and its Union with Metallic Oxides," *Ibid.*, 2, 154-156 (1820).
263. Sir J. F. W. Herschel, "On the Absorption of Light by Coloured Media, and on the Colours of the Prismatic Spectrum Exhibited by Certain Flames; with an Account of a Ready Mode of Determining the Absolute Dispersive Power of any Medium, by Direct Experiment," *Trans. Roy. Soc. Edinb.*, 9, 445-460 (1823).
264. Sir J. F. W. Herschel, "Extract of a Letter to Dr. Ritchie Explaining a New Process of Actinometry," *Edinb. J. Sci.*, 3, 107 (1825).
265. Sir J. F. W. Herschel, "On the Action of Light in Determining the Precipitation of Muriate of Platinum by Lime-water," *Phil. Mag.*, ser. 3, 1, 58-60 (1832).
266. Sir. J. F. W. Herschel, "On the Absorption of Light by Col-

oured Media, Viewed in Connexion with the Undulatory Theory," *Rept. Brit. Assoc.*, **3**, pt. 2, 373-374 (1833); *Phil. Mag.*, ser. 3, **3**, 401-412 (1833).

267. Sir J. F. W. Herschel, "Explanation of the Principle and Construction of the Actinometer," *Rept. Brit. Assoc.*, **3**, pt. 2, 379-381 (1833).

268. Sir J. F. W. Herschel, "A Letter to the Rev. W. Whewell on the Chemical Action of the Solar Rays," *Rept. Brit. Assoc.*, **9**, pt. 2, 9-11 (1839).

269. Sir J. F. W. Herschel, "Note on the Art of Photography, or the Application of the Chemical Rays of Light to the Purposes of Pictorial Representation," *Proc. Roy. Soc.* (London), **4**, 131-133 (1839).

270. Sir J. F. W. Herschel, "On the Chemical Action of the Rays of the Solar Spectrum on Preparations of Silver and other Substances, both Metallic and Nonmetallic, and on some Photographic Processes, *Phil. Trans.*, **130**, 1-60 (1840).

271. Letter from Herschel to Hunt dated February 20, 1841, Herschel Letter No. 5, International Museum of Photography, George Eastman House, Rochester, New York.

272. Sir W. Herschel, "Investigation of the Powers of the Prismatic Colours to Heat and Illuminate Objects; with Remarks, that Prove the Different Refrangibility of Radiant Heat. To which is Added, an Inquiry into the Method of Viewing the Sun Advantageously, with Telescope of Large Apertures and High Magnifying Powers," *Phil. Trans.*, **90**, 255-283 (1800).

273. Sir W. Herschel, "Experiments on the Refrangibility of the Invisible Rays of the Sun," *Ibid.*, 284-292.

274. Sir W. Herschel, "Experiments on the Solar, and on the Terrestrial Rays that Occasion Heat; with a Comparative View of the Laws to which Light and Heat, or Rather the Rays which Occasion Them, are Subject, in order to Determine Whether They are the Same, or Different," *Ibid.*, 293-326, 437-538.

275. T. B. Jordan, "On a New Mode of Registering the Indications of Meteorological Instruments," *Rept. Roy. Cornwall Polytech. Soc.*, **6**, 184-189 (1838).

276. T. B. Jordan, "Description of a New Heliograph," *Ibid.*, **7**, 115-116 (1839).

277. G. J. Knox and Rev. T. Knox, "Justification of Mrs. Somerville's Experiments Upon the Magnetizing Power of the More Refrangible Solar Rays," *Proc. Roy. Irish Acad.*, **1**, 393-395 (1836-1840) [Paper read Feb. 10, 1840]; *Phil. Mag.*, ser. 3, **17**, 153-154 (1840).

278. In developing a method of engraving daguerreotypes, Berres was assisted "with cordial zeal" by Kratochwila, a government employee.[219] Kratochwila's contributions to photography were practically unknown in Britain.[279]

279. Ref. 80, pp. 262, 275-276, and 278.

280. J. L. Lassaigne, "Procédé photogénique," *Compt. Rend.*, 8, 547 (April 8, 1839).

281. J. L. Lassaigne, "Réclamation de priorité relative à la préparation d'un papier destiné à recevoir des images photogéniques," *Compt. Rend.*, 10, 374 (March 2, 1840); *Chemist*, 1, 150 (May 1840).

282. Lubeck[283] was probably a typesetting error of Seebeck. In the second edition, Hunt corrected this error.[284]

283. Ref. 64, p. 2

284. Ref. 66, p. 2

285. F. J. Malaguti, "Premier mémoire sur la faculté qu'ont certains liquides de retarder les effets chimiques de la lumière diffuse," *Ann. Chim.*, ser. 2, 72, 5-27 (1839).

286. D. P. Morichini, "Kompasnadeln, im violetten Lichte des Farbenspektrums magnetisirt," *Ann. Physik*, 43, 212-217 (1813).

287. D. P. Morichini, "Zweite abhandlung über die magnetisirende Kraft des äussersten Randes des violetten," *J. Chem. Physik*, 20, 16-45 (1817).

288. Sir I. Newton, "Opticks, or a Treatise of the Reflections, Refractions, Inflections and Colours of Light," 4th ed., William Innys, London, 1730. Book 2.

289. J. N. Niepce, "Héliographie," *Lit. Gaz.*, No. 1154, 138 (March 2, 1839). (Niepce's communication to the Royal Society, dated Kew, December 8, 1827, translated into English and published with a letter to the editor from Francis Bauer.[290])

290. Francis Bauer, *Ibid.*, 137-138. (Letter dated February 27, 1839.)

291. J. N. Niepce, "Notice sur l'héliographie," in "Historique et Description des Procédés du Daguerréotype et du Diorama," by L. J. M. Daguerre,[228] pp. 39-46. (English translation in McLean edition,[229] pp. 41-48.)

292. M. Ponton, "Notice of a Cheap and Simple Method of Preparing Paper for Photographic Drawing, in which the Use of Any Salt of Silver is Dispensed with," *Edinb. New Phil. J.*, 27, 169-171 (1839). (Read before the Society of Arts for Scotland on May 29, 1839.)

293. J. J. R. von Prechtl,[294] "Fixation des images photogéniques," *Compt. Rend.*, 10, 766 (May 11, 1840); *Chemist*, 1, 211 (July 1840).

294. Prechtl was misspelled Preschtl in *Compt. Rend.* and in the index of *Chemist.* Prechtl was misspelled Preschot in the article in *Chemist.* The fact that Hunt used the name Preschot shows that Hunt read *Chemist.*

295. J. W. Ritter, "Versuche über das Sonnenlicht," *Ann. Physik,* 7, 527 (1801); *Ibid.,* 12, 409-415 (1802).

296. Count B. T. Rumford, "On the Propagation of Heat in Fluids," London, 1798, pt. II; *J. Nat. Phil. Chem. Arts,* 2, 160-167 (July 1798).

297. Count B. T. Rumford, "An Inquiry Concerning the Chemical Properties that have been Attributed to Light," *Phil. Trans.,* 88, 449-468 (1798).

298. K. F. E. Schafhäutl, "On a New Method of Photogenic Drawing," *Rept. Brit. Assoc.,* 10, pt. 2, 71-72 (1840); *Chemist,* 1, 367-368 (Dec. 1840).

299. K. W. Scheele, "Traité chimique de l'air et du feu," trans. from the German by Baron de Dietrich, Paris, 1781.

300. J. T. Seebeck, "Von der chemischen Action des Lichts und der farbigen Beleuchtung," in "Zur Farbenlehre, historischer Theil II," by J. W. von Goethe, in "Goethes Werke," Hermann Böhlau, Weimar, section 2, v. 4, pp. 336-340 (1894).

301. For Seebeck's work printed or quoted by Goethe, see *Ibid.,* pp. 320 and 322; *Ibid.,* section 2, v. 5, pt. 2, p. 522 (1906).

302. T. J. Seebeck, "Einige neue Versuche und Beobachtungen über Spiegelung und Brechung des Lichtes," *J. Chem. Physik,* 7, 259-298, 382-384 (1813).

303. T. J. Seebeck, "Ueber die ungleiche Erregung der Wärme im prismatischen Sonnenbilde," *Abhandl. König. Akad. Wiss. Berlin,* 1818-1819, 305-350 (March 1819).

304. A. P. Séguier, "Sur l'ioduration des planches métalliques destinées à recevoir les images, et sur le rôle que jouent les bandes de plaqué dont on a coutume de les entourer," *Compt. Rend.,* 10, 10-11 (Jan. 6, 1840); *Chemist,* 1, 82-83 (March, 1840).

305. A. P. Séguier, *Compt. Rend.,* 10, 391 (March 9, 1840); *Chemist,* 1, 150 (May, 1840). ("A single scouring, with tripoli moistened with acidulated water, appears to be sufficient to cleanse the [daguerreotype] plates thoroughly.")

306. A. P. Séguier, *Compt. Rend.,* 10, 628 (April 13, 1840); *Chemist,* 1, 187 (June, 1840). (Séguier presented daguerreotype plates made by A. Masson using Séguier's method of polishing the plates.[305])

307. J. F. Soleil, "Nouveau procédé d'application du mercure sur les dessins obtenus avec le daguerréotype," *Compt. Rend.,* 10, 373-374 (March 2, 1840); *Chemist,* 1, 149-150 (May 1840).

308.  J. F. Soleil, "Procédé pour déterminer à l'avance la durée de l'exposition des épreuves à la chambre noire," *Compt. Rend.*, **10**, 842-843 (May 25, 1840); *Chemist*, **1**, 210-211 (July 1840).

309.  M. Somerville, "On the Magnetizing Power of the More Refrangible Solar Rays," *Phil. Trans.*, **116**, pt. 2, 132-139 (1826). (Read Feb. 2, 1826.)

310.  T. Spencer, "Instructions for the Multiplication of Works of Art in Metal by Voltaic Electricity; with an Introductory Chapter on Electro-chemical Decompositions by Feeble Currents," R. Griffin & Co., Glasgow, and Thomas Tegg, London, 1840. 62 p. No. 4 of Griffin's Scientific Miscellany.[311]

311.  "New Works on Chemistry," *Chemist*, **1**, 332-334 (Nov. 1840). (A review of Spencer's book.[310])

312.  Hunt referred[313] to Spencer's "Electrography." Peddie's "Subject Index of Books to 1880, First Series"[314] lists two books under "Electrotyping," one of which is "Electrography, 1840" by "T. Spencer." No such book has been found. Spencer's book,[310] having a very long and not very readily recognizable title, might have been referred to as "Electrography." The word electrography was proposed by Spencer in his preface[315] to replace "electrotype" and other names used at the time.

313.  Ref. 64, p. 72.

314.  R. A. Peddie, "Subject Index of Books Published up to and Including 1880, Series 1," H. Pordes, London, 1962.

315.  Ref. 310, p. viii.

316.  W. H. F. Talbot, "Some Account of the Art of Photogenic Drawing, or the Process by which Natural Objects May be Made to Delineate Themselves without the Aid of the Artist's Pencil," *Proc. Roy. Soc.* (London), **4**, 120-121 (1838).[317]

317.  Talbot's first paper was read before the Royal Society on January 31, 1839, but it was not published in the *Phil. Trans.* A report of Talbot's exhibit on Friday, January 25, 1839 at the Royal Institution[318] and a report of Talbot's paper to the Royal Society[319] were published on February 2 in the *Lit. Gaz.* These reports were preceded by a feature story on "The New Art"[320] and a letter from Talbot.[321] The full paper was published in March in the *Phil. Mag.* [322] Talbot also published a private edition of this paper.[323]

318.  *Lit. Gaz.*, No. **1150**, 74-75 (Feb. 2, 1839).

319.  *Ibid.*, 75.

320.  *Ibid.*, 72-73.

321.  W. H. F. Talbot, *Ibid.*, 73-74. (Letter dated Jan. 30, 1839.)

322. W. H. F. Talbot, "Some Account of the Art of Photogenic Drawing," *Phil. Mag.*, ser. 3, 14, 196-208 (1839).

323. W. H. F. Talbot, "Some Account of the Art of Photogenic Drawing, or the Process by which Natural Objects May be Made to Delineate Themselves without the Aid of the Artist's Pencil," London, 1839.[324]

324. A copy of Talbot's privately printed paper[323] is preserved in the International Museum of Photography, George Eastman House, Rochester, New York, and has been reprinted by Newhall.[325]

325. Beaumont Newhall, "On Photography, a Source Book of Photo History in Facsimile," Century House, Watkins Glen, New York. 1956. pp. 61-72.

326. W. H. F. Talbot, "An Account of the Processes Employed in Photogenic Drawing, in a Letter to S. Hunter Christie, Esq., Sec. R.S.," *Proc. Roy. Soc.* (London), 4, 124-126 (1839).[327]

327. Talbot's second paper was read on February 21, 1839, and was reported on February 23 by *Athenaeum*.[328] The complete letter was printed on the same day in the *Lit. Gaz.*[329] and later in the *Phil. Mag.*[330] The *Lit. Gaz.* version with the editor's comment was reprinted by Newhall.[331]

328. *Athenaeum*, No. 591, 156 (Feb. 23, 1839).

329. *Lit. Gaz.*, No. 1153, 123-124 (Feb. 23, 1839).

330. W. H. F. Talbot, "An Account of the Processes Employed in Photogenic Drawing, in a Letter to Samuel H. Christie, Esq., Sec. R.S.," *Phil. Mag.*, ser. 3, 14, 209-211 (March 1839).

331. Ref. 325, pp. 73-74.

332. W. H. F. Talbot, "Note Respecting a New Kind of Sensitive Paper," *Proc. Roy. Soc.*, 4, 134 (1839).[333]

333. Talbot's third paper was read on March 21, 1839, and was reported on March 30 in the *Lit. Gaz.*[256] Meanwhile Talbot became involved in the Havell and Willmore controversy.[251,334,335]

334. W. H. F. Talbot, *Lit. Gaz.*, No. 1158, 202-203 (March 30, 1839). (Letter to the Editor, including a translation of Biot's comments.[222])

335. W. H. F. Talbot, *Ibid.*, No. 1160, 235-236 (April 13, 1839). (Letter dated April 8, 1839.)

336. W. H. F. Talbot, *Ibid.*, No. 1256, 108 (Feb. 13, 1841). Letter dated Feb. 5, 1841.)

337. W. H. F. Talbot, *Ibid.*, No. 1258, 139-140 (Feb., 27, 1841). (Letter dated Feb. 19, 1841).

338. J. T. Towson, "On the Proper Focus for the Daguerreotype," *Phil. Mag.*, ser. 3, **15**, 381-385 (Nov. 1839).[339]

339. C. W. Sutton, "John Thomas Towson (1804-1881)," *D.N.B.*, **19**, 1062 (1909). Sutton wrote that Towson and Hunt produced highly sensitive photographic papers, for the sale of which they appointed agents in London and elsewhere. Hunt did not mention any agents in his existing letters to Herschel. On pages 22 and 23 of his 1841 *Treatise*, Hunt did mention experiments of his and Towson's on very sensitive papers which they could not reliably duplicate.

340. Verignon, "Procédé pour obtenir sur papier des images photogéniques," *Compt. Rend.*, **10**, 336 (Feb. 24, 1840); *Chemist*, **1**, 119 (April 1840).

341. J. T. Willmore, *Lit. Gaz.*, No. **1159**, 215 (April 6, 1839). (Letter dated April 2, 1839.)

342. W. H. Wollaston, "On Certain Chemical Effects of Light," *J. Nat. Phil. Chem. Arts*, **8**, 293-297 (1804).

343. W. H. Wollaston, "A Method of Examining Refractive and Dispersive Powers, by Prismatic Reflection," *Phil. Trans.*, **92**, 365-380 (1802).

344. W. H. Wollaston, "On a Periscopic Camera Obscura and Microscope," *Phil. Trans.*, **102**, pt. 2, 370-377 (1812).

345. A. S. Wolcott, "Concave Reflector and Plate, etc. for Taking Likeness," U. S. Letter Patent No. 1582, May 8, 1840)

346. Since Hunt generally gave neither first names nor references for his quotations and his *Treatise* had no index, the 'Name Index,' pp. xl-xlii, supplies the complete names, the dates of birth and death, the pages of Hunt's book on which the name appeared, and the reference numbers (in parentheses) of the person's publications quoted by Hunt and notes on the names.

347. *Athenaeum*, No. **692**, 95 (Jan. 30, 1841).

348. Ref. 64, pp. 69-70.

349. D. F. J. Arago, "Nouvelles découvertes de M. Daguerre," *Compt. Rend.*, **12**, 1228-1229 (June 28, 1841).

350. Ref. 65, p. 89.

351. Ref. 64, p. 4, fn.

352. W. H. F. Talbot, "Obtaining Pictures of Representations of Objects," English Patent No. 8842, sealed Feb. 8, 1841.

353. Ref. 64, p. 82.

354. Ibid., p. 91.

355. "Griffin's Scientific Miscellany," an advertisement in Ref. 360.

356. "Books Published by Richard Griffin & Co," an advertisement in "Elements of Agricultural Chemistry, in a Course

of Lectures Delivered Before the Board of Agriculture," by Humphry Davy, new ed., R. Griffin, Glasgow, 1844.

357. W. Jerome Harrison, "John Joseph Griffin (1802-1877)," *D.N.B.*, 8, 670-671 (1908).

358. Justus Liebig, "Instructions for the Chemical Analysis of Organic Bodies," trans. by Dr. William Gregory, R. Griffin & Co., Glasgow, 1839. 59 p.

359. Wolfgang Franz Xaver ritter von Kobell, "Instructions for the Discrimination of Minerals, by Means of Simple Chemical Experiments," trans. by Robert Corbet Campbell, R. Griffin & Co., Glasgow, 1841.

360. John Joseph Griffin, "A System of Crystallography, with its Application to Mineralogy," originally issued in two parts: part 1, "Principles of Crystallography," 346 p., part 2, "Application to Mineralogy," 143 p., R. Griffin & Co., Glasgow, 1841.

361. Andrew Crombie Ramsay, "The Geology of the Island of Arran," R. Griffin & Co., Glasgow, 1841.

362. Henry Hunt Snelling, "The History and Practice of the Art of Photography," G. P. Putnam, New York, 1849. Reprinted with an introduction by Beaumont Newhall, Morgan & Morgan, Inc., Hastings-on-Hudson, New York, and the Fountain Press, London, 1970.

363. *Ibid.*, pp. 14, 21, 29, 81, 87, 109, 111, 112, 115, 123, 124 fn, 127.

364. *Ibid.*, p. 21.

365. Compare (a) the remarks on jugglers of India on p. 4 of Snelling's book and on pp. 1-2 of Hunt's *Treatise* of 1841, (b) the remarks on the selection of papers on pp. 87-88 of Snelling's book and pp. 6-7 of Hunt's *Treatise*, and (c) the description of Hunt's process on pp. 81-83 of Snelling's book and on pp. 94-96 of Hunt's *Treatise*. Snelling could not have quoted these materials from Hunt's *Researches on Light*[65] because it does not contain items (a) and (b) and has a version of (c) with different wording from his 1841 *Treatise*.

366. Ref. 66, advertisement page before title page.

367. On page 445 of Eder,[79] Hunt's 1841 *Treatise* was erroneously referred to as "Manual of Photog." On page 326 of the English translation of Eder,[80] the title was corrected but a second edition published in 1847 was added. No such edition has been located.

368. R. Hunt, "Researches on Light," *Phot. Art J.*, 1, 3-19, 65-91, 129-135, 193-208, 257-266, 321-333; 2, 1-14, 65-76 (1851).

369. R. Hunt, "The Poetry of Science," *Ibid.*, 2, 129-147, 193-206,

257-269, 321-355 (1851); *Ibid.*, 3, 5-20, 69-84, 133-148, 197-208, 261-270 (1852).

370.　R. Hunt, "Photography," *Ibid.*, 3, 325-342; 4, 5-20, 69-85, 133-150, 197-222, 261-276, 325-353 (1852).

371.　S. D. Humphrey, *Dag. J.*, 3, 51-52 (1851).

372.　R. Hunt, "Researches on Light," *Ibid.*, 2, 257-270, 289-304, 321-336, 353-368 (1851); *Ibid.*, 3, 1-16, 33-48, 65-70 (1851).

373.　R. Hunt, "Chemical Changes Produced by Solar Rays on Some Photographic Preparations Examined," *Ibid.*, 1, 193-200 (1851). (Reprint of Ref. 50.)

374.　R. Hunt, "On the Application of Science to the Fine and Useful Arts: on Mr. Hale Thompson's New Process for Silvering Glass by Chemical Agency," *Art J.*, 3, 75-76 (1851); *Dag. J.*, 1, 295-299 (1851).

375.　R. Hunt, "Improvement in Photography, Hyalotypes, etc.," *Art J.*, 3, 106-107 (1851); *Dag. J.*, 1, 328-330 (1851). The original article in the *Art J.* was unsigned. Since the article was published under the general heading "On the Application of Science to the Fine and Useful Arts" used with many articles by Hunt, it was reasonably assumed that Hunt also wrote this article.

376.　R. Hunt, "Photography, Recent Improvements," *Art J.*, 3, 188-190 (1851); *Dag. J.*, 2, 148-151 (1851).

377.　Ref. 64, p. 13.

378.　*Ibid.*, p. 20.

379.　*Ibid.*, p. 11.

380.　*Ibid.*, p. 18.

381.　*Ibid.*, p. 22.

382.　*Ibid.*, p. 49.

383.　William Thomas Brande,[384] "A Manual of Chemistry," 1st American ed., 3 vols. in one, to which are added notes and emendations by William James Macneven, George Long, New York, 1821, pp. 150-152.

384.　R. Hunt, "William Thomas Brande (1788-1866)," *D.N.B.*, 2, 1124-1126 (1908).

385.　W. T. Brande[384] and A. S. Taylor,[196] "Chemistry," Blanchard & Lea, Philadelphia, 1863, pp. 667-669.

386.　Comparison of the appendices on weights and measures in Brandes' chemistry textbooks published in 1821[383] and in 1863[385] shows that the troy units and the avoirdupois units remained unchanged during the forty-year period. The Imperial gallon was not listed in the 1821 edition since it was adopted in 1824.[387] See also Ref. 388.

387.　Louis A. Fischer, "History of Standard Weights and Mea-

sures in the United States," *Miscellaneous Publications, Bureau of Standards*, No. 64, Washington, D. C., 1925. p. 10.

388. Sir Richard Glazebrook, "Standards of Measurement: Their History and Development," Supplement to *Nature*, No. 3218, 17-28 (July 4, 1931).

389. Andrew Ure,[391] "A Dictionary of Arts, Manufactures, and Mines: Containing a Clear Exposition of Their Principles and Practices," 4th ed., Little, Brown, & Co., Boston, 1853, 2 vols.[392]

390. *Ibid.*, vol. 2, p. 695.

391. W. S. C. Copeman, "Andrew Ure, M.D., F.R.S. (1778-1857)," *Proc. Roy. Soc. Med.* (London), 44, 655-662 (1951).

392. The editorship of Ure's *Dictionary*, which began in 1821,[393] was passed on to Robert Hunt after Ure's death.[394-396]

393. Andrew Ure, "A Dictionary of Chemistry, on the Basis of Mr. Nicholson's; in which the Principles of the Science are Investigated Anew, and its Applications to the Phenomena of Nature, Medicine, Mineralogy, Agriculture, and Manufactures, Detailed," Thomas and George Underwood, J. Highley & Son, Simpkin & Marshall, T. Tegg, A. Black (Edinburgh), R. Griffin & Co. (Glasgow), and J. Cumming (Dublin), London, 1821.

394. R. Hunt, ed., "Ure's Dictionary of Arts, Manufactures, and Mines, Containing a Clear Explanation of Their Principles and Practices," 5th ed., rewritten and enlarged, Longman, Green, Longman, & Roberts, London, 1860. 3 vols.

395. R. Hunt, ed., "Ure's Dictionary of Arts, Manufactures, and Mines," 6th ed., Longman, Green, Longman, & Roberts, 1867. 3 vols.

396. R. Hunt, ed., "Ure's Dictionary of Arts, Manufactures, and Mines," assisted by F. W. Rudler, Longmans & Co., London, 1875-1878. 3 vols. (1875); supplement (1878).

397. In his *Treatise*, Hunt used more than one name for some of the chemicals and thus provided us with internal clues to the identities of the compounds. Other compounds have been identified from their chemistry and confirmed by consulting nineteenth-century chemistry books.[241,383,385,389,393,398]

398. Edward Turner, "Elements of Chemistry, Including the Recent Discoveries and Doctrines of the Science," 1st American ed. from the 5th London ed., with notes and emendations by Franklin Bache, Desilver, Thomas & Co., Philadelphia, Pa., 1835. p. 402.

399. *Ibid.*, pp. 552-553.

400. *Ibid.*, p. 402.

*A Positive Photograph*

Eng.ᵈ by J. Scott Glasgow

*A Negative Photograph*

PUBLISHED BY RICHARD CRIFFIN & Cᵒ CLASCOW

A POPULAR TREATISE

ON THE

ART OF PHOTOGRAPHY,

INCLUDING

DAGUERRÉOTYPE,

AND

ALL THE NEW METHODS OF PRODUCING PICTURES

BY THE CHEMICAL AGENCY OF LIGHT.

BY

ROBERT HUNT,

SECRETARY OF THE ROYAL CORNWALL POLYTECHNIC SOCIETY.

ILLUSTRATED BY ENGRAVINGS.

GLASGOW:

PUBLISHED BY RICHARD GRIFFIN AND COMPANY.

———

MDCCCXLI.

# INTRODUCTION.

---

THE announcement of the discovery of a process by which light—the most subtile of the elements, the mysterious agent of vision—was made to pencil, on solid tablets, the objects it illuminated, and permanently fix the fleeting shadow, possessed, at the same time, so much of the marvellous and beautiful, as to excite more than common wonder.

Nor was this feeling in any way lessened by the examination of the first specimens of the new art, which were presented to the world by Mr. Talbot,—so perfect in their outline, so minute in their detail, were these early *photographic* * delineations. But when the delicate pictures produced by M. Daguerre became public, words were weak to express the general admiration of those beautiful things, which infinitely surpassed, in their exquisite finish, the most perfect specimens of human art ; and which, in their distribution of light and shadow, and the magic of atmospheric effect, had a charm almost equalling that of the living landscape in its richest aspects.   At the same time, these pictures convinced one of the strict fidelity of those productions which the pencils of some of the old masters have given to the world.

All men, even the most unintellectual, are sensible to the influences of beauty, whether presented to their view in the completeness of Nature's works, or in the approaches of human effort towards perfection.   There is, with men in general, a soul-felt wish to approach to the excellence they admire, but it is too frequently trammelled by the bonds of ignorance and sensuality.   The desire being but seldom seconded by persevering industry, is unfortunately too often abortive—the approach to perfection being granted only as the reward of labour.

The photographic processes appeared, when first reported, to be so

---

* Photographic, or as they are sometimes called, Photogenic drawings, signify light delineated, or light generated pictures.

simple, that most persons conceived they could procure, without trouble, specimens of equal beauty with those exhibited by the artist and the philosopher ; and the desire of which we speak, was at once manifested in an unusual degree. It requires but the slightest consideration to convince us, that an element inappreciably subtile, must, in its action on chemical preparations, be affected by the most trifling change ; and that differences beyond detection by any other test, would become glaringly evident under the influence of light.

Failure damped the ardour of the pursuit, and owing to the uncertainty of the results with the sensitive paper, and the delicacy of the manipulation required for the silver plate, coupled with its most unfortunate expense, the enthusiasts of the moment wearied, and at length resigned the task they had felt so certain of accomplishing, displeased that they had met with difficulties, where none were anticipated.

This is scarcely to be regretted ; for that which is too easily obtained is rarely prized, and becoming common, it does not afford that stimuli which impels men onward in their pursuits, and leads to the improvement of every department of science or of art.

Photography does not possess the advantages of perfection, any more than other human inventions. Had it been left where we found it when the discovery was announced, it would have remained a beautiful, but almost useless thing—a philosophic toy, which lent a little assistance to the cultivation of taste, but afforded none to the economy of manufactures : whereas it now promises to be of important use to many of the arts of industry.

The multiplication of pictures from an original photograph is the great end of the art. The attempts made to engrave the Daguerréotype plate are all of them, to a certain extent, failures, the finer details being lost, and the "ærial perspective" entirely destroyed. Indeed, the employment of strong nitric acid, to etch the tracery marked out by the magic finger of light, appears much as if we were to employ a smith to rivet the downy feather to the wing of the butterfly.

It appears natural to suppose that the picture drawn by light must be multiplied by the same agent; and that it is to processes on paper, similar to those of our countryman, Mr. Talbot, or on some transparent substances, as glass, in the way suggested by Sir John Herschel, that we must direct our attention, if we wish to arrive at photographic publication.

" All noble growths are slow," is the remark of an American moral philosopher, of which a thousand examples proclaim the truth; and, looking at the progress of our new art in the very infancy of its being, what may we not expect from its maturer age.

It is with the view of arranging all the various processes which have been devised, into a systematic form, that the present treatise has been undertaken. Desirous of promoting the study of the art of photography to the utmost of my ability, the greatest care has been taken in verifying the different manipulatory processes which I have introduced. Nothing is inserted which has not been put to the test of many experiments, from which it is hoped that this publication will render real assistance, not only to those whom it may induce to experiment in photography, but even where the practice of the art has given a considerable degree of certainty in manipulation.

I arrogate not to myself any superiority in this respect,—far from it; the constant difficulties I have encountered, particularly from missing the exact proportions for producing any desired effect, was the first inducement to the present arrangement; and finding it of much use myself, and learning from many quarters that some popular information on the subject was required, I have studied to form a manual which might be extensively useful.

It appears necessary to state in this place, that throughout the volume the terms *positive* and *negative,* as suggested by Sir John Herschel, are used to express, respectively, pictures in which the lights and shades are as in nature, and in which they are the opposite, lights being represented by shades, and shades by lights. The Frontispiece contains examples of both these kinds of pictures. From the same authority the terms *direct* and *reversed* are also borrowed, to indicate pictures in which, as regards right and left, the objects appear as they do in the original, or the contrary.

ROBERT HUNT.

# CONTENTS.

Page

HISTORY OF PHOTOGRAPHY, . . . . . . . . . . . 1

PROCESSES ON PAPER, . . . . . . . . . . . 6
  1. ON THE SELECTION OF PAPER FOR PHOTOGRAPHIC PURPOSES, . . . 6
  2. NEGATIVE PHOTOGRAPHS, . . . . . . . . . . 9
    A.—On the Preparation of the Sensitive Paper with the Salts of Silver, . 9
      a. Nitrated Paper, . . . . . . . . . . 10
      b. Muriated Paper, . . . . . . . . . 11
      c. Iodidated Papers, . . . . . . . . . 18
      d. Bromidated Papers, . . . . . . . . . . 19
      e. Phosphated Papers, . . . . . . . . . . 21
      f. Papers Prepared with other Salts of Silver, . . . . . 21
      g. Dr. Schafhaeutl's Negative Process, . . . . . . . 23
    B.—On the Methods of Using the Photographic Papers prepared with the
        Salts of Silver.—Negative Kind, . . . . . . . 24
      a. On taking Copies of Botanical Specimens, Engravings, &c., . . . 24
      b. On using the Photographic Paper in the Camera Obscura, . . . 26
    C.—On Fixing the Negative Photographs, . . . . . . . 30
  3. POSITIVE PHOTOGRAPHS, . . . . . . . . . . 32
    A.—On the Production of Photographs with Correct Lights and Shadows,
        by means of Transfers, . . . . . . . . . 32
    B.—Positive Photographs from Etchings on Glass Plates, . . . . 34
    C.—On the Production of Positive Photographs, by the Use of the Hy-
        driodic Salts, . . . . . . . . . . . 35
    D.—Directions for taking Photographs, . . . . . . . 41

PROCESSES ON METALLIC AND GLASS TABLETS, . . . . . 48
  1. HELIOGRAPHY, . . . . . . . . . . . . 48
  2. DAGUERRÉOTYPE, . . . . . . . . . . . . 53
    A.—Original Process of Daguerre, . . . . . . . 53
    B.—Improvements in Daguerréotype, . . . . . . . . 60
      a. Improved Method of Iodizing the Silver, . . . . . . 60
      b. Methods of Fixing the Daguerréotype Pictures, . . . . . 61
    C.—Engraving the Daguerréotype Designs, . . . . . . 62
    D.—Application of the Daguerréotype to taking Portraits from Life, . 63
    E.—Simplification of the Daguerréotype Processes, . . . . . 67
    F.—On the Manner in which the Light operates to produce the Daguerréo-
        type Designs, . . . . . . . . . . . 70
  3. PROCESSES ON GLASS PLATES, BY SIR JOHN HERSCHEL, . . . . 71

|                                                                                                          | Page |
|----------------------------------------------------------------------------------------------------------|------|
| MISCELLANEOUS PROCESSES, .                                                                                | 73   |
| 1. On the Application of the Daguerréotype to Paper, . . . .                                              | 73   |
| 2. Photographic Processes without any Metallic Preparation, . .                                           | 76   |
| 3. Dr. Schafhaeutl's Process on Carbonised Plates, . . . .                                                | 79   |
| 4. A New Construction of the Photographic Camera Obscura, . .                                             | 80   |
| 5. On the Possibility of Producing Photographs in their Natural Colours,                                  | 82   |
| 6. Invisible Photographs, and their Reproduction, . . . .                                                 | 84   |
| 7. On the Spontaneous Darkening of the White Photographic Papers,                                         | 84   |
| 8. On the Use of the Salts of Gold as Photographic Agents, . .                                            | 85   |
| 9. On the Action of Heat on the Hydriodic Photographic Papers, .                                          | 86   |
| 10. On Copying Letter-Press, &c., on the Photographic Papers, by means of Juxtaposition, . . . . . . . . . . . | 86   |
| 11. On the Use of Photographic Paper for Registering the Indications of Meteorological Instruments, . . . . . . . | 87   |
| 12. The Influence of Chlorine and Iodine in rendering some kinds of Wood sensitive to Light, . . . . . . . . . | 89   |
| 13. Process for Preparing the Hyposulphite of Soda, . . . .                                               | 90   |
| CONCLUSION, . . . . . . . . . . . . .                                                                     | 91   |
| SUPPLEMENTARY CHAPTER, . . . . . . . . .                                                                  | 94   |
| A New Photographic Process by the Author, for Producing Pictures with the Camera Obscura in a Few Seconds, . . . . . | 94   |

# HISTORY OF PHOTOGRAPHY.

THE art of Photography is but as of yesterday's birth. The earliest recorded attempts at fixing images by the chemical influence of light, being those of Wedgwood and Davy, published in the Journal of the Royal Institution of Great Britain, in June, 1802. Neither of these eminent philosophers succeeded in producing a preparation of sufficient sensitiveness to receive any impression from the subdued light of the camera obscura. By the solar microscope, when the prepared paper was placed very near the lens, Sir H. Davy procured a faint image of the object therein; but being unacquainted with any method of preventing the further action of light on the picture, which is, of course, necessary to secure the impression, the pursuit of the subject was abandoned. From this period no attempt was made to overcome the difficulties which stopped the progress of a Davy, until 1814, when M. Niepce, of Chalons, on the Soane, appears to have first directed his attention to the production of pictures by light.

Although that branch of the subject, which had for its object the fixation of optical images, was unattended to, the chemical influences exerted by the individual rays of the solar spectrum, attracted the attention of men of science, and many important phenomena were discovered. As most of these have a practical bearing on the subject in hand, it may not be uninteresting to take a rapid survey of the progress of this inquiry.

The philosophers of antiquity appear to have had their attention excited by many of the more striking characters of light. Yet we have no account of their having attended to any of its chemical influences, although its action on coloured bodies—deepening their colour in some cases, and discharging it in others—must have been of every-day occurrence. The only facts which they have recorded, are, that some precious stones, particularly the amethyst and the opal, lost their sparkle by prolonged exposure to the rays of the sun.

It has been stated—I know not if on sufficient authority—that the jugglers of India were for many ages in possession of a secret, by which they were enabled in a brief space to copy the profile of any individual,

by the action of light. However this may have been, it does not appear that they know any thing of such a process in the present day.

The alchemists, amidst the multiplicity of their manipulations, dropped on the combination of silver and muriatic acid, to which white salt they gave the name of caustic silver, or, when fused, of horn silver, and they noticed that it was blackened by light; but, appearing to promise nothing to their cupidity, it attracted but little of their attention.

The illustrious Scheele, in his admirable *Traité de l'Air et du Feu*, gave us the first philosophical examination of this peculiar property of the salts of silver, and showed the dissimilar powers of the different rays of light in effecting this change. In 1801, Ritter proved the existence of rays a considerable distance beyond the visible spectrum, which had the property of speedily blackening chloride of silver. These researches excited the attention of the scientific world, and M. Berard, Lubeck and Berthollet, Sir William Herschel, Sir Henry Englefield, and others, directed their attention to the peculiar condition of the different rays in relation to luminous, calorific, and chemical influences. Dr. Wollaston pursued and published an interesting series of experiments on the changes effected by light on gum guaiacum. He found that papers washed with a solution of this gum in spirits of wine, had its yellow colour rapidly changed to green by the violet rays, while the red rays had the property of restoring the yellow hue. Sir Humphry Davy observed, that the puce-coloured oxide of lead became, when moistened, red, by exposure to the red ray, and black when exposed to the violet ray: that hydrogen and chlorine entered into combination more rapidly in the red, than in the violet rays, and that the green oxide of mercury, although not changed by the most refrangible rays, speedily became red in the least refrangible.

The revival of gold and silver from their oxides, by the action of the sun's light, also occupied the attention of Count Rumford, who communicated two valuable papers on this subject to the Royal Society. These, and some curious observations by Morichini and Configliachi, M. Berard and Mrs. Somerville, on the power of the violet rays to induce magnetism in steel needles, are the principal points of discovery in this branch of photometry. Indeed, with regard to the last mentioned, Berzelius states, from a review of the experiments of Seebech, that he concludes the fact announced by Mrs. Somerville rests on an illusion; which agrees with the opinions of Snow Harris, who endeavoured to produce polarity in needles exposed in vacuo to the influence of violet light, but failed in every instance.* These researches led the way to the establishment of the art, on the consideration of which we must now more particularly enter. It being admitted on all hands that the first attempts to delineate objects by light were those of Wedg-

---

* The Rev. Thomas Knox, and G. J. Knox, Esq., have very recently repeated these experiments; they have, however, only proved that the induced magnetism is dependent upon the oxidation of the steel, which takes place more rapidly in the violet, than in any of the other rays.—*See the Reports of the Royal Irish Academy.*

wood and Davy, we must allow the second in order of time to be those of M. Niepce.

The Photographic researches of M. Niepce, as before stated, appear to have commenced in 1814. It does not seem his early attempts were very successful ones, and after pursuing the subject alone for ten years, he, from an accidental disclosure, became acquainted with M. Daguerre, who had been for some time endeavouring, by some chemical process, to fix the images obtained with the camera obscura. In December, 1829, a deed of copartnery was executed between M. Niepce and M. Daguerre, for mutually investigating the subject.

M. Niepce had named his discovery Heliography.* In 1827, he presented a paper to the Royal Society of London, on the subject; but as he kept his process a secret, it could not, agreeably with one of their laws, be printed by them. This memoir was accompanied with several designs on metal, which were afterwards lodged in the collections of the curious. They prove M. Niepce to have been then acquainted with a method of forming pictures, by which the lights, demi-tints, and shadows, were represented as in nature; and he had also succeeded in rendering his *Heliographs*, when once formed, impervious to the further effects of the solar rays. Some of these specimens appear in the state of advanced etchings, but this was accomplished by a process similar to that pursued in common etchings, to be hereafter explained. Glass, copper plated with silver, and well plannished tin plate, were the substances on which M. Niepce spread his sensitive preparations. Paper impregnated with the chloride or the nitrate of silver, was the substance first selected by M. Daguerre. Heliography does not appear at any time to have produced any very delicate effects. The want of sensibility in the preparation,—the resin of some essential oils, or the oil of Lavender, in which asphaltum was dissolved,—rendered it necessary that the prepared plate should be exposed to luminous influence from seven to twelve hours. During so protracted an interval, the shadows pass from the left to the right of objects, and consequently all the fine effects arising from the contrasts of light and shade are destroyed. The first attempts of Daguerre appear to have been little more successful than those of Wedgwood. M. Arago thus speaks of the prepared papers: "The want of sensibility in this preparation, the confusion of images it produced, the uncertainty of the results, and the accidents which often interfered with the operation of transforming the lights into shadows, and the shadows into lights, could not fail to discourage so able an artist. Had Daguerre persisted in his first intention, his photographic designs might have found a place in collections, as the result of a curious philosophical experiment, but assuredly they never would have occupied the attention of the Chamber of Deputies." M. Arago should have hesitated ere he gave utterance to the concluding portion of this paragraph: experience has shown that all the difficulties he speaks of, were

* Pencilled by the Sun.

to be overcome; and two years from the delivery of the above speech had not elasped, when M. Biot presented to the academy a series of specimens on paper, the production of Mr. Fox Talbot, obtained, both by application, and with the camera, in which the lights and shadows were correctly represented, and which rivalled in point of sensitiveness the magic iodidated plate of Daguerre.* The discovery of Daguerre was reported to the world early in January, 1839, but the process by which his beautiful pictures were produced, was not made known until the July following, after a bill was passed, securing M. Daguerre a pension for life of 6,000 francs, and to M. Isidore Niepce, the son of M. Niepce above mentioned, a pension for life of 4,000 francs, with one half in reversion to the widows. It is to be regretted, that after the French Government had thus liberally purchased the secret of the process of the Daguerréotype, for " *the glory of endowing the world of science and of art, with one of the most surprising discoveries that honour their native land*," † on the argument that " *the invention did not admit of being secured by patent, for as soon as published all might avail themselves of its advantages*,"† that it should have been guarded by a patent right in England.

On the 31st of January, 1839, six months prior to the publication of M. Daguerre's process, Mr. Fox Talbot communicated to the Royal Society his photographic discoveries, and in February he *gave* to the world an account of the process he had devised for preparing a highly sensitive paper for photographic drawings. In the memoir read before the Royal Society, he states,—" In the spring of 1834, I began to put in practice a method which I had devised some time previously, for employing, to purposes of utility, the very curious property which has been

---

* I have been recently favoured with a communication from Mr. Talbot, accompanied by some most exquisite specimens of this new photographic art. One of these drawings, an elm tree, was effected by an exposure of one minute in the camera, and the minutest details, even " the topmost twig that looks up at the sky," are given with considerable strength and much picturesque effect. To distinguish this process from the ordinary ones and from the Daguerréotype, Mr. Talbot has bestowed upon it the name of Calotype,—and truly from its perfect character it well deserves its title—the beautiful.

It must however be borne in mind, that though this process is one of exquisite sensibility, it does not at once give the correct light and shadow to the picture, it is a *negative process*, and it is therefore necessary to take a second copy on ordinary photographic paper, to produce a faithful representation of the original. The discovery was accidental, and affords another proof of the very extensive inquiry which Photography has brought into view. It appears Mr. Talbot was trying some experiments on the relative sensitiveness of several kinds of papers, by exposing them for very short periods in the camera. Some papers which were taken from the instrument exhibiting no impression, were thrown aside in a dark room; after some time these were again examined, and strange to say, by a process of natural magic, pictures of the objects to which the camera had been pointed, were formed on them in the dark.

The secret of preparing this very extraordinary variety of photographic paper is still retained by Mr. Talbot, who has patented the process, and is desirous of improving, if possible, the already exquisitely sensitive calotype paper, before he gives in his specification to the Patent Office.

† M. Duchatel, Minister Secretary of State, on presenting the Bill to the Chamber of Deputies.

long known to chemists to be possessed by the nitrate of silver, namely, its discolouration when exposed to the violet rays of light." From this it appears that the English philosopher had pursued his researches ignorant of what had been done by others on the continent. It is not necessary to enlarge, in this place, on the merits of the two discoveries of Talbot and Daguerre; but it may be as well to show the kind of sensitiveness to which Mr. Talbot had arrived at this early period, in his preparations, which will be best done by a brief extract from his own communication.

" It is so natural," says this learned inquirer, " to associate the idea of *labour* with great complexity and elaborate detail of execution, that one is more struck at seeing the thousand florets of an *Agrostis* depicted with all its capillary branchlets, (and so accurately, that none of all this multitude shall want its little bivalve calyx, requiring to be examined through a lens,) than one is by the picture of the large and simple leaf of an oak or a chesnut. But in truth the difficulty is in both cases the same. The one of these takes no more time to execute than the other; for the object which would take the most skilful artist days or weeks of labour to trace or to copy, is effected by the boundless powers of natural chemistry in the space of a few seconds." And again, " to give some more definite idea of the rapidity of the process, I will state, that after various trials, the nearest valuation which I could make of the time necessary for obtaining the picture of an object, so as to have pretty distinct outlines, when I employed the full sunshine, was *half-a-second.*" This is to be understood of the paper used by Mr. Talbot for taking copies of objects by means of the solar microscope.

From this period the progress of Photography has been rapid. Sir John Herschel has devised many extremely ingenious and useful methods for preparing and fixing the drawings; and the curious scientific results which he has obtained, whilst studying the peculiar functions of the different rays of light, and of the various photographic materials which he has employed, are of the highest importance. It were useless to enumerate all who have by their experiments arrived at practical improvements in the art; particularly as they will be noticed under the different sections to which their discoveries properly belong. Suffice it then in this place to state, that the researches of Ponton, Fyfe, Draper, Becquerel, Donné, Soleil, and Bayard, with many others, have already advanced the art of Photography, and the processes of the Daguerréotype, to that point, at which their ultimate utility is clearly shown to depend merely on the simplification of their manipulatory details.

# PROCESSES ON PAPER.

---

## 1.—On the Selection of Paper for Photographic purposes.

It is natural to suppose, that a process, which involves the most delicate chemical changes, should require that more than ordinary care be taken in selecting the substance upon which preparations of a photographic character are to be spread. This becomes more evident as we proceed in our experiments to produce improved states of sensitiveness. As the material, whatever it may be, becomes more susceptible to luminous influence, the greater is the difficulty of producing perfectly uniform surfaces, and with paper this is more particularly the case than with solid plates. Paper is, however, so convenient and so economical, that it is of the first importance to overcome the few difficulties which stand in the way of its use, as the ground on which the photographic picture is to be drawn.

The principal difficulty we have to contend with in using paper, is, the different rates of imbibition which we often meet with in the same sheet, arising from trifling inequalities in its texture. This is, to a certain extent, to be overcome by a very careful examination of each sheet, by the light of a lamp or candle at night. By extending each sheet between the light and the eye, and slowly moving it up and down, and from left to right, the variations in its texture will be seen by the different quantities of light which permeate it in different parts; and it is always the safest course to reject every sheet in which such inequalities are detected. By day it is more difficult to do this than at night, owing to the interference of the reflected with the transmitted light. It will however often happen, that paper which has been carefully selected by the above means, will imbibe fluids very unequally. In all cases where the paper is to be soaked in saline solutions, we have another method of discovering those sources of annoyance. Having the solution in a broad shallow vessel, extend the paper, and gradually draw it over the surface of the fluid, taking care that it is wetted on one side only. A few trials will render this perfectly easy. As the fluid is absorbed, any irregularities are detected by the difference of appearance exhibited on the upper part, which will, over well defined spaces, remain of a dull white, whilst other portions will be shining with a reflective film of moisture. Where the importance of the use to which the paper is to be applied, as for instance, copying an elaborate piece of architecture with the camera,

will repay a little extra attention, it is recommended that the paper be tried by this test with pure water, and dried, before it is submitted to the salting operation. It will be sometimes found that the paper contains minute fibres of thread, arising from the mass of which it is formed not having been reduced to a perfect pulp. Such paper should be rejected, and so also should those kinds which are found to have many brown or black specks, as they materially interfere with some of the processes. Some specimens of paper have an artificial substance given to them by sulphate of lime, (plaster of paris) but, as these are generally the cheaper kinds of demy, they are to be avoided by purchasing the better sorts. No really sensitive paper can be prepared when this sulphate is present, and it has the singular property of reversing the action of the hydriodic salts on the darkened chloride of silver, producing a negative, in the place of a positive photograph. It is often desirable to operate on very thin paper, particularly when we wish to transfer our designs. It will be found that most sheets of this description are actually pierced with minute holes, through which the light passes uninterruptedly, and consequently, impairs any copy which may be taken from a drawing on such a sheet. In selecting such paper, of which the kind known as thin post is the best, the closest texture should be chosen. A plan will be hereafter given for remedying, to a certain extent, the imperfections of thin sheets. It is the custom for papermakers to fix their names and the date, on one leaf of the sheet of writing paper. It is generally wise to reject this leaf, or to select paper which is not so marked, as, in many of the photographic processes which will be described, these marks are brought out in most annoying distinctness. From the various kinds of size which the manufacturers use in their papers, it will be found that constantly varying effects will arise. A well sized paper is by no means objectionable: on the contrary, organic combinations exalt the darkening property of the nitrate and muriate of silver. But unless we are careful always to use the same variety of paper, for the same purpose, we shall be much perplexed by the constantly varying results which we shall obtain. No doubt when, with the advance of the art, the demand for paper for photographic purposes increases, some manufacturers will find it worth the necessary care to prepare paper agreeably to the directions of scientific men. Then we may expect uniform effects. In the mean time, all who desire to make any progress in Photography, must take the necessary precautions in selecting paper, or be content to meet with repeated failures.

It has been noticed by Sir John Herschel, that " when thin post paper, merely washed with nitrate of silver, without any previous or subsequent application, is exposed to clear sunshine, partly covered by and strongly pressed into contact with glass, and partly projecting beyond it, so as to be freely exposed to air, the darkening produced in a given time is very unequal in the two portions. That protected by the glass, contrary to what might have been expected, is very much more affected than the part exposed; more, indeed, in some instances, than

would be produced by free exposure during three or four times the given time.   When fixed by hyposulphite of soda, the difference is rendered yet more striking, to an extent hardly credible without trial." It was also found that " the same glass in several instances exercised quite as remarkable an influence in depressing, as in others it did in exalting the solar action." The researches of the author of the present volume, all go to prove that this peculiar effect is mainly dependent on the quality of the paper employed.   It is certain that the result is considerably influenced by it.   This being the case, the necessity of endeavouring to establish by experiment, some data, by which we might always throw the balance of action on the exalting side, is very evident, as by this means we are enabled to increase the strength and decision of outline in an extraordinary degree.   The following tables will exhibit the results of an extensive series of experiments, undertaken after the publication of Sir J. Herschel's memoir " on the Chemical Action of the Rays of the Solar Spectrum," in which he has given a table of results, obtained with different preparations on various kinds of paper; but as he has not established the influence of the paper, except in a few instances, independent of the preparation, it became desirable to endeavour to do so.

In pursuing this inquiry, it was found that the same description of paper, from different manufacturers, gave rise to widely different effects; so that the most carefully conducted experiments, several times repeated, have only given approximations to the truth; and it is advised that each inquirer should himself try the effect of plate glass, in exalting or depressing the darkening property of the silver, on the paper he may employ.   In the event of this being neglected, the following table will be of considerable utility:—

### I.—PAPERS PREPARED WITH MURIATE OF SODA.

*a.* Superfine satin post,.....................Considerable exalting effect.
*b.* Thick wove post,...........................Depressing influence.
*c.* Superfine demy,...........................Slight exalting effect.
*d.* Bath drawing card,.......................No influence.
*e.* Thick post,.................................Slight exalting effect.
*f.* Common bank post,......................        Ditto.
*g.* Thin post,..................................No influence.
*h.* Tissue paper,.............................Considerable exalting effect.

### II.—PAPERS PREPARED WITH MURIATE OF BARYTES.

*a.* Superfine satin post,.....................Slight exalting influence.
*b.* Thick wove post,..........................  Ditto, but stronger.
*c.* Superfine demy,...........................Similar to *a.*
*d.* Bath drawing card,.......................Similar to *a.*
*e.* Thick post, ...............................Considerable exalting influence.
*f.* Common bank post,.......................Similar to *a.*
*g.* Thin post,.................................Similar to *e.*
*h.* Tissue paper,.............................Results uncertain.

III.—PAPERS PREPARED WITH MURIATE OF AMMONIA.

*a.* Superfine satin post,.....................Strong exalting influence.
*b.* Thick wove post,........................Results uncertain.
*c.* Superfine demy,.........................Slight exalting effect.
*d.* Bath drawing card, ....................Results uncertain.
*e.* Thick post,................................ Ditto.
*f.* Common bank post,.....................Depressing influence.
*g.* Thin post,..............................No influence.
*h.* Tissue paper,...........................Strong exalting influence.

IV.—PAPERS PREPARED WITH BROMIDE OF POTASSIUM.

*a.* Superfine satin post,....................No influence.
*b.* Thick wove post,........................Results uncertain.
*c.* Superfine demy,.........................Strong exalting influence.
*d.* Bath drawing card,.....................No effect.
*e.* Thick post,...............................Depressing influence.
*f.* Common bank post,.....................Slight exalting effect.
*g.* Thin post,............................... Ditto.
*h.* Tissue paper,............................Results uncertain.

Unsized paper has been recommended by some, but in no instance have I found it to answer so well as paper which has been sized. The principal thing to be attended to in preparing sensitive sheets, is to prevent, as far as it is possible, the absorption of the silver solution into the pores of the paper. Therefore the superficial roughness of unsized sheets, and the depth of the imbibitions are serious objections to their use. It must not, however, be forgotten, that these objections apply in their force, only to the silver preparations; in some modifications of Mr. Ponton's processes, with the bichromate of potash, the common bibulous paper, used for filtering liquids, has been found to answer remarkably well, on account of the facility with which it absorbs any size or varnish.

## 2.—NEGATIVE PHOTOGRAPHS.

A.—ON THE PREPARATION OF THE SENSITIVE PAPER WITH THE SALTS OF SILVER.

THE only apparatus required by the photographic manufacturer for the preparation of his papers, are,—a very soft sponge brush, a large camel-hair pencil, a wide shallow vessel capable of receiving the sheet without folds, and a few smooth planed boards, sufficiently large to stretch the paper upon. He must supply himself with a few sheets of good *white* blotting paper, and several pieces of soft linen, or cotton cloth, a box of

pins, (the common tinned ones will answer, but, if the expense is not a consideration, those made of silver wire will do better,) and a glass rod or two.

The materials necessary to produce all the varieties of sensitive paper which will be brought under consideration in this section are—

1. Nitrate of Silver. The crystallized salt should, if possible, always be procured. The fused nitrate, which is sold in cylindrical sticks, is more liable to contamination, and the paper in which each stick of two drachms is wrapped being weighed with the silver, renders it less economical. A preparation is sometimes sold for nitrate of silver, at from sixpence to ninepence the ounce less than the ordinary price, which may induce the unwary to purchase it. This reduction of price is effected by fusing with the salt of silver a proportion of some cupreous salt, generally the nitrate. This fraud is readily detected by observing if the salt becomes moist on exposure to the air. A very small admixture of copper renders the nitrate of silver deliquescent. The evils to the photographer are, want of sensibility to light, and the perishability (even in the dark) of the finished drawing.

2. Muriate of Soda, (Common Salt.)
3. ———— of Baryta.
4. ———— of Strontia.
5. ———— of Ammonia.
6. ———— of Peroxide of Iron.
7. ———— of Lime.
8. Chlorate of Potash.
9. Chloride of Soda, (Labarraque's disinfecting Soda Liquid.)
10. Hydrochloric Acid, (Spirits of Salts.)
11. Solution of Chlorine in water.
12. Phosphate of Soda.
13. Hydrochloric Ether.
15. Tartrate of Potash and Soda, (Rochelle Salts.)
16. Iodide of Potassium, (Hydriodate of Potash.)
17. Bromide of Potassium, (Hydrobromate of Potash.)
18. Diacetate of Lead, (Sugar of Lead.)
19. Spirits of Wine.
20. Nitric Ether.
21. Distilled Water, or Boiled Rain Water.

Many other chemical preparations, and some of the elementary bodies, will be often mentioned in connection with many processes to which the white papers are applied, but it is not thought essential to enumerate them in this place.

### a. NITRATED PAPER.

The most simple kind of photographic paper which is prepared, is that washed with the nitrate of silver only; and for many purposes it answers remarkably well, particularly for copying lace or feathers, and it

has this advantage over every other kind, that it is perfectly fixed by well soaking in warm water.

The best proportions in which this salt can be used, is one part, dissolved in four of water. Care must be taken to apply it equally, with a quick but steady motion, over every part of the paper. It will be found the best practice to pin the sheet by its four corners, to one of the flat boards above mentioned, and then holding it with the left hand, a little inclined, to sweep the brush, from the upper outside corner, over the whole of the sheet, removing it as seldom as possible. The lines in figure 1 will represent the manner in which the brush should be moved over the paper, commencing at *a* and ending at *b*. On no account must the lines be brushed across, nor must we attempt to cover a spot which has not been wetted, by the application of fresh solution to the place, as it will, in darkening, become a well defined space of a different shade from the rest of the sheet. The only plan is, when a space has escaped our attention in the first washing, to go over the whole sheet with a more dilute solution. It is indeed always the safest course to give the sheet two washings.

Fig. 1.

The simply nitrated paper not being very sensitive to luminous agency, it is desirable to increase its power. This may be done to some extent in many simple ways.

By soaking the paper in a solution of isinglass or parchment size, or by rubbing it over with the white of egg, and drying it prior to the application of the sensitive wash, it will be found to blacken much more readily, and assume different tones of colour, which may be varied at the taste of the operator.

By dissolving the nitrate of silver in common rectified spirits of wine, instead of water, we produce a tolerably sensitive nitrated paper, which darkens to a very beautiful chocolate brown; but this wash must not be used on any sheets prepared with isinglass, parchment, or albumen, as these substances are coagulated by alcohol.

The nitrate of silver is not sufficiently sensible to change readily in diffused light, consequently it is unfit for use in the camera obscura, and it is only in strong sunshine that a copy of an engraving can be taken with it.

### b. MURIATED PAPER.

As the method of preparing photographic paper, published by Mr. Talbot in 1839, is the first with which the public became acquainted, it is right that that gentleman's processes should take precedence of any others. We cannot do better than use his own description of them. " In order to make what may be called ordinary photogenic* paper,

---

* Photogenic was the term first used, by the suggestion of Mr. Talbot.

I select, in the first place, paper of a good firm quality and smooth surface. I do not know that any answers better than superfine writing paper. I dip it into a weak solution of common salt, and wipe it dry, by which the salt is uniformly distributed throughout its substance. I then spread a solution of nitrate of silver on one surface only, and dry it at the fire. The solution should not be saturated, but six or eight times diluted with water. When dry, the paper is fit for use.

" I have found by experiment that there is a certain proportion between the quantity of salt and that of the solution of silver which answers best, and gives the maximum effect. If the strength of the salt is augmented beyond this point, the effect diminishes, and, in certain cases, becomes exceedingly small.

" This paper, if properly made, is very useful for all ordinary photogenic purposes. For example, nothing can be more perfect than the images it gives of leaves and flowers, especially with a summer sun,—the light, passing through the leaves, delineates every ramification of their nerves.

" Now, suppose we take a sheet thus prepared, and wash it with a *saturated* solution of salt, and then dry it. We shall find (especially if the paper has been kept some weeks before the trial is made) that its sensibility is greatly diminished, and, in some cases, seems quite extinct. But if it is again washed with a liberal quantity of the solution of silver, it becomes again sensible to light, and even more so than it was at first. In this way, by alternately washing the paper with salt and silver, and drying it between times, I have succeeded in increasing its sensibility to the degree that is requisite for receiving the images of the camera obscura.

" In conducting this operation, it will be found that the results are sometimes more and sometimes less satisfactory, in consequence of small and accidental variations in the proportions employed. It happens sometimes that the chloride of silver is disposed to darken of itself without any exposure to light; this shows that the attempt to give it sensibility has been carried too far. The object is to *approach* to this condition as near as possible without *reaching* it, so that the substance may be in a state ready to yield to the slightest extraneous force, such as the feeble impact of the violet rays when much attenuated. Having therefore prepared a number of sheets of paper, with chemical proportions slightly different from one another, let a piece be cut from each, and having been duly marked or numbered, let them be placed, side by side, in a very weak diffused light for a quarter of an hour. Then, if any one of them, as frequently happens, exhibits a marked advantage over its competitors, I select the paper which bears the corresponding number to be placed in the camera obscura." *

In this extract from Mr. Talbot's communication, we have enumerated, in brief, most of the peculiarities of the photographic processes:

* The London and Edinburgh Philosophical Magazine, March, 1839, page 209, vol. 14.

—the increased sensitiveness given to paper, by alternate ablutions of saline and argentine washes—the striking differences of effect produced by accidental variations of the proportions in which the chemical ingredients are applied—and the spontaneous change which takes place, even in the dark, on the more sensitive varieties of the paper, are all subjects of great interest, which demand yet further investigation, and which, if followed out, promise some most important explanations of chemical phenomena at present involved in uncertainty, particularly of some which appear to show the influence of time—an element not sufficiently taken into account—in overcoming the weaker affinities. A few particulars of remarkable changes, as observed in photographic papers, will have a place in this volume.

The proportions in which the muriate of soda has been used, are exceedingly various; in general, the solution has been made too strong; but several respectable chemists have recommended a wash as much too weak. For different uses, papers of various qualities should be employed. It will be found well in practice to keep papers of three orders of sensitiveness prepared; the proportions of salt and silver for each being as follows:—

*Sensitive Paper for the Camera Obscura.*

Muriate of soda, fifty grains to an ounce of water.

Nitrate of silver, one hundred and twenty grains to an ounce of distilled water.

The paper is first soaked in the saline solution, and after being carefully wiped with linen, or pressed between folds of blotting paper and dried, it is to be washed twice with the solution of silver, drying it by a warm fire between each washing. This paper is very liable to become brown in the dark.

*Less Sensitive Paper for copies of Engravings—Botanical or Entomological specimens.*

Muriate of soda, twenty-five grains to an ounce of water.

Nitrate of silver, ninety grains to an ounce of distilled water.

Applied as above directed.

*Common Sensitive Paper, for Copying Lace-work, Feathers, Patterns of Watch-work, &c.*

Muriate of soda, twenty grains to an ounce of water.

Nitrate of silver, forty grains to an ounce of distilled water.

Applied as above directed.

This paper keeps tolerably well, but we cannot always depend upon its darkening equally in all parts.

The irregularities discoverable in the texture of the finest kinds of paper have before been mentioned. These give rise, however carefully the successive washes may have been applied, to irregular patches with sharply defined outlines, exhibiting a much lower degree of sensibility

than the other parts of the sheet. These patches have been attributed by Sir John Herschel and Mr. Talbot to " the assumption of definite and different chemical states of the silver within and without their area." A few experiments will prove this to be the case.

Prepare a piece of the less sensitive paper, with only one wash of silver, and whilst wet expose it to the sunshine; in a few minutes it

Fig. 2.

will exhibit the influence of light, by becoming very irregularly darkened, assuming such an appearance as that given in fig. 2, the light part being a pale blue, and the shaded portions a deep brown. In pursuing our inquiry into the cause of this singularity, it will be found that over the light parts a. pure chloride of silver, or a chloride with a slight excess of the muriate of soda is diffused, but over the dark parts the chloride of silver is united with an excess of the nitrate of silver. Where the rates of imbibition are different, this defect must follow, as a natural consequence, in very many cases; but it is found to occur frequently where we cannot detect any sufficient cause for the annoyance. Although we are acquainted with the proximate causes of the differences produced, yet the ultimate ones are involved in doubt. It is a remarkable fact, that the same irregular patches are formed *in the dark* on papers which have been kept a long of time. Sir John Herschel has suggested, as a means of preventing these troublesome occurrences, that the saline wash used should, prior to its application, be made to dissolve as much as possible of the chloride of silver, which it does to a considerable extent; and that the last wash of the nitrate of silver should be diluted with an equal quantity of water, and applied twice, instead of in one application. There can be no doubt but this evil is almost entirely overcome by operating in this way, but it is unfortunate that the process is somewhat injurious to the sensibility of the paper.

It may be as well to mention in this place, that it is in all cases necessary, where considerable sensitiveness is required, that there should exist an excess of the nitrate of silver in combination, or more properly speaking, *mixed* with the chloride. Mr. Cooper, with a view to the production of an uniform paper, recommends that it be *soaked* for a considerable length of time in the saline wash, and after it is dried that the sheet should by an assistant, be *dipped* into the silver solution: while the operator

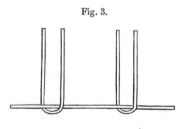

Fig. 3.

moves over its surface a glass rod held in two bent pieces of glass as in fig. 3; the object of which is to remove the small air-bubbles, that form on the surface of the paper, and protect it from the action of the fluid. This process, however well it may answer in preparing paper for copying engravings, and the like,

will yield but poor paper for camera purposes, and it is objectionable on the score of economy.

Papers prepared with the muriate of soda, have been more extensively used than any others, owing to the ease with which this material is always to be procured, and for most purposes it answers as well as almost any other, but it does not produce the most sensitive photographic ground.

Muriate of strontia, used in the proportion of thirty-five grains to two ounces of water, with a silver solution of one hundred grains to the ounce, the metallic wash being applied twice, as before directed, forms a beautiful and very sensitive paper. Muriate of baryta, in similar proportions, produces a paper as much like it as possible, with this difference, that the barytic paper always assumes a peculiar richness of colour. The colorific action of the barytic salts will become the subject of our remarks by and by.

It may not be entirely useless, or uninteresting, to state the more striking peculiarities of a few of the *mordant* washes, on the study of which depends the possibility of our ever producing photographs in their natural colours, a problem of the highest interest. It will be found that nearly every variety of paper exposed to the full action of the solar beams, will pass through various shades of brown, and become at last of a deep olive colour; it must therefore be understood that the process of darkening is in all cases stopped short of this point.

In order to prevent unnecessary divisions in the subject, under this head will also be embraced a few other solutions, which are analogous to the muriates. It should be understood, that unless the contrary is distinctly stated, the proportion of silver to be used is as above recommended for use, with the salts of strontia and baryta.

Muriate of Lime—not particularly sensitive, deepening to a brick red in full sunshine, but is less liable to change in the fixing processes than almost any other preparation.

Muriate of Potash, is scarcely in any respect different from the muriate of soda. The nitrate of potash, however, which is formed in the paper, is less liable to be affected by a humid atmosphere than the nitrate of soda.

Muriate of Ammonia, used in the proportion of two scruples to four ounces of water, and the silver solution in the proportion of sixty grains of the nitrate to one ounce of water, forms a very beautiful paper, equalling in sensibility, the best kind prepared with the muriate of soda, at nearly one-half its expense. It darkens to a fine chocolate brown.

Muriate of Iron. A solution of this salt appears in the first instance to answer remarkably well; but, unfortunately, the pictures formed perish slowly, however carefully guarded from the influence of light.

Chlorate of Potash. Mr. Cooper recommends a solution of this salt, and a silver wash of sixty grains to the ounce of water, as capable of forming a good paper. Some of the specimens prepared with it are of exceeding beauty, the ground being of a very pretty blue, or rather

lilac; but these papers cannot be used where any considerable degree of sensitiveness is desired.

MURIATIC ACID. A slightly acidulated solution of this acid produces a very tolerable paper, but it is extremely difficult to hit the best proportions for use. If too weak, the paper fails in sensibility, and a slight increase occasions a very injurious action on the paper, raising the *pile* like a down over the sheet. This kind of paper looses its sensitiveness with great rapidity; in about six or seven days, however carefully kept, it is scarcely susceptible to luminous influence. By washing the paper after it is prepared in pure water, it keeps much better, but after being washed, light changes it to a rather disagreeable brick red, prior to which the colour in general is a fine brown.

Dr. Schafhaeutl has proposed the use of the muriatic acid in a different way, and certainly his process has some advantages: when it is carefully attended to, the liability to spots or patches appears to be less than in any of the ordinary methods, and a very sensitive paper results, but it will not keep. This process will be found at the end of the negative silver ones.

AQUEOUS SOLUTION OF CHLORINE gives rise to a paper possessing in an eminent degree the merits of that prepared with muriatic acid, and it has the advantage of retaining its sensibility much longer.

SOLUTIONS OF CHLORIDES OF LIME AND SODA. Either of these solutions may be used indiscriminately, provided the strength of the silver solution is such as to employ all the chlorine they have in their combination. They give rise to pictures having a deep red ground.

HYDRO-CHLORIC ETHER. When the nitrate of silver is dissolved in this ether, and applied without any preparation to the paper, it does not at first prove very sensitive to light; but after a little exposure, the darkening process goes on with some rapidity, and at length passes into a deep brown, verging on a black. It is certainly preferable to the simple solution of the nitrate in water, but in no respect equal to the chlorides.

It is necessary now to direct attention to the effects of organic matter in accelerating the blackening process. Sir John Herschel, whose researches in this branch of science are marked with the same high philosophic spirit which has distinguished his career, and which promise to effect more in establishing the art of photography on a secure basis, than those of any other individual, has given particular attention to this matter. As it is impossible to convey the valuable information that Sir John has published, more concisely than in his own clear and elegant language, I shall take the liberty of extracting rather freely from his memoir.[*]

" A great many experiments were made by precipitating organic liquids, both vegetable and animal, with solutions of lead; as also,

---

[*] On the chemical action of the rays of the solar spectrum on preparations of silver, and other substances, both metallic and non-metallic, and on some photographic processes. —*Philosophical Transactions*, 1840.

after adding alum, with alkaline solutions. Both alumina and oxide of lead are well known to have an affinity to many of these fugitive organic compounds which cannot be concentrated by evaporation without injury, —an affinity sufficient to carry them down in combination, when precipitated, either as hydrates or as insoluble salts. Such precipitates, when collected, were applied in the state of cream on paper, and when dry were washed with the nitrate. It was here that the first prominently successful result was obtained. The precipitate thrown down from a liquid of this description by lead, was found to give a far higher degree of sensitiveness than any I had before obtained, receiving an equal depth of impression, when exposed, in comparison with mere nitrated paper, in less than a fifth of the time; and, moreover, acquiring a beautiful ruddy brown tint, almost amounting to crimson, with a peculiarly rich and velvety effect.* Alumina, similarly precipitated from the same liquid, gave no such result. Struck by this difference, which manifestly referred itself to the precipitate, it now occurred to me to omit the organic matter, (whose necessity I had never before thought of questioning,) and to operate with an alkaline precipitant on a mere aqueous solution of nitrate of lead, so as to produce simply a hydrate of that metal. The result was instructive. A cream of this hydrate being applied and dried, acquired, when washed with nitrate of silver, a considerable increase of sensitiveness over what the nitrate alone would have given, though less than in the experiment where organized matter was present. The rich crimson hue also acquired in that case under the influence of light, was not now produced. Two peculiarities of action were thus brought into view; the one that of the oxide of lead as a *mordant*, (if we may use a term borrowed from the art of dyeing,) the other, that of organic matter as a colorific agent.—

" Paper washed with acetate of lead was impregnated with various insoluble salts of that metal, such as the sulphate, phosphate, muriate, hydriodate, borate, oxalate, and others, by washing with their appropriate neutral salts, and when dry, applying the nitrate of silver as usual. The results, however, were in no way striking, as regards sensitiveness, in any case but in that of the muriatic applications. In all cases where such applications were used, a paper was produced infinitely more sensitive than any I had at that time made. And I may here observe, that in this respect the muriate of strontia appeared to have decided advantage.—

" The paper with a basis of lead turns yellow by keeping in the dark, and the tint goes on gradually deepening to a dark brown. But, what is very singular, this change is not equally rapid on all kinds of paper, a difference depending no doubt on the size employed, which, it may be observed here once for all, is of the utmost influence on all photographic processes. In one sort of paper, known by the name of *blue wove post*,

---

* It has been found that this rich tint may be communicated by soaking the drawing formed on many of the nitrated papers in a saturated solution of sugar of lead.

D

it is instantaneous, taking place the moment the nitrate, if abundant, is applied. And yet I find this very paper to resist discolouration, by keeping, better than any other, when the mordant base is silver in place of lead. On the other hand, a paper of that kind called *smooth demy*, rendered sensitive by the process first described, was found to acquire, by long keeping, a grey or slate colour, which increases to such a degree as might be supposed to render it useless. Yet in this state, when it is impressed with a photographic image, the process of fixing it with the hyposulphite of soda destroys this colour completely, leaving the ground as white as when fresh prepared. This fortunate restoration, however, does not take place when the paper has been *browned* as above described. Some of the muriatic salts are more apt to induce this discolouration than others, especially those with earthy bases. But the effects in this respect are so capricious, that it is in vain to attempt giving any connected account of them.

" In consequence of this spontaneous discolouration, I disused for ordinary purposes this mode of preparation, and adopted the following series of washes, on Mr. Talbot's principle,—viz., 1st, nitrate of silver, S. G. $= 1.096$, (say 1.1;) 2ndly, muriate of soda, 1 salt $+$ 19 water; 3rdly, nitrate of silver, S. G. 1.132, (say 1.15,) saturating the muriatic solution with chloride of silver, and occasionally dividing the last application into two consecutive washes of equal strength by dilution. This, as an ordinary working paper, is easily prepared, and has sensibility enough for most purposes. It gives very good camera pictures, and, if that particular sort of paper above named is used, it retains its whiteness well in the dark, at least for some weeks."

From the description which Sir John Herschel has given of the spontaneous browning of the paper, it may appear that little more need be said on the subject, or that if any thing more is required, that it should follow in this place; it has, however, been thought best to occupy a future chapter with it, as some new matter somewhat distinct from the subject of the present chapter will be introduced.

It would be tedious and useless to mention all the combinations of alkaline and earthy muriates which have been devised to vary the effect, or increase the sensitiveness of the silver preparations; the very considerable differences produced through the influence of these salts, will afford peculiarly interesting results to any inquirer, and furnish him with a curious collection of photographic specimens. As a general rule, the solutions of the muriate, and indeed all other salts, and of the silver washes, should be made in the combining proportions of the material used; with a scale of chemical equivalents at hand, the photographic experimentalist need not err far, taking care that a slight excess of pure nitrate of silver prevails.

### c. IODIDATED PAPERS.

I distinguish by this name those papers which are impregnated with the iodide of silver, either by applying the already formed iodide sus-

pended in some viscid fluid, or by alternately washing with the nitrate of silver and some hydriodic saline solution.

By these means papers may be prepared which are exquisitely sensitive to luminous influence, provided the right proportions are hit; but, at the same time, nothing can be more insensible to the same agency, than the iodide of silver in some forms of combination. These singular differences in precipitates to all appearance the same, led to the belief that more than one definite compound of these elements existed. Experiment has, however, proved that the blackening of one variety of iodidated paper, and the preservation of another, depends not on two definite combinations, but on the simple admixture of a very minute excess of the nitrate of silver. The papers prepared with the iodide of silver have all the peculiarities of those prepared with the chloride, and although, in some instances, they seem to exhibit a much higher order of sensitiveness, they cannot be recommended for general purposes, with that confidence which experience has given to the chloride. It may, however, be proper to state the best proportions in which the iodidated papers can be prepared, and the best method of applying the solutions.

The finest kind of paper being chosen, it should be pinned by its four corners to a board, and carefully washed over with a solution of six grains of the nitrate of silver to half an ounce of water; when this is dry, it is to be washed with iodide of potassium, five grains in the same quantity of water, and dried by, but at some little distance from, the fire; then, some short period before the paper is required for use, it must be again washed with the silver solution, and quickly dried, with the same precaution as before. If this paper is warmed too much in drying, it changes from its delicate primrose colour to a bright pink or a rosy brown, which, although still sensitive, is not so much so as the parts which are not so altered. The peculiar property of this salt to change thus readily by calorific influence, and some other very remarkable effects produced on already darkened paper, when washed with a hydriodic salt, and exposed to artificial heat, or the pure calorific rays of the spectrum, which will be hereafter noticed, appears to promise a process of drawing which may be called thermography. Opening as this does a wide range of highly interesting and most important experiments, it is to be hoped some one may pursue the subject, and endeavour to establish the peculiar phenomena which present themselves, on some scientific basis.

### d. BROMIDATED PAPERS.

In many of the Works on chemistry, it is stated that the chloride is the most sensitive to light of all the salts of silver; and when they are exposed in a perfectly formed and pure state to solar influence, it will be found that this is nearly correct. Modern discovery has, however, shown that these salts may exist in peculiar conditions, in which the affinities are so delicately balanced, as to be disturbed by the faintest gleam; and it is singular, that as it regards the chloride, iodide, and

bromide of silver, when in this condition, the order of sensibility is reversed, and the most decided action is evident on the bromide, before the eye can detect any change in the chloride. This fact early attracted the notice of Mr. Fox Talbot, and if he has not entirely abandoned the use of the chloride, he certainly prefers the bromide for all purposes requiring highly sensitive papers.

The slight additional expense of the bromides is not worthy consideration, particularly as their use may be confined to papers for the camera obscura, the pictures on which are of course of the negative character, and the positive photographs can be formed by transfer on the chlorided papers of a highly sensitive kind.

It will be found that the bromide and iodide are much alike in the singular want of sensibility, which they sometimes exhibit under circumstances which are not easy of explanation.

If a paper first washed with a solution of nitrate of silver, have applied to it bromide of potassium in different proportions, say 20 grains, 15 grains, and 10 grains each, in two drachms of water, and, when dry, be again washed over with the silver solution, it will be found, unless, as is occasionally the case, some organic combination interferes, that the order of sensitiveness will begin with the weakest solution, the strongest being the least influenced by light. The different degrees of darkness induced are fairly represented in the margin. As the different bromides give to photographic paper varieties which much resemble those enumerated under the muriates, I have thought it unnecessary to give an account of any, except that prepared with the bromide of potassium, which is the kind I have adopted, after having tried upwards of two hundred combinations of silver, and the other bromides.

Fig. 4.

10 grs

15 grs

20 grs

To prepare a highly sensitive paper of this kind, select some sheets of very superior demy, and wash it on one side only with bromide of potassium: forty grains to one ounce of distilled water, over which, when dry, pass a solution of one hundred grains of nitrate of silver in the same quantity of water. The paper must be dried as quickly as possible, without exposing it to too much heat; then again washed with the silver solution, and, when dry, carefully preserved for use.

It will be perceived that I adopt a slightly different manipulation from that recommended by Mr. Talbot. Instead of washing the paper with the solution of silver first, and applying the bromide or the muriate over this, and then the silver wash again, I use the alkaline salt first, and apply the metallic washes one on the other. I have been induced to this, from observing that the photographic preparation penetrates less deeply into the paper, than when laid on as originally prescribed, and, consequently, the sensibility of it is increased. It will be found that an addition of about one-twelfth of spirits of wine to the

solution of silver, will much increase the blackness of the paper when solarised; and I think we may safely say, that the sensibility is also improved by it, at all events it is not at all impaired. M. Biot has expressed his opinion, that it is not possible to find any substance more sensitive to light than the bromide of silver.

### e. PHOSPHATED PAPERS.

Dr. Fyfe appears to have been the first to suggest the use of the phosphate of silver as a photographic material, but I am obliged to confess it has not, in my hands, proved any thing like so successful, as, from Dr. Fyfe's description, it was in his own. Indeed, he himself observes, in speaking of its use in the camera obscura:—" Though representations may be got in this way, yet, so far as I have found, they have not the minute distinctness of those got by the method already mentioned, (i. e. by application.) Owing to the interference of the lens, the light does not act nearly so powerfully on the paper, as when it has to permeate merely a frame of glass."

For all practical purposes, the method which Dr. Fyfe has given of preparing these papers, is perhaps the best:—" The paper is first soaked in the phosphate of soda and then dried, after which the nitrate is spread over one side by a brush; the paper again dried, and afterwards again put through the salt, by which any excess of silver is converted to phosphate. As thus prepared, it acquires a yellow tinge, which becomes black by exposure to light." It will be evident from these directions, that what was formerly said about the necessity of having the nitrate of silver in excess, is here, according to Dr. Fyfe, objectionable. It certainly does not appear to be so essential in this preparation, that any thing but pure phosphate of silver should be used, yet I cannot help fancying, that a slight advantage is gained, even here, by allowing a little excess of nitrate. Dr. Fyfe has given a process for applying the phosphate of silver already formed as a paint, on metal, glass, or paper. It, however, requires the skill of an artist to produce an even surface, and unless a uniform ground is given, the picture is deformed by waving lines of different shades. A method of precipitating argentine salts on smooth surfaces, will be given in the following pages, by which means the most uniform face is procured, and many beautiful effects produced.

### f. PAPERS PREPARED WITH OTHER SALTS OF SILVER.

With the exception of the carbonate, tartrate, acetate, citrate, oxalate, and one or two others, the salts of silver, besides those already described, do not appear to be much influenced by light. Many have been mentioned by authors as absolutely insensible to its influence; but recent experiments have produced modifications of these salts which are delicately sensitive to the solar ray. Amongst others, the chromate has been named, and certainly it has not yet been rendered sensitive to an exposure of some hours to daylight; but one experiment of mine has proved, that the solar beam will, in a few days, produce a

fine revival of metallic silver from its chromate; and another experiment with it has the most pleasing result of bringing within the range of probabilities, the production of photographic pictures in their natural colours.

This is mentioned to show, that in the present state of our knowledge, we cannot venture to affirm that any salt of silver, or, indeed, of any of the other metals, exists, having an absolute insensibility to light, or in which the required unstable equilibrium may not be induced, so that the sun's beam might change the character of its combinations. Papers washed with either of the alkaline carbonates, and then with a solution of nitrate of silver, resemble in their character those prepared with the muriates, but are not darkened so readily.

The tartrate of silver possesses some very extraordinary peculiarities. Papers may be prepared, either by spreading the tartrate at once over the surface, or better, by soaking the paper in a solution of Rochelle salt, (the tartrate of potash and soda,) and then applying two washes of the solution of nitrate of silver. The first action of light is very feeble, but there gradually comes on a stronger discolouration, which eventually proceeds with great rapidity, and at length blackens to an extent beyond almost every other paper. This discolouration may be wonderfully accelerated by washing over the tartrated paper with a very dilute solution of the hydriodate of potash, during the process of darkening. It is not easy to use this when copying any thing, but there are cases in which the extreme degree of darkness which this preparation acquires renders it valuable. The acetate of silver comports itself in the same manner as the tartrate. The citrate, oxalate, &c., are only interesting as forming part of the series of argentine preparations which exhibit decisive changes when exposed to light. The methods of rendering them available will be sufficiently understood from the foregoing details, and it would only be an unnecessary waste of words to give any more particular directions as it regards them.

It is proper to express my belief, that we are not yet arrived at the utmost point of sensitiveness, which it is in the province of chemistry to impart to paper. I am persuaded, from effects I have observed, but which I have not been able to reproduce, that it is quite as likely, we may eventually produce a paper, giving an *instantaneous* effect, as it is certain this has been accomplished by M. Daguerre on his metallic tablets. One circumstance is well worthy of recording:—Mr. John Towson of Devonport, who pursued, conjointly with myself, a most extensive series of researches on photographic agents, was endeavouring to form a solution of silver, in which the elements should be so delicately balanced, as to be overturned by the action of the faintest light. To do this, he dissolved some very pure silver in nitric acid, to which spirits of wine was added somewhat suddenly, in proportions equal to the acid-used, and the precipitation of the fulminate prevented by a quick effusion of cold water, sufficient to bring the specific gravity of the solution to 1.17, and to this a few drops of ammonia were added.

Pieces of bank post paper dipped in this solution became, the instant they were presented to the declining light of an autumnal evening, a beautiful black having a purple tinge. This effect did not seem to come on gradually, but as by a sudden impulse, at once. Both this gentleman and myself have often endeavoured to repeat this, but in no one instance have either of us succeeded in producing any thing nearly so sensitive. It should be stated, that the solution prepared in the evening, had become, by the following morning, only ordinarily sensitive, and that papers prepared with it were deliquescent and bad. In repeating any modification of this experiment, the greatest care should be taken, as explosions of considerable violence are otherwise likely to occur.

Another series of experiments on the fulminates of silver have produced very pleasing photographic results, but I am not enabled to specify any particular method of preparing them, which may be certain of reproducing the results to which I allude. Nothing can be more capricious than they are: the same salt darkening rapidly to-day, which will to-morrow appear to be absolutely insensible to radiation, and which will again, in a few days, recover its sensitiveness, to lose it as speedily as before.

These notices will show the immense field of inquiry which photography has opened up, as fertile as it is extensive, in which every inquirer may be assured of the reward of discoveries of interest to science, and of importance to the arts.

### g. Dr. Schafhaeutl's Negative Process.

At the tenth meeting of the British Association for the Advancement of Science, two new processes on paper, and one on metal, were brought forward by Dr. Schafbaeutl. These processes involve some very delicate manipulatory details, which render them very tedious, and, in the hands of the inexperienced, uncertain. However, as they sometimes give very perfect results, it would have been improper to have omitted them.

Penny's improved patent metallic paper is recommended. This is spread with a concentrated solution of the nitrate of silver, (140 grains to 2½ drachms of fused nitrate, to 6 fluid drachms of distilled water,) by merely drawing the paper over the surface of the solution contained in a large dish. In order to convert this nitrate into a chloride, the author exposed it to the vapours of boiling muriatic acid. A coating of a chloride of silver, shining with a peculiar silky lustre, was by this method generated on the surface of the paper, without penetrating into its mass; and in order to give to this coating of chloride the highest degree of sensibility, it was dried, and then drawn over the surface of the solution of nitrate of silver again. After having been dried, the paper was ready for use, and no repetition of this treatment was able to improve its sensitiveness.

Even on the ordinary kinds of writing paper, I have found this

manipulation produce extreme sensitiveness, but much exact attention is required to prevent any excess of muriatic acid, which, in the state of vapour, is rapidly absorbed by the paper. The whole of the nitrate of silver employed in the first instance, must be converted into a muriate, and there the process should stop.

The Doctor's method of fixing, which I give here to avoid confusion, is also extremely difficult. The drawing is to be steeped for five or ten minutes in alcohol, and, after removing all superfluous moisture by means of blotting paper, and drying it slightly before the fire, the paper thus prepared is drawn through diluted muriatic acid, mixed with a few drops of an acid nitrate of quicksilver, prepared by dissolving quicksilver in pure nitric acid, and again dissolving the crystallised salt to saturation in water acidulated with nitric acid. The addition of the nitrate of mercury requires great caution, and its proper action must be tried first on slips of paper, upon which have been produced different tints and shadows by exposure to light; because if added in too great a quantity, the lightest shades entirely disappear. The paper having been drawn through the above mentioned solution, is well washed in water, and then dried in a degree of heat approaching to about 158° Fahr., or, in fact, till the white places assume a very slight tinge of yellow. The appearance of this tint indicates that the drawing is fixed permanently.

The author speaks of reversing these drawings by transfers, which I do not understand, and have never succeeded in doing with any thing like a good effect. The yellow tinge induced on the paper to give the drawing permanence, most effectually prevents the permeation of those rays of light which blacken the sensitive chloride of silver.

----

## B.—On the Methods of Using the Photographic Papers prepared with the Salts of Silver. Negative kind.

### a. On taking copies of Botanical Specimens, Engravings, &c.

For the multiplication of photographic drawings, it is necessary to be provided with a frame and glass, the most convenient size for which is about that of a single leaf of quarto post writing paper. The glass must be of such thickness as to resist some considerable pressure, and it should be selected as colourless as possible, great care being taken to avoid such as have a tint of yellow or red, these colours preventing the permeation of the most efficient rays. Figures 5 and 6 represent the frame, the one showing it in front as in taking a copy of leaves; and the other the back with its piece of stout tinned iron, which presses on a cushion, securing the close contact of the paper with every part of the object to be copied, and its brass bar, which, when pressed into angular apertures in the sides of the frame, gives the required pressure to the paper.

Fig. 5.                    Fig. 6.

Having placed the frame face downwards, carefully lay out on the glass the object to be copied, on which lay the photographic paper very smoothly. Having placed on this the cushion, which may be either of flannel or velvet, fix the metal back, and adjust it by the bar, until every part of the object and paper are in the closest contact. The frame might, for very particular purposes, be rendered more complete, by having the back adjusted with binding screws; but for all ordinary uses, the bar answers every purpose.

In placing botanical specimens, the under surface of the leaves should be next the glass, their upper and smooth surface in contact with the paper. Although very beautiful copies may be taken of dried specimens, they bear no comparison with those from fresh gathered leaves or plants, in which, with the most delicate gradations of shades, the nerves of the leaves, and the down clothing the stems, are exhibited with incomparable fidelity. In the event of the plant having any thick roots or buds, it will be best to divide them with a sharp knife, for the purpose of equalising the thickness in all parts, and ensuring close contact.

Engravings are to be placed with their faces to the prepared side of the paper, and laid very smoothly on the glass, and then with the cushion and back pressed into the closest contact possible; the least difference in the contact permitting the dispersion of light, occasions a cloudiness and want of sharpness in the photograph. Of course, a copy of any thing taken by means of the light which has passed through it, must present all the defects as well as all the beauties of the article, whatever it may be. A photographic copy of an engraving gives us, besides the lines of the engraving, all the imperfections of the paper: this renders it necessary that those engravings should be selected which are on tolerably perfect paper. If the preservation of the engraving is not a matter of much moment, by washing it over the back, with a varnish of Canada balsam and spirits of turpentine, it is rendered highly transparent, and, of course, the resulting impression is much improved. Care must, however, be taken, in using the varnish very thin, that it may not impart any yellow tinge to the paper. An exposure of a few minutes only, is sufficient to produce strong and faithful copies, during sunshine; in diffused daylight a longer period is necessary. A method of producing very beautiful *positive* photographs with the white papers, by making an etching on glass, will be described in the division of the work appropriated to the positive variety of these drawings.

E

### b. On using the Photographic paper in the Camera Obscura.

The most important object of the photographic art, is the securing the shadowy images of the camera obscura—the fixing of a shade, and multiplying its likeness. As this is the most important, so is it the department requiring the greatest care. It need scarcely be mentioned, that a camera obscura is a darkened chamber or box, to which light is admitted through a small hole in which a lens is fixed. In the ordinary cameras used by artists for sketching, a mirror is constantly used, which throws the image on a semitransparent table.

Fig. 7 is a section of such an instrument. *a à* represents the box, in

Fig. 7.

one end of which is fixed the lens *b.* The lenticular image falls on the mirror *c*, placed at such an angle that it is reflected on the plate of ground glass *d.* *e* is a screen to prevent the overpowering influence of daylight, which would render the picture almost invisible. This form of the apparatus, though very interesting as a philosophical toy, and extremely useful to the artist, is by no means fitted for photographic purposes. The light radiated from external objects, suffers considerable diminution of chemical power in penetrating the lens, and the reflection from the mirror so far reduces its intensity, that its action on photographic agents is infinitely slow. To obviate the objection of the reflected image, it is only necessary to place the photographic paper in the place of the mirror, but not in an angular position.

Fig. 8, represents the photographic camera of the common form;

Fig. 8.

*a à* is the outer box, in which is fixed the lens *b*, and *c ċ* another box sliding within it; at the inner end of which is placed the prepared paper *d;* by sliding this box forth and back, we are enabled to adjust the paper to the correct focus of the lens, which can be observed through a small hole at *e.*

The most sensitive pieces of paper being selected, by testing the

sheets in the manner suggested by Mr. Talbot, (page 12,) one of them is carefully fastened by the four corners to the inner box; and with the sensitive side towards the lens, is placed in the outer box, so that the most defined images fall on its surface.   In this position, it is left undisturbed a sufficient length of time to receive the impression, which is, of course, formed by the strong light of the sky, and all brilliantly illuminated objects.   These darken the paper to an extent corresponding with the quantity of light they radiate; thus the darkest portion of the picture is the sky, and the bright objects exhibit various gradations of darkness, while the shadows producing no action, leave the paper still white.

The length of time required to produce the best effect, is, of course, very variable, depending on the intensity of day light, and the sensibility of the paper.   It may, however, be stated, as a general guide, that with highly sensitive paper, in the sunshine of a summer *morning*, a good picture should be produced within thirty minutes; even with paper which is ordinarily sensitive, one hour is sufficient.   I have purposely given the most simple method of procuring photographs with the camera obscura, considering that many, by producing tolerable effects with a very inexpensive apparatus, and with little trouble, may be induced to take the additional pains requisite, to furnish them with the gems of the art; who, if annoyed with tedious processes in the first place, might abandon the pursuit in displeasure.

A camera of a very simple kind may be constructed out of a cigar box; a hole being pierced in one end of it, and fitted with a lens, the photographic paper may be pinned upon a stiff piece of card-board the size of the box, and placed in the focus of the lens.   It is necessary that the box be painted on the inside with a mixture of lamp black and stiff size, to prevent the reflection of the dispersed light.   Fig. 9, gives this arrangement.

Fig. 9.

Some of the most important results, relative to the chemical action of the different rays, have been arrived at with an apparatus of this kind; and Dr. Draper, of New-York, the first who succeeded in taking portraits by the Daguerréotype, used no other.   Daguerre's apparatus is sold at twenty guineas and upwards; here we find one of the most delicate of the photographic processes, accomplished with an instrument, the cost of which is only two or three shillings.

A description of a camera obscura of a superior kind, adapted for every photographic purpose, and comparatively inexpensive, will be found in another part of this treatise.

I would now direct particular attention to a few points of great importance, by following which, pictures of a very superior character may be produced. It is necessary that we should, in the first place, consider the character of the element with which we have to work—*Light*. Every beam of light which flows from its solar source is a bundle of rays, having each a very distinct character as to colour and its chemical functions. These rays are easily shown by allowing a pencil of sunlight to fall on the edge of a prism, by which an elongated image is obtained in the various colours of which it is constituted—red, orange, yellow,

Fig. 10.

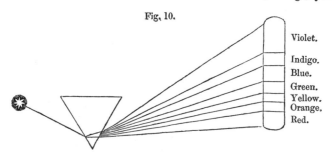

Violet.
Indigo.
Blue.
Green.
Yellow.
Orange.
Red.

green, blue, indigo, and violet. This coloured image is called the solar or the prismatic spectrum. The red ray, being the least refracted, is found at the beginning, and the violet, being the most so, at the extremity of the spectrum. Below the ordinarily visible red ray, another ray of a deeper red may be detected, by examining the rays through a deep blue glass; and by means of very delicate thermometers, it has been ascertained, that rays which do not affect our organs of vision, exist beyond these rays; whilst chemical compounds sensitive to light prove the existence of another class of rays far beyond the violet.

If we place a piece of sensitive paper in such a position that the spectrum falls upon it, it will be found to be very unequally impressed by the various rays. Some very extraordinary peculiarities have been

Picture produced.

Fig. 11.

Visible Spectrum.

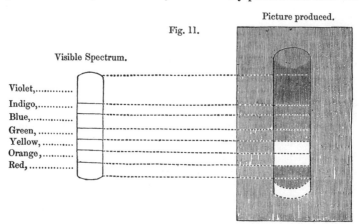

Violet,............
Indigo,............
Blue,...............
Green, ............
Yellow, ...........
Orange,............
Red, ...............

observed by Sir John Herschel and myself; but it will be sufficient for our present purpose to state the general features of the impression. Some distance below the visible red ray, the paper will be found quite uncoloured; on the part where the red ray fell, a tinting of *red or pink* will be evident. The orange and yellow rays leave no stain, and the green in general but a faint one. In the place occupied by the blue ray, the first decided darkening is evident, which increases through the indigo and violet rays, and extends some distance beyond them. The shaded wood-engraving, figure 11, will serve to assist this description.

I shall have occasion again to recur to this subject in my concluding summary.

It will be evident from what I have stated, that the maximum of chemical action exists between the blue, indigo, and violet rays; and it must be plain upon consideration, that the refrangibility of these rays being different, they must also have different focal distances, or in plainer terms, that there are differences in the distance from the lens, at which each dissevered ray has its maximum of action. For photographic purposes the indigo or violet rays are the ones with which we work with the best effect. Sir John Herschel insists on the necessity of using perfectly achromatic glasses, by which we unite all the rays into one focus. I have however found that the several reflecting and refracting surfaces of an achromatic lens retard the darkening action to some extent, and by simply adjusting the paper to the focus of the violet rays, I have produced pictures more speedily with a common double convex lens, than when I have used an achromatic one, and as well defined in all their parts. This plan was first suggested by Mr. John Towson of Devonport, before mentioned, and a paper on the subject was published by that gentleman in the London and Edinburgh Philosophical Magazine. It has since appeared, that Professor Draper is in the habit of using the same adjustment in taking portraits from the life by the Daguerréotype. A few experiments will prove the advantage of using, what may be called for want of better terms, the *chemical* instead of the *luminous* focus. Adjust the camera, so that the most perfect picture falls on the paper; note the time required to get a fair impression. Then having placed equally sensitive paper in the camera, bring it a little nearer the lens than before; under the same circumstances of light a better picture will be produced in a shorter period: by repeating this, a point will be arrived at, where the picture possesses greater sharpness of outline, and altogether exhibits a more decided effect. This is the focus required for photographic purposes. It will be found, in general, at about one fortieth of the whole focal distance, nearer the lens, than the true visible focus.

I have before mentioned, that on some papers, plates of glass have the property of deepening the tints; we may avail ourselves of this in using the camera. Experiment will also show, that the photographic paper darkens more readily when its sensitive coating is exposed to light still wet, than when it is allowed to dry before exposure; therefore a great improvement is, to keep papers for camera purposes prepared with the

first washes only, applying the last sensitive wash, the moment before it is exposed to luminous influence.  If, when wet, the paper is placed very carefully on a piece of perfectly clear plate glass, the wet side in contact with the glass, and then placed in the camera, the glass being between the paper and the lens, we avail ourselves of both the above advantages at the same time.  The paper must lie so close to the glass that perfect reflection is everywhere obtained; the minutest film of air between them admits of the dispersion of the light, and gives a cloudiness to the photograph.  Both Mr. Fox Talbot and Sir John Herschel are in the habit of adopting a similar manipulation.

It is worthy of notice that the morning sun, between the hours of eight and twelve, produces much better effects, than can be obtained after the hour of noon.  For drawings by application, this is but slightly, if at all felt, but with the camera it is of some consequence to attend to this fact.  We are not yet in a position to record more than the fact, the cause of the difference is not yet detected; probably it may be found to exist in a greater absorptive action of the atmosphere, caused by the elevation of aqueous vapour from the earth.  But the experiments of M. Malaguti seem to imply the contrary, this philosopher having found that the chemical rays permeate water more readily than they do air; some experiments of my own, are not, however, in accordance with M. Malaguti's results.  In the neighbourhood of large towns it might be accounted for, by the circumstance of the air becoming, during the day, more and more impregnated with coal smoke, &c., which offers very powerful interruption to the free passage of chemical light.  This will, however, scarcely account for the same being found to exist in the open country, some miles from any town.  Until our meteorological observers are in the habit of registering the variations of light, by means of some well devised instrument, we cannot expect to arrive at any very definite results.  The subject involves some matters of the first importance in photometry and meteorology, and it is to be desired that our public observatories should be furnished with the required instruments.

C.—On Fixing the Negative Photographs.

The power of destroying the susceptibility of a photographic agent to the further action of light, when the picture is completed by its influence, is absolutely necessary for the perfection of the art.  Various plans have been suggested for accomplishing this, which have been attended with very different results ; few if any of the materials used, producing the effect, and, at the same time, leaving the picture unimpaired.  The hyposulphite of soda is decidedly superior to every other fixing material; but it will be interesting to name a few others which may be used with advantage.

The pictures formed on papers prepared with the nitrate of silver

only, may be rendered quite insusceptible of change, by washing them in very pure water.  The water must be quite free from any muriate, as these salts attack the picture with considerable energy, and soon destroy it.

Photographs on the muriated papers are not however so easily fixed. Well soaking these in water, dissolves out the excess of nitrate of silver, and thus the sensibility is somewhat diminished; indeed, they may be considered as half-fixed, and may in this state be kept for any convenient opportunity of completing the operation.*

Muriate of soda (common salt) was recommended by Mr. Talbot as a fixing material, but it seldom is perfectly successful; as a cheap and easy method, it may be occasionally adopted, when the picture to be preserved is not of any particular consequence.

It may appear strange to many that the same material which is used to give sensitiveness to the paper should be applied to destroy it.  This may be easily explained: in the first instance, it assists in the formation of the chloride of silver, in the other, it dissolves out a large portion of that salt from the paper, the chloride being soluble in a strong solution of muriate of soda.  When common salt is used, the solution of it should be tolerably strong.  The picture being first washed in water, is to be placed in the brine, and allowed to remain in it for some little time; then, being taken out, is to be well washed in water, and slowly dried.  If the brine is used in a saturated state, the white parts of the photograph are changed to a pale blue—a tint which is not, in some cases, at all unpleasant.

The chloride of silver being soluble in solution of ammonia and some of its salts, they have been recommended for fixing photographs.  The ammonia, however, attacks the oxide, which forms the darkened parts, so rapidly, that there is great risk of its destroying the picture, or, at least, of greatly impairing it.  It matters not whether the solution of ammonia or its carbonate be used, but it must be considerably diluted. The only photographs on which I have used it with any success, are those prepared with the phosphate of silver, and to these it imparts a red tinge, which is fatal to their use for transfers.

The ferrocyanate of potash, or, as it is more commonly called, the prussiate of potash, converts the chloride into a cyanide of silver, which is not susceptible of change by light, consequently this cheap salt has been employed as a fixing agent, but most unfortunately, photographs which have been subjected to this preparation are slowly, but surely, obliterated in the dark.

The iodide of silver, which is readily formed by washing the photograph with a solution of the iodide of potassium, is scarcely sensitive to light; and this salt, used in the proportions of five or six grains to four

---

* I have found that the chloride of silver spread on paper, after being washed, slowly lost its sensibility to light.  I have by me at this time some pictures prepared two years since, which have had no other fixing, but which are now unchanged, by many days exposure to full sunshine.

or five ounces of water, answers tolerably well where transfers are not required. It tinges the white lights of the picture of a pale yellow, a colour which is extremely active in absorbing the chemical rays of light, and is therefore quite inapplicable where any copies of the original photograph are required, and in describing the hydriodated photographs, other objections will be noticed.

To use the hyposulphite of soda with effect, there are several precautions necessary. In the first place, all the free nitrate of silver must be dissolved out of the paper by well washing; the photograph is then to be dried, and being spread on a plane surface, is to be washed over on both sides with a saturated solution of the hyposulphite of soda. The picture must then be washed, by allowing a small stream of water to flow over it, at the same time dabbing it with a piece of soft sponge, until the water passes off perfectly tasteless. This operation should be repeated twice, or, in particular cases, even three times. The hyposulphite of soda has the property of dissolving a large quantity of several of the salts of silver, but particularly of the chloride, with which it combines, forming a triple salt of an exceedingly sweet taste. This salt is liable to spontaneous decomposition, accompanied with separation of silver in the state of sulphuret; hence the necessity of freeing the paper, by washing, of every trace of it, the sulphuret of silver being of a dirty brown. It might appear that the use of warm water would more effectually cleanse the paper; so far from it, it occasions the immediate formation of the sulphuret.

Where the colour is not an objection, the chromate of silver may be formed in the light parts, by washing the photograph with a solution of the bichromate of potash, by which we have a red picture on a dark ground.

In the repeated washings required to fix the photographic drawings, the paper is considerably injured, and much care is necessary to prevent it becoming torn in the process. An earthenware slab is at all times very convenient, on which to spread the paper during the different washings, and it is always the best plan to place the picture between folds of blotting paper to dry it.

The fixing materials all act to some extent on the darkened portions of the picture, but the more intense the light by which the colour was effected, the less are the shadows injured by their application.

---

## 3.—POSITIVE PHOTOGRAPHS.

### A.—On the Production of Photographs with correct Lights and Shadows by means of Transfers.

The negative photographs being, in their representation of lights and shadows, the reverse of nature, the paper being rendered, by darkening, opaque in those parts which have been acted on by the light, and

remaining transparent over the spaces occupied by shadows, it must be evident that a copy taken by application on the white paper, from such a photograph, must be the opposite of the original photograph, that is, it will exhibit shadows, demi-tints, and lights, in their correct order.

It will be found that a negative copy from an engraving, provided it be carefully taken, possesses all the sharpness of the original, however highly it is finished, but this is not the case with the second, or positive copy ; this will be fainter in its shadows, and will want that definedness of outline which is the great beauty of a picture.

The principal causes of this are, the want of perfect opacity in the darkened silver in which the picture is traced, the great difficulty of removing every portion of the silver from the transparent parts, and the imperfections of the paper, which are in general much increased by the processes to which it is subjected in the preparation of the ground and the fixing of the photographs.

Of course, if a negative photograph is intended to be used for multiplying an original design, it is essential that the utmost caution be observed in every part of the process. The shadows should be very deep, and of great sharpness, and the lights perfectly free of any stains. Having procured a negative photograph of the required excellence, we may proceed to take a copy of it in the same manner as I have directed engravings should be copied. This will, however, rarely give a photograph equalling in any respect the sharpness of the one of which it is a transfer. Had this been done, the great end of the photographic art would have been attained, and this treatise might have been illustrated by specimens of the art it attempts to describe.

There is another mode of proceeding which requires some care, but which produces a much better effect. Two negative photographs are taken from an engraving, and carefully fixed; they are then to be delicately adjusted, face to back, so that all their lines exactly correspond; being fastened in this position with fine needles, they are to be cemented together at the edges with a little gum, and kept under a slight pressure until quite dry. This double photograph may now be used to produce positive drawings from in the same manner as if single. I have found it advantageous to damp the paper in some cases, which increases its transparency, but it renders it liable to injury by dissolving out the nitrate from the paper with which it is put in contact. A plan of varnishing might, I have no doubt, be devised, which would prove highly advantageous, in the way of photographic transfers. It need scarcely be stated that these positive drawings require the same methods for fixing them as have already been described.

Owing to the faintness of the light which acts on the paper in the camera, the depth of shadow in the resulting photograph, is much less than in drawings procured by the direct rays of the sun; consequently, the transfer from a camera picture is still more imperfect than one from the other kinds of photographs. I have tried various plans to increase the effect, but none have been attended with very good results. It must

F

be evident that there are difficulties, almost insurmountable, in the way of adjusting two camera pictures in the manner above described. There are few objects on which the shadows would not vary in the time required for taking two pictures; and even where this objection is not much felt, it will be found extremely difficult to maintain the camera in exactly the same position during the removal of one, and the adjusting of another piece of sensitive paper.

Means must be sought for increasing the opacity of the shadows of the picture, without impairing the transparency of the brighter parts; in this way alone can we expect to arrive at the desired point with the delicate photographs of the camera obscura. It must be confessed that some of the specimens recently circulated by Mr. Fox Talbot, evidently produced by transfer from camera views, possess in a very high degree, many of the excellencies of those photographs taken by direct application from an original engraving.

It may not be amiss to mention two or three plans which I have tried for darkening the shadows, and which have been attended with some success; indeed, they appear to promise, with perseverance, all that we desire.

If, when the photographic drawing is properly fixed, we wash it over with a very dilute solution of hydriodate of potash, and expose it to the sun, a considerable degree of darkness is induced over the shadows of the picture. By well washing the photograph in warm salt and water, or a solution of the hyposulphite of soda, the iodine is removed, and if the first fixing has been properly managed, the lights are left uninjured. I have, in a few instances, succeeded in reviving metallic silver from the oxide, by exposing the drawing, moistened with water, to sulphuretted hydrogen. In this way, the most perfect opacity is produced, the shadows being formed by a coating of metalliferous sulphuret of silver.

By exposing the fixed photograph to iodine, and then to the action of light, I have occasionally succeeded in covering the dark parts with the vapour of mercury; but this process, though certainly practicable, requires further experiments to perfect it. Those who are provided with the apparatus for the Daguerréotype, will find the repetition of this process repay them. A few failures must be expected, but sometimes the labour will be rewarded by a singularly beautiful result.

---

B.—Positive Photographs from Etchings on Glass Plates.

A very easy method of producing any number of positive photographs from an original design, is in the power of every one having some slight artistic talent. The merit of having suggested the process I am about to describe, has been claimed by Messrs. Havell * and Wellmore, and also

* While these pages have been passing through the press, the death of this gentleman has been announced. He appears to have fallen a victim to his enthusiastic endeavours to apply photography and electrography to purposes of utility in his own art, that of an engraver.

by Mr. Talbot; indeed, there appears no reason to doubt the originality of either of these gentlemen, Mr. Havell having prosecuted his experiment in ignorance of the fact that Mr. Talbot had used the same means to diversify his photographic specimens.  Mr. Talbot proposes that a plate of warmed glass be evenly covered with a common etching ground, and blackened by the smoke of a candle.  The design is then to be made, by carefully removing from the glass all those parts which should represent the *lines* and *shadows*, and shading out the middle tints.  It will be evident that the light passing through the uncovered parts of the glass, and being obstructed by the covered portions, will impress on the white photographic papers a correct picture, having the appearance of a spirited ink drawing.

Mr. Havell's method was to place a thin plate of glass on the subject to be copied, upon which the high lights were painted with a mixture of white lead and copal varnish, the proportion of varnish being increased for the darker shading of the picture.  The next day Mr. Havell removed, with the point of a pen-knife, the white ground, to represent the dark etched lines of the original.  A sheet of prepared paper having been placed behind the glass, and thus exposed to light, a tolerable impression was produced; the half tints had, however, absorbed too much of the violet rays, an imperfection which was remedied by painting the parts over with black on the other side of the glass; if allowed to remain too long exposed to the sun's rays, the middle tints became too dark, and destroyed the effect of the sketch.  Another method employed by Mr. Havell was to spread a ground composed of white lead, sugar of lead, and copal varnish, over a plate of glass, and having transferred a pencil drawing in the usual manner, to work it out with the etching point.

Various modifications of these processes have been introduced by different artists, and it evidently admits of many very beautiful applications.  When the etching is executed by an engraver, the photograph has all the finish of a delicate copper-plate engraving.  The only thing which detracts from this method of photography is, that the great merit of self acting power is lost.

---

C.—On the Production of Positive Photographs by the use of the Hydriodic Salts.

A very short time after the publication of Mr. Talbot's processes, which I anxiously repeated with various modifications, I discovered a singular property in the hydriodate of potash of again whitening the paper darkened by exposure, and also, that the bleaching process was very much accelerated by the influence of light.  Early in the year 1839, Lassaigne, Mr. Talbot, Sir John Herschel, and Dr. Fyfe, appear to have fallen on the same discovery.

As this process, giving by one operation pictures with their lights correct, promised to be of much interest, I gave it for a very considerable time my undivided attention. The most extraordinary character of the hydriodic salts is, that a very slight difference in the strength of the solutions, in the composition of the photographic paper, or in the character of the incident light, produces totally opposite effects; in one case the paper is rapidly whitened, in the other a deep blackness is produced almost as rapidly. Sometimes these opposing actions are in equilibrium, and then the paper continues for a long time perfectly insensible.

The uncertainty attending the application of these salts, arising from the above cause, has greatly circumscribed their use as photographic agents. However, I am inclined to hope, that my researches have reduced to certainty their somewhat inconstant effects, and rendered this method of producing photographs one of the most easy, as it is the most beautiful. That the various positions I wish to establish may be completely understood, and to ensure the same results in other hands, it will be necessary to enter into a somewhat detailed account of the various kinds of paper used, and to give tolerably full directions for successfully using them, either in the camera, or for drawings by application,—to examine attentively the effects of different organic and inorganic preparations on the paper, and to analyse the influence of the different rays upon it.

These particulars will be copied chiefly from my paper " On the Use of the Hydriodic Salts as Photographic Agents," published in the London and Edinburgh Philosophical Magazine, for September and October, 1840, to which will be added, the results of my experience since that time.

The variable texture of the finest kinds of paper occasioning irregularities of imbibition, is a constant source of annoyance, deforming the drawings with dark patches, which are very difficult to remove ; consequently my first endeavours were directed to the formation of a surface, on which the photographic preparations might be spread with perfect uniformity.

A variety of sizes were used with very variable results. Nearly all the animal glutens appear to possess a colorific property, which may render them available in many of the negative processes, but they all seem to protect the darkened silver from the action of the hydriodic solutions. The gums are acted on by the nitrate of silver and browned, independent of light, which browning considerably mars the effect of the finished picture. It is a singular fact, that the tragacanth and acacia gums render the drawings much less permanent. I therefore found it necessary for general practice to abandon the use of all sizes, except such as enter into the composition of the paper in the manufacture. It occurred to me that it might be possible to saturate the paper with a metallic solution, which should be of itself entirely uninfluenced by light, on which the silver coating might be spread without suffering any

material chemical change. The results being curious, and illustrative of some of the peculiarities of the hydriodic salts, it will be interesting to study a few of them.

*Sulphate and Muriate of Iron.* These salts, when used in small proportions, appeared to overcome many of the first difficulties, but all the drawings on papers thus prepared faded out in the dark. If after these photographs have faded entirely out, they are soaked for a short time in a solution of the ferrocyanate of potash, and then are exposed to the light, the picture is revived, but with reversed lights and shadows.

*Acetate and Nitrate of Lead.* These salts have been much used by Sir John Herschel, both in the negative and positive processes, and, it appears, with considerable success. I found a tolerably good result when I used a *saturated* solution; but papers thus prepared required a stronger light than other kinds. When I used weaker solutions, the drawings were covered with black patches. On these a little further explanation is required. When the strong solution has been used, the hydriodic acid which has not been expended in forming the iodide of silver—which forms the lights of the picture—goes to form the iodide of lead. This iodide is soluble in boiling water, and is easily removed from the paper. When the weaker solution of lead has been used, instead of the formation of an iodide, the hydriodate exerts one of its peculiar functions in producing an oxide of the metal.

*Muriate and Nitrate of Copper.* These salts, in any quantities, render the action of the hydriodates very quick, and, when used in moderate proportions, they appeared to promise at first much assistance in quickening the process. I have obtained, with papers into the preparation of which nitrate of copper has entered, perfect camera views in ten minutes, but experience has proved their inapplicability, the edges of the parts in shadow being destroyed by chemical action.

*Chlorides of Gold and Platina* act similarly to each other. They remain inactive until the picture is formed, then a rapid oxidation of these metals takes place, and all the bright parts of the picture are darkened.

A very extensive variety of preparations, metallic and non-metallic, were used with like effects, and I am convinced that the only plan of obtaining a perfectly equal surface, without impairing the sensitiveness of the paper, is careful manipulation with the muriated and silver solutions.

By attention to the following directions, simple in their character, but arrived at by a long series of inquiries, any one may prepare photographic papers on which the hydriodic solutions shall act with perfect uniformity :—

Soak the paper for a few minutes in a muriated wash, removing with a soft brush any air-bubbles which may form on it. The superfluous moisture must be wiped off with very clean cotton cloths, and the papers dried at common temperatures. When dry, the paper must be pinned out on a board, and the silver solution spread over it boldly but lightly, with a very soft sponge brush. It is to be

*instantly* exposed to sunshine, and, if practicable, carried into the open air, as the more speedily evaporation proceeds, the less does the silver penetrate the paper, and the more delicate it is. The first surface is very irregular, being as before described, and represented in figure 2. As soon as the surface appears dry, the silver solution must be again applied as before, and the exposure repeated. It must now be exposed until a fine chocolate-brown colour is produced equally on all parts of the surface, and then, until required for use, be carefully preserved from the further influence of light. If the paper is to be kept long, the darkening must not be allowed to proceed so far as when it is to be speedily made use of.

In darkening these papers, the greatest possible attention must be paid to the quantity of light to which they are submitted, every thing depending on the rapidity of the blackening process. The morning sun should be chosen, for the reasons before stated. A perfectly cloudless sky is of great advantage. The injurious consequence of a cloud obscuring the sun during the *last* darkening process, is the formation of a surface which has the appearance of being washed with a dirty brush. This is with difficulty removed by the hydriodates, and the resulting pictures want that clearness which constitute their beauty. Papers darkened by the diffused light of a cloudy day, are scarcely, if at all, acted on by these salts. Great care must be taken to prevent the silver solution from flowing over the edges of the paper, as thereby an extra quantity of darkened silver is formed on both sides, which requires a long-continued action of the hydriodates and light to bleach.

The kind of paper on which the silver is spread, is an object of much importance. A paper known to stationers as satin post, double-glazed, bearing the mark of J. Whatman, Turkey Mill, is decidedly superior to every other kind I have tried. The dark specks which abound in some sorts of paper must be avoided, and the spots made by flies very carefully guarded against. These are of small consequence during the darkening process, but when the hydriodic wash is applied, they form centres of chemical action, and the bleaching process goes on around them, independently of light, deforming the drawing with small rings, which are continually extending their diameters.

The saline washes may be considerably varied, and combined to an indefinite extent, with a continued change of effect, which is singularly interesting. In their application we should be guided, as in the negative process, by their combining proportions. The following list of the salts which will give the best effects, selected from upwards of seven hundred combinations, will show the variety of colours produced. They are placed in the order of the sensitiveness they appear to maintain, when used as nearly as possible under the same circumstances.

<div align="center">Colour of Picture.</div>

Muriate of Ammonia,............*Red, changing to black in the sunshine.*
Chloride of Sodium,............    *Ditto.*          *ditto.*
Muriate of Strontia,..........*A fine brown.*

Colour of Picture.

MURIATE OF BARYTA,............*A rich brown, inclining to purple.*

SOL. CHLORIDE OF LIME,.........*Very red.*

SOL. CHLORIDE OF SODA,.........*A brick red.*

IODIDE OF POTASSIUM,............*Yellowish brown.*

CHLORATE OF POTASH,.........{ *Variable, sometimes yellowish, often of a steel blue.*

PHOSPHATE OF SODA,............*Mouse colour.*

TARTRATE OF SODA, ..............*Dark brown.*

URATE OF SODA,..................*Yellowish brown.*

MURIATE OF IRON,...............*Deep brown, which blackens.*

BROMIDE OF SODIUM, ............*Red brown, of a peculiarly rich tint.*

The change mentioned in the colour of the finished picture is that which arises from a fresh exposure to the solar rays; where no change is mentioned, it is too slight to be worth notice. This phenomenon will presently occupy our attention.

When papers prepared with any of the above, except the phosphates, are soaked for a little time in water, and dried in the sunshine, the picture produced, it matters not what hydriodate is used, is rendered peculiarly red, and does not change by re-exposure. By washing some of the papers with weak solution of ammonia, this peculiarity is produced in a very striking manner.

*The Solution of Silver.* Take of crystallized nitrate of silver 120 grains, distilled water 12 fluid drachms, when the salt is dissolved, add of alcohol 4 fluid drachms, which renders the solution opaque; after a few hours, a minute quantity of a dark powder, which appears to be an oxide of silver, is deposited, and must be separated by the filter. The addition of the alcohol to the solution was adopted from an observation I made of its influence in retarding the chemical action of the hydriodates on the salt of silver, which goes on in the shade. Its use is therefore to make the action depend more on *luminous influence* than would be the case without it.

*Nitric Ether.* The sweet spirits of nitre not only checks the bleaching process in the shade, but acts with the hydriodic salts to exalt the oxidation of the silver, or increase the blackness of it. In copying lace or any fine linear object, it is a very valuable agent, but it is useless for any other purposes, as all the faintly lighted parts are of the same tint.

*Hydrochloric Ether,* used as the solvent of the silver, and applied without any saline wash, has a similar property to the nitric ether, but as it is readily acted on by faint light, it is of greater value. However, papers prepared with it must be used within twenty-four hours, as after that they quickly lose their sensitiveness, and soon become nearly useless.

To fix with any degree of certainty the strength of the solution of the hydriodic salts, which will in all cases produce the best effects, appears to me impossible; every variety of light to which it has been exposed to darken, requiring a solution of different specific gravity.

*Hydriodates of Potash and Soda.* The former of these salts being more easily procured than any other of the hydriodates, is the one generally employed. The strength of the solution of these salts best adapted for the general kinds of paper, is thirty grains to an ounce of water. The following results will exhibit the different energies manifested by these solutions at several strengths, as tried on the same paper by the same light:—

|   |   |   |   |   |   |   |
|---|---|---|---|---|---|---|
| 120 grains of the salt to an ounce of water took to whiten the paper, ..................... } | | | | | 12 minutes. | |
| 100 | do. | do. | to | do. | 10 | do. |
| 80 | do. | do. | to | do. | 9 | do. |
| 60 | do. | do. | to | do. | 7 | do. |
| 40 | do. | do. | to | do. | 6 | do. |
| 30 | do. | do. | to | do. | 4 | do. |
| 20 | do. | do. | to | do. | 6 | do. |
| 10 | do. | do. | to | do. | 12 | do. |

The other hydriodic salts correspond nearly with these in their action; a certain point of dilution being necessary with all.

*Hydriodate of Ammonia*, if used on unsized paper, has some advantage as to quickness over either the salts of potash or soda. This preparation is, however, so readily decomposed, that the size of the paper occasions a liberation of iodine, and the consequent formation of yellow-brown spots.

*Hydriodate of Iron.* This metallic hydriodate acts with avidity on the darkened paper; but even in the shade its chemical energy is too great, destroying the sharpness of outline, and impairing the middle tints of the drawing. It also renders the paper very yellow.

*Hydriodate of Manganese* answers remarkably well when it can be procured absolutely free of iron. When the manganesic solution contains iron, even in the smallest quantities, light and dark spots are formed over the picture, which give it a curious speckled appearance.

*Hydriodate of Baryta* possesses advantages over every other *simple* hydriodic solution, both as regards quickness of action and the sharpness of outline. A solution may, however, be made still superior to it, by combining a portion of iron with it. Forty grains of the hydriodate of baryta being dissolved in one ounce of distilled water, five grains of very pure sulphate of iron should be added to it and allowed to dissolve slowly. Sulphate of baryta is precipitated, which should be separated by filtration, when the solution is composed of hydriodate of baryta and iron. By now adding a drop or two of diluted sulphuric acid, more baryta is precipitated, and a portion of hydriodic acid set free. The solution must be allowed to stand until it is clear, and then carefully decanted off from the sediment, as filtering paper decomposes the acid, and free iodine is liberated. By this means we procure a photographic solution of very active character. It should be prepared in small

quantities, as it suffers decomposition under the influences of the atmosphere and light.

*Hydriodic Acid*, if used on paper which will not decompose its aqueous solution, which is rather difficult to find, acts very readily on the darkened silver. A portion of this acid free in any of the solutions, most materially quickens the action. From the barytic solution it is always easy to set free the required portion, by precipitating the barytes by sulphuric acid. As the hydriodate of barytes is rarely kept by the retail chemist, it may be useful to give an easy method of preparing the solution of the required strength.

Put into a Florence flask one ounce of iodine, and cover it with one fluid ounce and half of distilled water; to this add half a drachm of phosphorus cut into small pieces; apply a very gentle heat until they unite, and the liquid becomes colourless; then add another fluid ounce and a half of water. It is now a solution of hydriodic acid and phosphoric acid. By adding carbonate of barytes to it, a phosphate of barytes is formed, which, being insoluble, falls to the bottom, whilst the soluble hydriodate of barytes remains dissolved. Make up the quantity of the solution to nine ounces with distilled water, and carefully preserve it in a green glass stoppered bottle.

---

### D.—Directions for taking Photographs.

For drawings by application, less care is required than for the camera obscura. With a very soft flat brush apply the hydriodic solution on both sides of the prepared paper, until it appears equally absorbed; place it in close contact with the object to be copied, and expose it to sunshine. The exposure should continue until the parts of the paper exposed to uninterrupted light, which first change to a pale yellow, are seen to *brown* a little. The observance of this simple rule will be found of very great advantage in practice. Immersion for a short time in soft water removes the brown hue, and renders the bright parts of the picture clearer than they would otherwise have been.

Engravings to be copied by this process,—which they are most beautifully,—should be soaked in water and superimposed on the photographic papers, quite wet. If the paper is intended to be used in the camera, it is best to soak it in the hydriodic solution until a slight change is apparent, from chemical action on the silver; it is then to be stretched on a slight frame of wood, which is made to fit the camera, and not allowed to touch in any part but at the edges; placed in the dark chamber of the camera at the proper focus, and pointed to the object of which a copy is required, which, with good sunshine, is effected in about twenty minutes, varying of course with the degree of sensibility which is manifested by the paper. If the wetted paper is placed upon any

G

porous body, it will be found, owing to the capillary communication established between different points, that the solution is removed from some parts to others, and different states of sensitiveness induced. Another advantage of the frame is, the paper being by the moisture rendered semi-transparent, the light penetrates and acts to a greater depth, thus cutting out fine lines which would otherwise be lost. However, if the camera is large, there is an objection to the frame; the solution is apt to gather into drops, and act intensely on small spots to the injury of the general effect. When using a large sheet, the safest course is to spread it out when wetted upon a piece of very clean *wet* glass, great care being taken that the paper and glass are in close contact. The picture is not formed so quickly when the glass is used, as when the paper is extended on a frame, owing to the evaporation being slightly retarded. The additional time required, about one-sixth longer, is, however, in most cases, of little consequence.

The picture being formed by the influence of light, it is required, to render it unchangeable by any further action of the luminous fluid, not only that the hydriodic salt be entirely removed from the paper, but that the iodide of silver which is formed, be also dissolved out of the drawing.

By well washing the drawing in warm water, the hydriodate is removed, and the pictures thus prepared have been stated to be permanent; and if they are kept in a portfolio, and only occasionally exposed, they are really so ; for I shall show presently, that they have the property of *being restored in the dark, to the state in which they were prior to the destructive action of light.* A drawing which I executed in June, 1839, which has often been exposed for days successively to the action of sunshine, and has altogether been very little cared for, continues to this date (March, 1841,) as perfect as at first. These photographs will not, however, bear *long-continued* exposure without injury—about three months in summer, or six weeks in winter, being sufficient to destroy them. As this gradual decay involves some very curious and interesting chemical phenomena, I shall make no excuse for dwelling on the subject a little.

The drawing fades first in the dark parts, and as they are perceived to lose their definedness, the lights are seen to darken, until at last the contrast between light and shadow is very weak.

If a dark paper is washed with an hydriodate and exposed to sunshine, it is first bleached, becoming yellow, then the light again darkens it. If, when quite dry, it is carefully kept from the light, it will be found in a few days to be again restored to its original yellow colour, which may be again darkened by exposure, and the yellow colour be again restored in the dark. The sensitiveness to the influence of light diminishes after each exposure, but I have not been enabled to arrive at the point at which this entirely ceases. If a dark paper, bleached by an hydriodate and light, be again darkened, and then placed in a bottle of water, the yellow is much more quickly restored, and bubbles

of gas will escape freely, which will be found to be oxygen. By enclosing pieces of hydriodated paper in a tube to darken, we discover, as might have been expected, some hydrogen is set free. If the paper is then well dried, and carefully shut up in a warm dry tube, it remains dark; moisten the tube or the paper, and the yellowness is speedily restored.

Take a photograph thus formed, and place it in a vessel of water, in *a few days* it will fade out, and bubbles of oxygen will gather around the sides. If the water is examined, there will be found no trace of either silver or iodine; thus it is evident the action has been confined to the paper.

We see that the iodide of silver has the power of separating hydrogen from its combinations. I cannot regard this singular salt of silver as a definite compound: it appears to me to combine with iodine in uncertain proportions. In the process of darkening, the liberation of hydrogen is certain; but I have not in any one instance been enabled to detect free iodine; of course it must exist, either in the darkened surface, or in combination with the unaffected under layer: possibly this may be the iodide of silver, with iodine in simple mixture, which, when light acts no longer on the preparation, is liberated, combines with the hydrogen of that portion of moisture which the hygrometric nature of the paper is sure to furnish, and as an hydriodate again attacks the darkened surface, restoring thus the iodide of silver. This is strikingly illustrative of the fading of the photograph.

The picture is formed of iodide of silver in its light parts, and oxide of silver in its shadows. As the yellow salt darkens under the influence of light, it parts with its iodine, which immediately attacks the dark oxide, and gradually converts it into an iodide. The *modus operandi* of the restoration which takes place in the dark is not quite so apparent. It is possible that the active agent LIGHT being quiescent, the play of affinities comes undisturbed into operation—that the dark parts of the picture absorb oxygen from the atmosphere, and restore to the lighter portions the iodine it has before robbed them of. A series of experiments on the iodide of silver, in its pure state, will still more strikingly exhibit this very remarkable peculiarity.

Precipitate with any hydriodate, silver, from its nitrate in solution, and expose the vessel containing it, liquid and all, to sunshine, the exposed surfaces of the iodide will blacken; remove the vessel into the dark, and *after a few hours*, all the blackness will have disappeared. We may thus continually restore and remove the blackness at pleasure. If we wash and then well dry the precipitate, it blackens with difficulty, and if kept quite dry, it continues dark, but moisten it, and the yellow is restored after a little time. In a watch-glass, or any capsule, place a little solution of silver, in another, some solution of any hydriodic salt, connect the two with a filament of cotton, and make up an electric circuit with a piece of platina wire, expose this little arrangement to the light, and it will be seen, in a very short time, that iodine is liberated

in one vessel, and the yellow iodide of silver formed in the other, which blackens as quickly as it is formed.

Place a similar arrangement in the dark, iodine is slowly liberated. *No iodide of silver is formed*, but around the wire a beautiful crystallization of metallic silver. Seal a piece of platina wire into two small glass tubes, these, when filled, the one with hydriodate of potash in solution, and the other with a solution of the nitrate of silver, reverse into two watch-glasses containing the same solutions, the glasses being connected with a piece of cotton. An exposure during a few hours to daylight, will occasion the hydriodic solution in the tube to become quite brown with liberated iodine, a small portion of the iodide of silver will form along the cotton, and at the end dipping in the salt of silver. During the night the hydriodic liquid will become again colourless and transparent, and the dark salt along the cotton will resume its native yellow hue.

Fig. 12.

From this it is evident that absolute permanence will not be given to these photographs until we succeed in removing from the paper all the iodide of silver formed. The hyposulphites dissolve iodide of silver, therefore it might have been expected, *a priori*, they would have been successful on these drawings. If they are washed over with the hyposulphite of soda, and then quickly rinsed in plenty of cold water, the drawing is improved, but no better fixed than with cold water alone. If we persevere in using the hyposulphite, the iodide is darkened by combining with a portion of sulphur, and the lights become of a dingy yellow, which is not at all pleasant.

No plan of fixing will be found more efficacious with this variety of photographic drawings, than soaking them for some hours in cold water, and then well washing them in hot water.

It often happens that a picture, when taken from the camera, is less distinct than could be desired: it should not however be rejected on that account. All the details exist, although not visible. In many cases the soaking is sufficient to call them into sight: if they cannot be so evoked, a wash of hartshorn, or muriatic acid, seldom fails to bring them up. Care, however, must be taken not to use them too strong, and the picture must be washed on the instant, to remove the acid or alkali.

One very singular property of these photographs is, that when first prepared, and after the washing, they are not fixed or otherwise; but when exposed to sunshine, they change in their dark parts from a red to a black. This peculiarity will be found by experiment to be entirely dependent on the influence of the red light, or that portion of the sunbeam which appears to have the greatest heating power—hence called the calorific rays.

I have before mentioned the peculiar state of equilibrium in which the paper is when wetted with the hydriodate, and that a slight difference in the incident light will either bleach or blacken the same sheet.

If four glasses, or coloured fluids be prepared, which admit respectively the blue, green, yellow and red rays, and we place them over an hydriodated paper, having an engraving superposed, it will be bleached under the influence of the blue light, and a perfect picture produced; while under the rays transmitted by the green glass, the drawing will be a negative one, the paper having assumed, in the parts which represent the lights, a very defined blackness. The yellow light, if pure, will produce the same effect, and the red light not only induces a like change, but occasions the dark parts of the engraving to be represented in strong lights: this last peculiarity is dependent on the heating rays, and opens a wide field for inquiry. My point now, however, is only to show that the darkening of the finished photograph is occasioned by the *least* refrangible rays of light; whereas, its preparation is effected by the *most* refrangible.

I know not of any other process which shows, in a way at once so decided and beautiful, the wonderful constitution of every beam of light which reaches us; yet this is but one of numerous results of an analogous character, produced by these opposite powers, both necessary to the constitution of the solar beam, which is poured over the earth, and effects those various changes which give to it diversified beauty, and renders it conducive to the wellbeing of animated creatures.

Before quitting this branch of the art, it will be interesting to examine the modifications which have been introduced by some continental inquirers.

M. Lassaigne, who has claimed priority in the use of the iodide of potassium, saturated his paper with a sub-chloride of silver, which was allowed to assume a violet-brown colour, and it was then impregnated with the iodidated solution.

M. Bayard simply allowed ordinary letter paper, prepared according to Mr. Talbot's method, to blacken by light. He then steeped it for some seconds in a solution of iodide of potassium, and laying it on a slate, he placed it in the camera.

M. Verignon introduced a somewhat more complicated process. His directions are,—White paper should first be washed with water acidulated by hydrochloric (muriatic) acid, then, after being well dried, steeped in the following solution:—Water fourteen parts, with one part of a compound formed of two parts of muriate of ammonia, two parts of bromide of sodium, and one of chloride of strontium. The paper dried again is passed into a very weak solution of nitrate of silver. There is thus formed, by double decomposition, a chloride and bromide of silver, which is made to turn black by exposing the paper to the light for about half-an-hour. To use this paper, it is steeped in a very weak solution of the iodide of sodium, and placed, quite wet, into the camera obscura, at the proper focus. In fine weather, M. Verignon states, the effect is produced in twelve minutes. I have, however, never produced a good picture by this process in less than thirty minutes. A great objection to this mode of preparation is the very rapid deterioration of

the paper; every day it will become less and less sensitive to light, and at the end of a fortnight it is useless.

The papers recommended for use in the former pages, have the advantage of keeping well, provided ordinary care is taken with them. It is necessary to exclude them from the light—to keep them very dry —and, as much as possible, they should be protected from the action of the air. I have kept papers, prepared with the muriate of ammonia, baryta, and strontia, for twelve months, and have found them but very little impaired.

Dr. Schafhaeutl allows paper prepared in the way mentioned at a former page, to darken in a bright sun light. It is then macerated for at least half-an-hour, in a liquid prepared by mixing one part of the already described acid nitrate of mercury, with nine or ten parts of alcohol. A bright lemon yellow precipitate of basic hyponitrate of the protoxide of quicksilver falls, and the clear liquor is preserved for use. The macerated paper is removed from the alcoholic solution, and quickly drawn over the surface of diluted muriatic acid, (one part strong acid to seven or ten of water,) then quickly washed in water, and slightly and carefully dried at a heat not exceeding 212° of Fahr. The paper is now ready for being bleached by the rays of the sun; and, in order to fix the drawing, nothing more is required than to steep the paper a few minutes in alcohol, which dissolves the free bichloride of mercury. I must confess, however, that in my hands the process has not been so successful as it is described to have been by the author of it.

It is perhaps necessary to remark, that we cannot multiply designs from an original hydriodated photograph. The yellow colour of the paper is of itself fatal to transfers, and independently of this, the wet hydriodic solution would immediately destroy any superposed photograph.

We have seen in a former chapter that the white photographic papers are darkened by the blue, indigo, and violet rays. On the dark papers

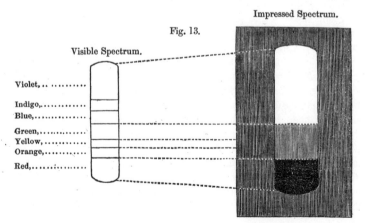

Fig. 13.

Visible Spectrum.

Impressed Spectrum.

Violet, .. ..........

Indigo, ...........
Blue, ..............

Green, .............
Yellow, ...........
Orange, ..........

Red, ...............

washed with the hydriodic salts in solution, the bleaching is effected most energetically by the violet rays; it proceeds with lessening intensity to the blue, while all the rays below the yellow have a darkening influence on the paper. This effect will be best illustrated by figure 13.

The remarkable manner in which the point of greatest intensity is shifted from the blue to the violet, when papers have but a very slight difference in their composition or mode of preparation, is an extremely curious point of philosophical inquiry. It will be evident from what has been said, that it is necessary the focus of the violet rays should be always chosen in using the hydriodated papers in the camera.

# PROCESSES ON METALLIC AND GLASS TABLETS

## 1.—HELIOGRAPHY.

M. Niepce was the first inquirer who appears to have produced permanent pictures by the influence of the sun's rays. This process—Heliography—is in many respects peculiar, which renders it necessary, although his preparation was only acted on by an exposure of many hours to full sunshine, to give a particular account of it; the more so, as some points of considerable interest require further elucidation.

The substance employed by M. Niepce was *asphaltum*, or bitumen of Judea. He thus directs its preparation:—" I about half fill a wine-glass with this pulverised bitumen, I pour upon it, drop by drop, the essential oil of lavender,* until the bitumen is completely saturated. I afterwards add as much more of the essential oil as causes the whole to stand about three lines above the mixture, which is then covered and submitted to a gentle heat until the essential oil is fully impregnated with the colouring matter of the bitumen. If this varnish is not of the required consistency, it is to be allowed to evaporate slowly, without heat, in a shallow dish, care being taken to protect it from moisture, by which it is injured, and at last decomposed. In winter, or during rainy weather, the precaution is doubly necessary. A tablet of plated silver is to be highly polished, on which a thin coating of the varnish is to be applied cold, with a light roll of very soft skin ; this will impart to it a fine vermilion colour, and cover it with a very thin and equal coating. The plate is then placed upon heated iron, which is wrapped round with several folds of paper, from which by this method all moisture had been previously expelled. When the varnish has ceased to simmer, the plate is withdrawn from the heat, and left to cool and dry in a gentle tempera-ture, and protected from a damp atmosphere. In this part of the operation a light disc of metal, with a handle in the centre, should be held before the mouth, in order to condense the moisture of the breath."

The plate thus prepared is now in a fit state for use, and may be immediately fixed in the correct focus of the camera. After it has been exposed a sufficient length of time for receiving the impression, a very faint outline alone is visible. The next operation is to bring out the hidden picture, which is accomplished by a solvent.

* The English oil of lavender is too expensive for this purpose. An article sold as the French oil of lavender, redrawn, is very much cheaper, and answers in every respect as well, if not better.

This solvent must be carefully adapted to the purposes for which it is designed; it is difficult to fix with certainty the proportions of its components; but in all cases it is better that it be too weak than too strong,—in the former case the image does not come out strongly,—in the latter it is completely destroyed. The solution is prepared of one part—not by weight, but volume—of the essential oil of lavender, poured upon ten parts—by measure also—of oil of white petroleum. The mixture, which is first milky, becomes clear in two or three days. This compound will act until it becomes saturated with the asphaltum, which state is readily distinguished by an opaque appearance, and dark brown colour. A tin vessel somewhat larger than the photographic tablet, and one inch deep, must be provided. This is to have as much of the solvent in it as will cover the plate. The tablet is plunged into the solution, and the operator, observing it by reflected light, begins to see the images of the objects, to which it has been exposed, slowly unfolding their forms, though still veiled by the gradually darkening supernatant fluid. The plate is then lifted out, and held in a vertical position, till as much as possible of the solvent has been allowed to drop away. When the dropping has ceased, we proceed to the last, and not the least important operation, of washing the plate.

Fig. 14.

This is performed by carefully placing the tablet upon a long board, fixed at a large angle, the supports being joined to it by hinges, to admit of the necessary changes of inclination, under different circumstances; two small blocks, not thicker than the tablet, are fixed on the board, on which the plate rests. Water must now be slowly poured upon the upper part of the board, and allowed to flow evenly over the surface of the picture. The descending stream clears away all the solvent that may yet adhere to the varnish. The plate is now to be dried with great care by a gentle evaporation: to preserve the picture, it is requisite to cover it up from the action of light, and protect it from humidity.

The varnish may be applied indifferently to metals, stone, or glass; but M. Niepce prefers copper plated with silver. To take copies of engravings, a small quantity of wax is dissolved in essential oil of lavender, and added to the varnish already described—the engraving, first varnished over the back, is placed on the surface of the prepared tablet, face towards it, and then exposed to the action of the light. In the camera obscura an exposure of from six to eight hours, varying with the intensity of light, is required; while, from four to six hours is

H

necessary to produce a copy of an engraving. The picture, in the first instance, is represented by the contrast between the polished silver and the varnish coating. The discoverer afterwards adopted a plan of darkening the silver by iodine, which appears to have led the way to Daguerre's beautiful process. To darken the tablet, it was placed in a box in which some iodine was strewed, and watched until the best effect was produced. The varnish was afterwards removed by spirit of wine.

Of the use of glass plates, M. Niepce thus speaks:—" Two experiments in landscape upon glass, by means of the camera, gave me results which, although imperfect, appear deserving of notice, because this variety of application may be brought more easily to perfection, and in the end become a most interesting department of Heliography.

" In one of these trials the light acted in such a way that the varnish was removed in proportion to the intensity with which the light had acted, and the picture exhibited a more marked gradation of tone, so that, viewed by transmitted light, the landscape produced, to a certain extent, the well known effects of the diorama.

" In the second trial, on the contrary, the action of the luminous fluid having been more intense, the parts acted upon by the strongest lights, not having been attacked by the solvent, remained transparent; the difference of tone resulted from the relative thickness of the coatings of varnish.

" If this landscape is viewed by reflection in a mirror, on the varnished side, and at a certain angle, the effect is remarkably striking; while, seen by transmitted light, it is confused and shapeless: but, what is equally surprising, in this position the mimic tracery seems to affect the local colour of the objects."

A statement that M. Niepce was enabled to engrave by light, went the round of the press; but this does not appear to have been the case. All that the author of Heliography effected, was the etching of the plate, after it had undergone its various processes, and the drawing was completed, by the action of nitric acid in the usual manner ; the parts of the copperplate protected by the varnish remained, of course, unacted on, whilst the other parts were rapidly attacked by the acid. The author remarks that his process cannot be used during the winter season, as the cold and moisture renders the varnish brittle, and detaches it from the glass or metal.

M. Niepce afterwards used a more unctuous varnish, composed of *bitumen from Judea, dissolved in animal oil of Dippel,* an article which it is rather difficult to obtain in England. This composition is of much greater tenacity and higher colour than the former, and, after being applied, it can immediately be submitted to the action of light, which appears to render it solid more quickly, from the greater volatility of the animal oil. M. Daguerre remarks, that this very property diminishes still further the resources of the process as respects the lights of the drawings thus obtained. These processes of M. Niepce were much

improved by M. Daguerre, who makes the following remarks on the subject.—

The substance which should be used in preference to bitumen, is the residuum obtained by evaporating the essential oil of lavender, which is to be dissolved in alcohol, and applied in an extremely thin wash. Although all bituminous and resinous substances are, without any exception, endowed with the same property—that of being affected by light—the preference ought to be given to those which are the most unctuous, because they give greater firmness to the drawings. Several essential oils lose this character when they are exposed to too strong a heat.

It is not, however, from the ease with which it is decomposed, that we are to prefer the essential oil of lavender. There are, for instance, the resins, which, being dissolved in alcohol, and spread upon glass or metal, leave, by the evaporation of the spirit, a very white and infinitely sensitive coating. But this greater sensibility to light, caused by a quicker evaporation, (?) renders also the images obtained, much more liable to injury from the agent by which they were created. They grow faint, and disappear altogether, when exposed but for a few months to the sun. The residuum of the essential oil of lavender is more effectually fixed, but even this is not altogether uninfluenced by the eroding effects of a direct exposure to the sun's light.

The essence is evaporated in a shallow dish by heat, till the resinous residuum acquires such a consistency, that when cold it rings on being struck with the point of a knife, and flies off in pieces when separated from the dish. A small quantity of this material, is afterwards to be dissolved in alcohol or ether; the solution formed should be transparent, and of a lemon-yellow colour. The clearer the solution, the more delicate will be the coating on the plate; it must not, however, be too thin, because it could not thicken or spread out into a white coat; indispensable requisites for obtaining good effects in photographic designs. The use of the alcohol or ether, is to facilitate the application of the resin under a very attenuated form, the spirit being entirely evaporated before the light effects its delineations on the tablet. In order to obtain greater vigour, the metal ought to have an exquisite polish. There is more charm about sketches taken on glass plates, and above all, much greater delicacy.

Before commencing operations, the experimenter must carefully clean his glass or metal plate. For this purpose, emery, reduced to an impalpable powder, mixed with alcohol, may be used; applying it by means of cotton-wool: but this part of the process must always be concluded by dry-polishing, that no trace of moisture may remain on the tablet. The plate of metal or glass being thus prepared, in order to supply the wash or coating, it is held in one hand, and with the other, the solution is to be poured over it from a flask or bottle having a wide mouth, so that it may flow rapidly and cover the whole surface. It is at first necessary to hold the plate a little inclined; but as soon as the solution is poured on, and has ceased to flow freely, it is raised

perpendicularly. The finger is then passed behind and below the plate, in order to draw off a portion of the liquid, which, tending always to ascend, would double the thickness of the covering; the finger must be wiped each time, and be passed very rapidly along the whole length of the plate from below, and on the side opposite the coating. When the liquid has ceased to run, the plate is dried in the dark. The coating being well dried, it is to be placed in the camera obscura. The time required to procure a photographic copy of a landscape is from seven to eight hours; but single monuments strongly illuminated by the sun, or very bright in themselves, are copied in about three hours.

When operating on glass, it is necessary, in order to increase the light, to place the plate upon a piece of paper, with great care, that the connection is perfect over every part, as, otherwise, confusion is produced in the design by imperfect reflection.

It frequently happens that when the plate is removed from the camera, there is no trace of any image upon its surface—it is therefore necessary to use another process to bring out the hidden design.

To do this, provide a tin vessel, larger than the tablet, having all round a ledge or border 50 millimeters (2 English inches) in depth. Let this be three quarters full of the oil of petroleum; fix your tablet by the back to a piece of wood which completely covers the vessel, and place it so that the tablet, face downwards, is over but not touching the oil. The vapour of the petroleum penetrates the coating of the plate in those parts on which the light has acted feebly—that is, in the portions which correspond to the shadows, imparting to them a transparency, as if nothing were there. On the contrary, the points of the resinous coating, on which light has acted, having been rendered impervious to the vapour, remain unchanged.

The design must be examined from time to time, and withdrawn as soon as a vigorous effect is obtained. By urging the action too far, even the strongest lights will be attacked by the vapour, and disappear, to the destruction of the piece. The picture, when finished, is to be protected from the dust, by being kept covered with a glass, which also protects the silver plate from tarnishing.

It may perhaps appear to some that I have needlessly given the particulars of a process, now entirely superseded by others, possessing the most infinite sensibility—producing in a few minutes a better effect than was given by the HELIOGRAPHIC process in several hours. There are, however, so many curious facts connected with the action of light on these resins, that no treatise on Photography could be considered complete without some description of them.

M. Daguerre makes the remark, that numerous experiments tried by him prove that light cannot fall upon a body without leaving traces of decomposition; and they also demonstrate that these bodies possess the power of renewing in darkness, what has been lost by luminous action, provided total decomposition has not been effected.

In my description of the Hydriodic processes, I have shown that restoration is effected in the dark on a metallic oxide in a way which somewhat resembles that observed by M. Daguerre.

That light, the element which gives beauty to our planet, and sheds gladness over all things, by the touch of its Ithuriel wand, should be so active a destroyer, is a strange, a startling fact—to support which we have, independently of the discoveries of the photologist, abundant evidence in the physiology of the vegetable and the animal kingdoms.

## 2.—DAGUERRÉOTYPE.

### A.—ORIGINAL PROCESS OF DAGUERRE.

FROM the primary importance of this very beautiful branch of the Photographic art, I shall devote a considerable space to a description of the original process, and add thereto some account of each improvement which has been published, having any practical advantage, either by lessening the labour required, or reducing the expense.

The pictures of the Daguerréotype are executed upon thin sheets of silver plated on copper. Although the copper serves principally to support the silver foil, the combination of the two metals appears to tend to the perfection of the effect. It is essential that the silver be very pure. The thickness of the copper should be sufficient to maintain perfect flatness, and a smooth surface; so that the images may not be distorted by any warping or unevenness. Unnecessary thickness is to be avoided, on account of the weight.

The process is divided into five operations. The first consists in cleaning and polishing the plate, to fit it for receiving the sensitive coating on which light forms the picture. The second is the formation of the sensitive *ioduret of silver* over the face of the tablet. The third is the adjusting of the plate in the camera obscura, for the purpose of receiving the impression. The fourth is the bringing out of the Photographic picture, which is invisible when the plate is taken from the camera. The fifth and last operation is to remove the sensitive coating, and thus prevent that susceptibility of change under luminous influence, which would otherwise exist, and quickly destroy the picture.

### FIRST OPERATION.

A SMALL phial of olive oil—some finely carded cotton—a muslin bag of finely levigated pumice—a phial of nitric acid, diluted in the proportion of one part of acid to sixteen parts of water, are required for this operation. The operator must also provide himself with a small spirit lamp, and an iron wire frame, upon which the plate is to be placed whilst being heated over the lamp. The following figures represent this frame. The first view is as seen from above. The second is a sec-

Fig. 15.

tion and elevation, showing the manner in which it is fixed.

The plate being first powdered over with pumice, by shaking the bag, a piece of cotton, dipped into the olive oil, is then carefully rubbed over it with a continuous circular motion, commencing from the centre. When the plate is well polished, it must be cleaned by powdering it all over with pumice, and then rubbing it with dry cotton, always rounding and crossing the strokes, it being impossible to obtain a true surface by any other motion of the hand.

The surface of the plate is now rubbed all over with a pledget of cotton, slightly wetted with the diluted nitric acid. Frequently change the cotton, and keep rubbing briskly, that the acid may be equally diffused over the silver, as, if it is permitted to run into drops, it stains the tablet. It will be seen when the acid has been properly diffused, from the appearance of a thin film equally spread over the surface. It is then to be cleaned off with a little pumice and dry cotton.

The plate is now placed on the wire frame—the silver upwards, and the spirit lamp held in the hand, and moved about below it, so that the flame plays upon the copper. This is continued for five minutes, when a white coating is formed all over the surface of the silver; the lamp is then withdrawn. A charcoal fire may be used instead of the lamp. The plate is now cooled *suddenly*, by placing it on a mass of metal, or a stone floor. When perfectly cold, it is again polished with dry cotton and pumice. It is necessary that acid be again applied two or three times, in the manner before directed, the dry pumice being powdered over the plate each time, and polished off gently with dry cotton. Care must be taken not to breathe upon the plate, or touch it with the fingers, for the slightest stain upon the surface will be a defect in the drawing. It is indispensable that the last operation with the acid be performed

Fig. 16.

immediately before it is intended for use. Let every particle of dust be removed, by cleaning all the edges and the back also with cotton. After the first polishing, the plate is fixed on a board by means of four fillets, BBBB, of plated copper. To each of these is soldered two small projecting pieces, which hold the tablet near the corners; and the whole is retained in a proper position by means of screws, as represented at DDDD.

### SECOND OPERATION.

It is necessary for this operation, which is really the most important

of all, that a box, similar to figs. 17 and 18 be provided. Figure 17 represents a section, supposed to pass down the middle of the apparatus by the line A B, in fig. 18, which represents the box as seen from above. C is a small lid which accurately fits the interior, and

Fig. 17.　　　　　　　　　　　　Fig. 18.

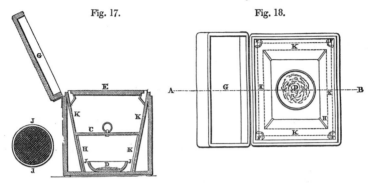

divides the box into two chambers. It is kept constantly in its place when the box is not in use—the purpose of it being to concentrate the vapour of the iodine, that it may act more readily upon the plate when it is exposed to it. D is the little capsule in which the iodine is placed, which is covered with the ring, J, upon which is stretched a piece of fine gauze, by which the particles of iodine are prevented from rising and staining the plate, while the vapour, of course, passes freely through it. E is the board with the plate attached, which rests on the four small projecting pieces, F fig. 18. G is the lid of the box, which is kept closed, except when the plate is removed or inserted. H represents the supports for the cover C. K, tapering sides all round, forming a funnel-shaped box within.

To prepare the plate:—The cover, C, being taken out, the cup, D, is charged with a sufficient quantity of iodine, broken into small pieces, and covered with the gauze, J. The board, E, is now, with the plate attached, placed, face downwards, in its proper position, and the box carefully closed.

In this position the plate remains until the vapour of the iodine has produced a definite golden yellow colour, nothing more nor less.* If the operation is prolonged beyond the point at which this effect is produced, a violet colour is assumed, which is much less sensitive to light; and if the yellow coating is too pale, the picture produced will prove very faint in all its parts. The time for this cannot be fixed, as it depends entirely on the temperature of the surrounding air. No artificial heat must be applied, unless in the case of elevating the temperature of an apartment

* If a piece of iodine is placed on a silver tablet, it will speedily be surrounded with coloured rings: *two yellow* rings will be remarked, one without and the other within the circle. The outside yellow ring alone is sensitive to light. This experiment will show the necessity of stopping the process of iodidation as soon as the first yellow is formed over the surface of the silver.

in which the operation may be going on. It is also important that the temperature of the inside of the box should be the same as it is without, as otherwise a deposition of moisture is liable to take place over the surface of the plate. It is well to leave a portion of iodine always in the box; for, as it is slowly vaporized, it is absorbed by the wood, and when required it is given out over the more extended surface more equally, and with greater rapidity.

As, according to the season of the year, the time for producing the required effect may vary from five minutes, to half an hour or more, it is necessary, from time to time, to inspect the plate. This is also necessary, to see if the iodine is acting equally on every part of the silver, as it sometimes happens that the colour is sooner produced on one side than on the other, and the plate, when such is the case, must be turned one quarter round. The plate must be inspected in a darkened room, to which a faint light is admitted in some indirect way, as by a door a little open. The board being lifted from the box with both hands, the operator turning the plate towards him rapidly, observes the colour. If too pale, it must be returned to the box; but if it has assumed the violet colour it is useless, and the whole process must be again gone through.

From description, this operation may appear very difficult; but with a little practice the precise interval necessary to produce the best effect is pretty easily guessed at. When the proper yellow colour is produced, the plate must be put into a frame, which fits the camera obscura, and

Fig. 19.                                        Fig. 20.

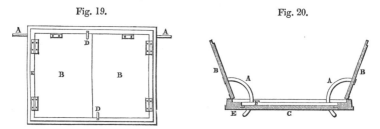

the doors are instantly closed upon it, to prevent the access of light. The figures represent this frame, fig. 19, with the doors, B B, closed on the plate; and fig. 20, with the doors opened by the half circles, A A. D D, are stops by which the doors are fastened until the moment when the plate is required for use. The third operation should, if possible, immediately succeed the second: the longest interval between them should not exceed an hour, as the iodine and silver lose their requisite photogenic properties.* It is necessary to observe, that the iodine ought never to be touched with the fingers, as we are very liable to injure the plate by touching it with the hands thus stained.

* This is contrary to the experience of the author of this volume; and Dr. Draper of New York states, that he has found the plates improve by keeping a few hours before they are used.

### THIRD OPERATION.

THE third operation is the fixing of the plate at the proper focal distance from the lens of the camera obscura, and placing the camera itself in the right position for taking the view we desire. Fig. 21 is

Fig. 21.

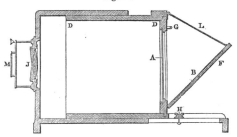

a perpendicular section, lengthwise, of Daguerre's camera. A is a ground glass by which the focus is adjusted; it is then removed, and the photographic plate substituted, as in C, fig. 22. B is a mirror for observing the effects of objects, and selecting the best points of view. It is inclined at an angle of 45°, by means of the support, L. To adjust the focus, the mirror is lowered, and the piece of ground glass, A, used. The focus is easily adjusted by sliding the box, D, out or in, as represented in the plate. When the focus is adjusted, it is retained in its place by means of the screw, H. The object glass, J, is achromatic and periscopic; its diameter is about one inch, and its focal distance rather more than fourteen inches. M is a stop a short distance from the lens, the object of which is to cut off all those rays of light which do not come directly from the object to which the camera is directed. This instrument reverses the objects—that which is to the right in nature being to the left in the photograph. This can be remedied by using a mirror outside, as K J, in figure 22. This arrangement, however, reduces the quantity of light, and increases the time of the operation one-third. It will, of course, be adopted only when there is time to spare. After having placed the camera in front of the landscape, or any object of which we desire the representation, our first attention must be to adjust the plate at such a distance from the lens, that a neat and sharply defined picture is

Fig. 22.

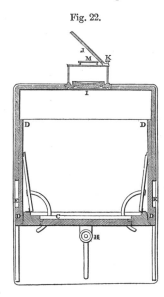

I

produced. This is, of course, done by the obscured glass. The adjust-
ment being satisfactorily made, the glass is removed, and its place sup-
plied by the frame containing the prepared plate, and the whole secured
by the screws. The doors are now opened by means of the half circles,
and the plate exposed to receive the picture. The length of time neces-
sary for the production of the best effect, varying with the quantity
of light, is a matter which requires the exercise of considerable judg-
ment, particularly as no impression is visible upon the tablet when it is
withdrawn from the camera. At Paris this varies from three to thirty
minutes. The most favourable time is from seven to three o'clock. A
drawing which, in the months of June and July, may be taken in three
or four minutes, will require five or six in May or August, seven or
eight in April and September, and so on, according to the season.
Objects in shadow, even during the brightest weather, will require
twenty minutes to be correctly delineated. From what has been stated,
it will be evident that it is impossible to fix, with any precision, the
exact length of time necessary to obtain photographic designs; but by
practice we soon learn to calculate the required time with considerable
correctness. The latitude is, of course, a fixed element in this calcula-
tion. In the sunny climes of Italy and southern France, these designs
may be obtained much more promptly than in the uncertain clime of
Great Britain. It is very important that the time necessary is not ex-
ceeded,—prolonged solarization has the effect of blackening the plate,
and this destroys the clearness of the design. If the operator has
failed in his first experiment, let him immediately commence with an-
other plate; correcting the second trial by the first, he will seldom fail
to produce a good photograph.

### FOURTH OPERATION.

THE apparatus required in this opera-
tion is represented by fig. 23. A, is the
lid of the box; B, a black board with
grooves to receive the plate; C, cup
containing a little mercury, J; D, spirit
lamp; F, thermometer; G, glass through
which to inspect the operation; H, tablet
as removed from the camera; I, stand for
the spirit lamp. All the interior of this
apparatus should be covered with hard
black varnish. The board and the affixed
plate being withdrawn from the camera,
are placed at an angle of about 45° within
this box—the tablet with the picture
downwards, so that it may be seen through
the glass G. The box being carefully
closed, the spirit lamp is to be lighted
and placed under the cup containing the

Fig. 23.

mercury. The heat is to be applied until the thermometer, the bulb of which is covered with the mercury, indicates a temperature of 60° centigrade, (140° Fahr.) The lamp is then withdrawn, and if the thermometer has risen rapidly, it will continue to rise without the aid of the lamp; but the elevation ought not to be allowed to exceed 75° cent. (167° Fahr.)

After a few minutes, the image of nature impressed, but till now invisible, on the plate, begins to appear; the operator assures himself of the progress of this development by examining the picture through the glass, G, by a taper, taking care that the rays do not fall too strongly on the plate, and injure the nascent images. The operation is continued till the thermometer sinks to 45° cent. (113° Fahr.) When the objects have been strongly illuminated, or when the plate has been kept in the camera too long, it will be found that this operation is completed before the thermometer has fallen to 55° Cent. (131° Fahr.) This is, however, always known by observing the sketch through the glass.

Fig. 24.

After each operation the apparatus is carefully cleaned in every part, and in particular the strips of metal which hold the plate are well rubbed with pumice and water, to remove the adhering mercury and iodine. The plate may now be deposited in the grooved box, (figure 24,) in which it may be kept, excluded from the light, until it is convenient to perform the last fixing operation.

### FIFTH OPERATION.

THIS process has for its object the removal of the iodine from the plate of silver, which prevents the further action of the light.

A saturated solution of common salt may be used for this purpose, but it does not answer near so well as a weak solution of the hyposulphite of soda. In the first place, the plate is to be placed in a trough of water, plunging and withdrawing it immediately; it is then to be plunged into one of the above saline solutions, which would act upon the drawing if it was not previously hardened by washing in water.

To assist the effect of the saline washes, the plate must be moved to and fro, which is best done by passing a wire beneath the plate. When the yellow colour has quite disappeared, the plate is lifted out, great care being taken that the impression is not touched, and it is again plunged into water. A vessel of warm distilled water, or very pure rain water boiled and cooled, being provided, the plate is fixed on an inclined plane, and the water is poured in a continuous stream over the picture. The drops of water which may remain upon the plate must be removed by forcibly blowing upon it, for otherwise, in drying, they would leave stains on the drawings. This finishes the drawing, and it only remains to preserve the silver from tarnishing and from dust.

The shadows in the Daguerréotype pictures are represented by the polished surface of the silver, and the lights by the adhering mercury, which will not bear the slightest rubbing. To preserve these sketches,

they must be placed in cases of pasteboard, with a glass over them, and then framed in wood. They are now unalterable by the sun's light.

The same plate may be employed for many successive trials, provided the silver be not polished through to the copper. It is very important, after each trial, that the mercury be removed immediately, by polishing with pumice powder and oil. If this be neglected, the mercury finally adheres to the silver, and good drawings cannot be obtained if this amalgam is present.

---

## B.—IMPROVEMENTS IN DAGUERRÉOTYPE.

THE above constitute the substance of the directions given by M. Daguerre, in his pamphlet and patent specification. The process has, however, been much simplified and shortened: the enormous expense of the original apparatus having been found quite unnecessary. A few pages may therefore with propriety be devoted to the improvements of the Daguerréotype.

### a. Improved method of Iodizing the Silver, by M. Daguerre.

The inventor has given some very decisive experiments, showing the necessity of using metal strips of the same kind as the tablet, or of cutting a deep line round it. He has shown that in using strips of copper, of glass, of gum lac, of card-board, or of platina, the edges of the tablet are surcharged with iodine. M. Daguerre then states that, but for the difficulty of fixing them, the bands might be very much reduced in size; for it is sufficient for them to produce their effect that there be a solution of continuity between them, and this is proved by the fact that nearly the same result is obtained by engraving at the $\frac{1}{8}$th of an inch from the edge of the plate a line deep enough to reach the copper. The objections to this are, that during the polishing process the engraving is filled with dust, and it retains water, which sometimes occasions stains. He then proposes as a very great simplification of this process, that the plate be laid flat in a shallow box containing two grooves, one to receive the plate and the other a board saturated with iodine. Around the plate he places a border of either powdered starch or lime, and the iodine *descends* from the board to the tablet. The starch or lime absorbs the iodine with avidity, and thus prevents its attacking the edges of the silver, and the vapour is diffused with perfect evenness over it. Another advantage is, that the saturated board may be used for several days in succession, without being at all renovated.

M. Seguier somewhat modifies even this process. A box of hard wood, varnished internally with gum lac, contains a lump of soft wood furnished with a card of cotton sprinkled with iodine. Upon this is placed a plate covered with card-board on each of its faces. One of

these card-boards furnishes, by radiation, to the metal the vapour of iodine, while the other returns to the cotton that which it had lost. It suffices to turn the plate from time to time, in order that the operation may go on with equal rapidity. A plate of glass is placed upon the upper card-board, where it is not operated on. The plate is sustained a little above the charged cotton, by frames of hard wood, varnished with gum lac. By increasing the distance between the cotton and the plate, or the contrary, we are enabled to suit the arrangement to the temperature of the season, and thus always operate with facility and promptitude. M. Seguier also states that a single scouring with tripoli, moistened with acidulated water, is sufficient to cleanse the plates thoroughly, and does away with the tedious process of scouring with oil, and afterwards the operation of heating the tablet over a spirit lamp. M. Soliel has proposed the use of the chloride of silver to determine the time required to produce a good impression on the iodated plate in the camera. His method is to fix at the bottom of a tube, blackened within, a piece of card on which chloride of silver mixed with gum or dextrine* is spread. The tube thus disposed is turned from the side of the object of which we wish to take the image, and the time that the chloride of silver takes to become of a greyish slate colour, will be the time required for the light of the camera to produce a good effect on the iodated silver.

### b. Methods of fixing the Daguerréotype Pictures.

Various methods have been tried for more perfectly fixing the Daguerréotype pictures, but most of the proposed plans impair the beautiful delicacy of the design. The object desired, is to occasion a more perfect adhesion of the mercury and silver, and this is said to be effectually done by M. H. Fizeau, whose method is as follows:—About fifteen grains of chloride of gold is dissolved in a pint of pure water; thrice that quantity of the hyposulphite of soda is dissolved in a like quantity of water: the former solution is then poured into the latter, stirring all the while. The mixed liquor, at first slightly yellow, soon becomes perfectly limpid. It appears to be a double hyposulphite of soda and gold rather than a chloride of sodium, which appears to act no part in the operation.

After the plate has undergone the usual photographic processes, it is washed in alcohol and water. It is then placed upon an iron frame, and covered with some of the solution of the salt of gold and soda. Heat is applied by means of a powerful lamp, and the impression becomes clear, and acquires in a few minutes great force. When this is produced, the liquid must be poured off, and the plate washed and dried. It appears that in this operation silver is dissolved, and gold is precipitated on the silver and on the mercury. The silver is turned slightly brown by the thin layer of gold which covers it, by which the

---

* A kind of gum procured from starch and other similar substances.

shades are rendered more powerful; the mercury, on the contrary, is increased in solidity and lustre by its amalgamation with gold. The picture, when this operation is well performed, will bear rubbing with the finger.

M. Preschot proposes the use of the hydrosulphate of ammonia, and M. Choiselat a solution of the iodide of silver in the hyposulphite of soda; but neither of these preparations appear to effect the desired object. Various gums have been tried, but they all of them slowly injure the fine effect of these delicate designs.

Dr. Berres of Vienna, assisted by Mr. F. Kratochwila, has succeeded by another process, bearing some analogy to that of M. Fizeau, in fixing the Daguerréotype designs. He takes the photograph produced in the usual manner by the process of Daguerre, holds it for a few minutes over a moderately warmed nitric acid vapour, and then lays it in nitric acid of 13° or 14° Réaumur, (61¼° or 63½° Fahrenheit) in which a considerable quantity of copper or silver, or both together, has been previously dissolved. Shortly after being placed therein, a precipitate of metal is formed, and can be changed to any degree of intensity. The photographic picture coated with metal is now removed, washed in water, cleaned and dried; it is then polished with chalk or magnesia, and a dry soft cloth or leather—after which the coating will become clean, clear, and transparent, so that the picture with all its properties can again be seen.

---

C.—Engraving the Daguerréotype designs.

The announcement of a means of engraving the Daguerréotype naturally excited a great deal of attention, but it was soon found that the extreme uncertainty, even with the most careful manipulation, which constantly attended the process, together with the imperfect *etching* which was produced under the most favourable circumstances, rendered the announced discovery of but little value. The process followed by Dr. Berres was the following :—

The greatest care is necessary in preparing the Daguerréotype design from which it is intended to print. The picture must be prepared upon the most chemically pure silver, and carefully freed from iodine. Dr. Berres first *varnishes* the plate by holding it over a weak warm vapour of nitric acid, 25° to 30° Réaumur, (77° to 86° Fahr.) for two or three minutes. There must then be poured over it a solution of gum arabic, of the consistence of honey, and it must be placed in a horizontal position for some minutes, with the impression uppermost. It is then plunged, by means of a double pincette, whose ends are protected by a coating of asphaltum or hard-wood, in nitric acid, at 12° or 13° Réaumur (59° to 61¼° Fahr.) Let the coating of gum slowly melt off, or disappear, and commence now to add, though carefully and gradually, and

at a distance from the picture, a solution of nitric acid, of from 25° to 30°, for the purpose of deepening or increasing the etching power of the solution. After the acid has arrived at 16° or 17° Réaumur, (68° to 70¼° Fahr.) and gives off a peculiarly biting vapour, which powerfully affects the sense of smelling, the metal becomes softened, and then, generally at this point, the process commences of changing the shadow upon the plate into a deep engraving or etching. This is the decisive moment, and upon it must be bestowed the deepest attention. The best method of proving if the acid be strong enough, is to apply a drop from that in which the plate now lies to another plate : if the acid makes no impression, it is of course necessary to continue adding nitric acid ; if, however, it corrode too deeply, then it is necessary to add water, the acid being too strong. If the potency of the acid has been carried too far, a fermentation and white froth will cover the whole picture, and then not only the surface of the picture, but the whole surface of the plate will be corroded.

When by a proper strength of the etching-powers of the acid, a soft and expressive outline of the picture is produced, we may hope to finish the undertaking favourably. We have now only to guard against an ill-measured division of the acid, and the avoidance of a precipitate. To attain this end, the plate is frequently lifted out of the fluid, taking care that the etching power of the acid shall be induced to whatever part it may appear to act weakly, and seek to avoid the bubbles and precipitate by a gentle movement of the liquid. In this manner the process can be continually applied to the proper points of strength required upon the plates from which it is proposed to print. Dr. Donné has also employed nitric acid to etch these designs, but, owing to his process being conducted less carefully than Dr. Berres appears to have done, his designs were less delicately executed. I have made a great many experiments on this point : the most successful were some with aqueous chlorine, and a strong solution of the chloruret of lime. I am, however, quite convinced that any etching process will very materially impair the beauty of the minute details ; and to produce an engraving, having still preserved the rich effects of aerial perspective, by such means, is, I believe, a very remote hope.

By depositing on a Daguerréotype picture a metallic plate, by means of the process of the electrotype, the deposited plate has a very faithful, though faint delineation of the original on its face. To improve this impression, is, I think, within the range of probabilities.

----

D.—Application of the Daguerréotype to taking Portraits from Life.

This very interesting application of Daguerre's discovery has been perfected by Dr. Draper, Professor of Chemistry in the University of

New York, who has published his process in the London and Edinburgh Philosophical Magazine, for September, 1840, from which paper I shall take the liberty of making copious extracts. It was first stated, that it was necessary, to procure any impression of human features on the Daguerréotype plate, to paint the face white, or dust it over with a white powder, it being thought that the light reflected from the flesh would not have sufficient power to change the iodated surface. This has been shown to be an error, for even when the sun shines but dimly, there is no difficulty in delineating the features.

" When the sun, the sitter, and the camera, are situated in the same vertical plane, if a double convex non-achromatic lens of four inches diameter, and fourteen inches focus be employed, perfect miniatures can be procured in *the open air*, in a period varying with the character of the light from 20 to 90 seconds. The dress also is admirably given, even if it should be black; the slight differences of illumination are sufficient to characterise it, as well as to show each button and button-hole, and every fold. Partly owing to the intensity of such light, which cannot be endured without a distortion of the features, but chiefly owing to the circumstance that the rays descend at too great an angle, such pictures have the disadvantage of not exhibiting the eyes with distinctness, the shadow from the eyebrows and forehead encroaching on them. To procure fine proofs, the best position is to have the line joining the head of the sitter and the camera so arranged, as to make an angle with the incident rays, of less than ten degrees, so that all the space beneath the eyebrows shall be illuminated, and a slight shadow cast from the nose. This involves, obviously, the use of reflecting mirrors to direct the ray. A single mirror would answer, and would economise time, but in practice it is often convenient to employ two ; one placed, with a suitable mechanism, to direct the rays in vertical lines, and the second above it, to direct them in an invariable course towards the sitter.

" On a bright day, and with a sensitive plate, portraits can be obtained in the course of five or seven minutes, in the diffused daylight. The advantages, however, which might be supposed to accrue from the features being more composed, and of a natural aspect, are more than counterbalanced by the difficulty of retaining them so long in one constant mode of expression. But in the reflected sunshine, the eye cannot bear the effulgence of the rays. It is therefore absolutely necessary to pass them through some blue medium, which shall abstract from them their heat, and take away their offensive brilliancy. I have used for this purpose blue glass, and also ammoniaco-sulphate of copper, contained in a large trough of plate glass, the interstice being about an inch thick, and the fluid diluted to such a point, as to permit the eye to bear the light, and yet to intercept no more than was necessary. It is not requisite, when coloured glass is employed, to make use of a large surface ; for if the camera operation be carried on until the proof *almost* solarizes, no traces can be seen in the portrait of its edges and

boundaries; but if the process is stopped at an earlier interval, there will commonly be found a stain corresponding to the figure of the glass.

" The chair in which the sitter is placed has a staff at its back, terminating in an iron ring, that supports the head, so arranged as to have motion in directions to suit any stature and any attitude. By simply resting the back or side of the head against this ring, it may be kept sufficiently still to allow the minutest marks on the face to be copied. The hands should never rest upon the chest, for the motion of respiration disturbs them so much as to bring them out of a thick and clumsy appearance, destroying also the representation of the veins on the back, which, if they are held motionless, are copied with surprising beauty.

" It has already been stated, that certain pictorial advantages attend an arrangement in which the light is thrown upon the face at a small angle. This also allows us to get rid entirely of the shadow from the back-ground, or to compose it more gracefully in the picture; for this, it is well that the chair should be brought forward from the back-ground, from three to six feet.

" Those who undertake Daguerréotype portraitures, will of course arrange the back-grounds of their pictures according to their own tastes. When one that is quite uniform is required, a blanket, or a cloth of a drab colour, properly suspended, will be found to answer very well. Attention must be paid to the tint,—white, reflecting too much light, would solarize upon the proof before the face had time to come out, and, owing to its reflecting all the rays, a blur or irradiation would appear on all edges, due to chromatic aberration.

" It will readily be understood, that if it be desired to introduce a vase, an urn, or other ornament, it must not be arranged against the back-ground, but brought forward until it appears perfectly distinct upon the obscured glass of the camera.

" Different parts of the dress, for the same reason, require intervals, differing considerably, to be fairly copied; the white parts of a costume passing on to solarization before the yellow or black parts have made any decisive representation. We have therefore to make use of temporary expedients. A person dressed in a black coat and open waistcoat of the same colour, must put on a temporary front of a drab or flesh colour, or, by the time that his face and the fine shadows of his woollen clothing are evolved, his shirt will be solarized, and be blue, or even black, with a white halo around it. Where, however, the white parts of the dress do not expose much surface, or expose it obliquely, these precautions are not essential, the white collar will scarcely solarize until the face is passing into the same condition.

" Precautions of the same kind are necessary in ladies' dresses, which should not be of tints contrasting strongly.

" It will now be readily understood, that the whole art of taking Daguerréotype miniatures consists in directing an almost horizontal beam of light, through a blue coloured medium, upon the face of the sitter, who is retained in an unconstrained posture by an appropriate but simple

K

mechanism, at such a distance from the back-ground, or so arranged
with respect to the camera, that his shadow shall not be copied as a part
of his body."

Professor Draper uses a camera, having for its objective two double
convex lenses, the united focus of which, for parallel rays, is only eight
inches; they are four inches in diameter in the clear, and are mounted
in a barrel, in front of which the aperture is narrowed down to three
and a half inches, after the manner of Daguerre's.  He also has adopted
the principle of bringing the plate forward out of the best visible focus,
into the focus of the violet rays, as was first suggested by Mr. Towson
of Devonport, in 1839, who also made many experiments, about the
same period, with cameras having mirrors instead of lenses.  A patent
has since been taken out by Mr. Woolcott, a philosophical instrument
maker of New York, for a camera for portraiture, with an elliptical
mirror : which form of apparatus has also been patented by a Mr.
Beard, in England, who having somewhat modified Dr. Draper's arrange-
ments as to light, has recently been astonishing the public by the
rapidity with which he is enabled to copy " the human face divine."

A camera obscura of this description is very easily constructed.
Fig. 25 is a sectional view of the apparatus.  At one end of a box,

Fig. 25.

shaped as in the figure, and having an opening at D, is placed an ellip-
tical mirror, A.  The prepared plate B is fixed to the sliding frame C,
by which it is adjusted to the best focus.  The rays of light, radiating
from a figure placed at F, will, it must be evident, pass through the
opening at D, and fall on the mirror, as represented by the dotted lines,
and will be thence reflected to the plate B.

The mirror has certainly the advantage of throwing a greater quan-
tity of light upon the plate, but it has the great disadvantage of limiting
the size of the picture.  With a mirror of seven inches diameter, we
only procure pictures which will be perfect over two square inches ;
whereas, with a lens of three inches diameter and fourteen inches focal
length, pictures of a foot square may be worked.  From this it will be
seen, that the mirror is only applicable where single objects are to be
copied.

### E.—SIMPLIFICATION OF THE DAGUERRÉOTYPE PROCESSES.

THE extreme expense of the apparatus and plates, as supplied by the patentee, induced me, in the very first stage of my experiments, to endeavour to construct for myself, a set which should be equally as effective, and less expensive.

I was soon satisfied that all the arrangements might be much simplified, and any one may have constructed for himself, for less than twenty shillings, a set of apparatus, by which he shall be enabled to produce pictures equalling, in every respect, those procured with the set sold at twenty pounds.

My apparatus consists of a deal box the size of my plates, and three inches deep, with a thin loose board in the bottom. This board is well saturated with the tincture of iodine,—the spirit is allowed partially to evaporate, and then, being put in its place, the plate is adjusted at a proper height above it, varying the height according to the temperature, —the box being closed, the operation is completed in about three minutes. Another deal box, having a glass in one side, and a bottom of sheet iron, which is slightly concaved to contain mercury, with grooves upon which the plate may rest at the proper angles, serves to mercurialize the plates. My camera, which I use for every photographic process, is described in a future chapter. It is sometimes convenient, particularly when travelling, to use a piece of amalgamated copper, which may be prepared, when wanted, by rubbing it with some nitrate of mercury. The expense of the plates may be very much reduced: instead of using copper *plated* with silver, I would recommend the use of silvered copper, which every one can prepare for himself, at a very small expense. The following is the best method of proceeding:—

Procure a well planished copper plate of the required size, and well polish it, first with pumice stone and water, then with snake stone, and bring it up to a mirror surface, with either rotten-stone, or jeweller's rouge. Plates can be purchased in a high state of preparation from the engravers. Having prepared the copper plate, well rub it with salt and water, and then with the silvering powder. No kind answers better than that used by clock-makers, to silver their dial plates. It is composed of one part of well washed chloride of silver, five parts of cream of tartar, and four parts of table salt. This powder must be kept in a dark vessel, and in a dry place. For a plate six inches by five, as much of this composition as can be taken up on a shilling is sufficient. It is to be laid in the centre of the copper, and the fingers being wetted, to be quickly rubbed over every part of the plate, adding occasionally a little damp salt. The copper being covered with the silvering, it is to be speedily well washed in water, in which a little soda is dissolved, and as soon as the surface is of a fine silvery whiteness, it is to be dried with a very clean warm cloth. In this state the plates may be kept for use. The first process is to expose the plate to

the heat of a spirit flame, until the silvered surface becomes of a well defined golden-yellow colour; then, when the plate is cold, take a piece of cotton, dipped in very dilute nitric acid, and rub lightly over it until the white hue is restored, and dry it with very soft clean cloths. A weak solution of the hydriodate of potash, in which a small portion of iodine is dissolved, is now passed over the plate with a wide camel's hair brush. The silver is thus converted, over its surface, into an ioduret of silver; and in this state it is exposed to light, which blackens it. When dry, it is to be again polished, either with dilute acid, or a solution of carbonate of soda, and afterwards with dry cotton, and the smallest possible portion of prepared chalk; by this means a surface of the highest polish is produced. The *rationale* of this process is, in the first place, the heat applied drives off any adhering acid, and effects more perfect union between the copper and silver, so as to enable it to bear the subsequent processes. The first yellow surface appears to be an oxide of silver, with, possibly, a minute quantity of copper in combination, which being removed, leave a surface chemically pure. Copper plates may also be very beautifully silvered by galvanic agency, by which we are enabled to increase the thickness of the silver to any extent, and the necessity for the heating process is removed, the silver being absolutely pure. The best and simplest mode with which I am acquainted, is to divide an earthenware vessel with a diaphragm; one side should be filled with a very dilute solution of sulphuric acid, and the other with either a solution of ferroprussiate of potash, or muriate of soda, saturated with chloride of silver. The copper plate, varnished on one side, is united, by means of a copper wire, with a plate of zinc. The zinc plate being immersed in the acid, and the copper in the salt, a weak electric current is generated, which precipitates the silver in a very uniform manner over the entire surface.

At a very early stage of my inquiries I found that the influence of all the rays, excepting the yellow, was to loosen the adhesion of the iodidated surface, and the under layer of unaffected silver. When this changed film was removed by rubbing, the silver beneath always exhibited the most perfect lustre, and I have hence invariably adopted this mode of polishing my Dauguerréotype plates. The required surface is thus produced with one-third the labour, and a very great saving of time; besides which, the silver is in a much more susceptible state for receiving the vapour of the iodine. The plate being thus prepared, we proceed in the manner before directed.

It is somewhat singular, that on the first notice of Daguerre's pictures, long before the publication of his process, when I learnt that they were on "hard polished tablets," I entertained the idea that plates of copper thus silvered were oxidized, and then acted on by iodine. I applied the iodine, both in solution and vapour; but, of course, as the mercury was not used, I failed to effect any perfect pictures. It is, however, worthy of remark, that on one occasion, having placed a piece of silvered copper in a trough containing a weak solution

of iodine, with some leaves of hemlock superimposed, these being kept close by means of a piece of glass, over all the exposed portions the silver was completely removed, and the copper abraded to a considerable extent, while beneath the leaves the silver was scarcely affected. I thus procured a very beautiful etching, the figures being in high relief. This was frequently repeated with success; but other inquires having drawn off my attention, the process has been long neglected, although, I am convinced, it is capable of being turned to much useful account.

The only other improvement which has been published, is one by Mr. Backhoffner, who appears to have substituted bromine for iodine with some advantage.

In November, 1839, I pursued a series of experiments with bromine, but no very definite advantage was obtained. Some curious effects which I noticed at that time, are worthy of notice. I copy the remarks made in my memorandum-book at the time.

4. Exposed a plate to the vapour of bromine, it assumed a leaden-grey colour, which blackened by light very readily. Exposed this to mercury without much improving the effect, or altering the lights. Upon immersing this plate in a solution of the muriate of soda, the parts unacted on by light, became a jet black, whilst the parts on which light had acted were dissolved off, leaving a clean coating of silver. The effect was most decisive—*a black picture on a white ground.*

8. Allowed three plates to assume, the first a straw-yellow, the second a steel-blue, and the third a dull blue, and examined their sensitiveness; the plate which had arrived at the dull blue colour appeared to be the most sensitive.

These experiments, which were then pursued with a view to produce more permanent pictures—to fix the mercury—or to engrave the plate, were, however, abandoned, and have not yet been resumed, although I hope in a little time to turn my attention again to this point. On one occasion, after having prepared a picture according to the process prescribed by Daguerre, I placed it, without removing the iodine, in a vessel of chlorine; the picture was obliterated, and very speedily *blackened.* On exposing this *black* plate to light, it almost instantaneously *whitened.* This is mentioned to show the extent of curious subjects which photography is opening for inquiry, in the hope they may induce some person to pursue the subject.

It has been recently announced that the inventor of the Daguerréotype has succeeded in improving the sensibility of his plates to such an extent, as to render an *instantaneous exposure* sufficient for the production of the best effects; consequently securing faithful impressions of moving objects. In a communication with which I have been favoured from M. Daguerre, he says,—" Though the principle of my new discovery is certain, I am determined not to publish it before I have succeeded in making the execution of it as easy to every body as it is to myself. I have announced it immediately at the Royal Academy of Paris, merely to take date, and to ascertain my right to the priority of

the invention.   By means of that new process, it shall be possible *to fix
the images of objects in motion, such as public ceremonies, market places
covered with people, cattle, &c.—the effect being instantaneous."*
 The beauty of such representations, furnishing, as they will, objects
of great historical interest, and the most truthful evidence, must render
them of the highest value.

————

### F.—On the Manner in which the Light operates to produce the Daguerréotype Designs.

NUMEROUS speculations having been ventured, as to the peculiar
chemical changes which light produces on the iodidated silver tablets, all
of which, it appears to me, are very wide of the truth, I shall make no
apology for introducing a few remarks on this very interesting subject.
 Numerous experiments on plated copper, pure silver plates, and on
silvered glass and paper, have convinced me, that the first operations
of polishing with nitric acid, &c., are essential to the production of the
*most sensitive* surface.   All who will take the trouble to examine the
subject, will soon be convinced, that the acid softens the silver, bringing
it to a state in which it is extremely susceptible of being either oxidized
or iodized, according as the circumstance may occur, of its exposure to
the atmosphere or to iodine.
 I have discovered that all the rays of the prismatic spectrum act on
the Daguerréotype plate, except the yellow, and a circle of light of a
peculiar and mysterious character, which *surrounds* the visible spec-
trum.   The light acting on a prepared tablet, decomposes the film of
*ioduret of silver* to different depths, according to the order of refrangi-
bility of the rays: the violet ray effecting perfect decomposition, whilst
the red acts to a depth inappreciably slight.   Thus it is, that the spec-
trum impressed on a Daguerréotype plate reflects the natural colours,
in the same manner as Sir Isaac Newton has shown thin films act
under other circumstances; the thickness of each film of reduced silver
on the plate being in exact proportion to the chemical agency of the
coloured ray by which it was decomposed.
 On photographic papers, the decomposed argentine salt exists in a
state of oxide, mixed, in all probability, with some revived metal; but
on the silver tablet the iodine is liberated from all the parts on which
the light acts, and pure silver in a state of extreme division results.
The depth to which the decomposition has been effected, being in exact
relation to the intensity and *colour* of the light radiated from the object
which we desire to copy, the mercurial vapour unites with different
proportions of silver, and thus are formed the lights and middle tints of
the picture.   The shadows are produced by the unchanged silver from
which the *ioduret* is removed by the hyposulphite of soda.
 Daguerre himself laid much stress upon the necessity of exposing the

plate to the mercury at an angle of about 45°. This, perhaps, is the most convenient position, as it enables the operator to view the plate distinctly, and watch the development of the design ; but beyond this, I am satisfied there exists no real necessity for the angular position. Both horizontally and vertically, I have often produced equally effective Daguerréotypes. Looking at a Daguerréotype picture in such a position that the light is incident and reflected at a large angle, the drawing appears of the *negative* character—the silver in such a position appearing white, and the amalgam of mercury and silver a pale grey. View the plate in any position which admits of but a small angle of reflection, and we then see the design in all its exquisite beauty, correct in the arrangement of its lights and shades,—the silver appearing black, while the amalgam, by contrast in part, and partly in reality, appears nearly white. A very ingenious idea has been promulgated, that the light crystallizes the ioduret of silver, and that the mercury adheres to one of the facets of each minute crystal. If this was the case, the picture could be seen distinctly in one position only, whereas in many different positions it is equally clear. There does not appear to be any more difficulty in explaining why the mercurial amalgam should vary in its tint with change of position, than in explaining why a common mirror, or a polished metal plate, should appear white when viewed at one angle, and black in another.

---

### 3.—PROCESS ON GLASS PLATES, BY SIR JOHN HERSCHEL.

" A NEW and pretty variety of the photographic art," to use Sir John Herschel's own words, " has resulted from experiments conducted with a view to ascertain how far organic matter is indispensable to the rapid discolouration of argentine compounds."

At the bottom of a rather deep vessel, place a very clean plate of glass. Pour into this a solution of salt much diluted, and of nitrate of silver so dilute, that the mixture is only slightly milky. Let this stand undisturbed for a day or two ; then, with a syphon tube, draw off most of the liquid, and drain slowly away the last portions, drop by drop, by a few fibres of hemp laid parallel and moistened, without twisting. Leave the glass quite undisturbed till it is dry. Upon this plate of glass, now covered with a beautifully delicate and even film of chloride of silver, pour a solution of the nitrate of silver, and move the plate to and fro, until it is accurately diffused over the surface. It is now highly sensitive, and exposed in this state to the focus of a camera, with the glass towards the incident light, it will soon become impressed with a well defined negative picture, which is direct or reversed according as looked at from the front or the back. On pouring over this cautiously, by means of a pipette, a solution of hyposulphite of soda,

the picture disappears, but this is only while wet, for on washing it with pure water and drying, it is restored, and assumes, when laid on a black ground, much the air of a Daguerréotype, and still more so when smoked at the back, the silvered portions reflecting most light, so that its character is changed from a negative to a positive drawing. To obtain delicate pictures, the plate must be exposed wet, and when withdrawn must immediately be plunged in water, that the nitrate, which is liable to crystallize, may be abstracted.

Sir John Herschel has made some experiments on thickening the film of silver, by connecting it, under a weak solution of that metal, with the reducing pole of a voltaic pile.* " The attempt afforded distinct indications of its practicability, with patience and perseverance, as here and there, over some small portions of the surface, the lights had assumed a full metallic brilliancy under this process." Glass coated with the iodide of silver, and treated as above, is more sensitive than the chloride.

" When the glass is coated with bromide of silver, the action, *per se*, is very slow, and the discolouration ultimately produced far short of blackness ; but when moistened with nitrate of silver, sp. gr. 1.1, it is still more rapid than with the iodide, turning quite black in the course of a very few seconds' exposure to sunshine. Plates of glass thus coated, may be easily preserved for the use of the camera, and have the advantage of being ready at a moment's notice, requiring nothing but a wash over with the nitrate of silver, which may be delayed until the image is actually thrown on the plate, and adjusted to the correct focus with all deliberation. The sensitive wash being then applied with a soft flat camel-hair brush, the box may be closed and the picture impressed, after which it only requires to be thrown into water, and dried in the dark, to be rendered comparatively insensible, and may be finally fixed with hyposulphite of soda, which must be applied hot, its solvent power on the bromide being even less than on the iodide."

Sir John Herschel suggests a trial of the fluoride of silver upon glass, which, if proved to be decomposable by light, might possibly effect an etching on the glass, by the corroding property of the hydrofluoric acid.

Frequent trials of these and other methods, have not enabled me to add any thing to the above directions. The bromide of silver used in this way is capable of producing pictures of the most extreme delicacy; and as we are enabled to take a number of positive copies from an original negative photograph on glass, it is a means which promises to be exceedingly valuable in forwarding the most important branch of the photographic art, namely, publication.

* See Spencer's Electrography.

# MISCELLANEOUS PROCESSES.

_____

### 1.—On the Application of the Daguerréotype to Paper.

THE expense and inconvenience of metallic tablets rendered it in the highest degree desirable that paper might be employed in their place. A very extensive series of experiments at length led to the pleasing conclusion, of being enabled to prepare a paper, which answered in every respect as well as the silver plates, and in many much better. This discovery formed the subject of a communication to the Royal Society, which that learned body did me the honour to print in their Transactions. My memoir is entitled,—" *On the Influence of Iodine in rendering several Argentine Compounds, spread on Paper, sensitive to Light, and on a new method of producing, with greater distinctness, the Photographic Image.*" This paper contains the substance of the following remarks; but since the publication of the Transactions, I have been successful in simplifying the process of preparation.

My experiments established, in the most satisfactory manner, that even on the silver tablets a semi-oxidized surface was presented to the iodine. They also proved that perfectly *pure untarnished silver* was by no means readily acted on by the iodine. From this I was led to prepare oxides of silver in many different ways, which enabled me to spread them over paper, and the result was instructive. Any of the ordinary photographic papers allowed to darken to a full brown, which is a stage of induced oxidation, become, by long exposure to iodine, of a steel-blue or violet colour. If exposed in this state to sunshine for a long period, their colour changes from grey to a clear olive. Now, exposure to sunshine for a minute, or to diffused day light for five minutes, produces no *apparent* change; but mercurial vapour speedily attacks the portions which have been exposed to light, and a faithful picture is given of whatever may have been superposed. There is, however, a want of sufficient contrast between the lights and shadows. By allowing the first darkening to proceed until the paper acquires the olive colour which indicates the formation of a true oxide of silver, it will be found, although it is not more speedily acted on by the iodine, that it is more sensitive, and that a better picture is formed. The kind of photographic preparations used appears to have but little influence on the results,—a chloride, iodide, or bromide of silver, allowed to darken, answers equally well.

There are many things, unfortunately, which prevent our availing

L

ourselves of this easy method of producing a tolerably sensitive Daguerréotype paper. These are, certain irregular formations of oxides in different states, and the revival of metallic silver in some parts of the surface.

I next spread papers with the pure oxide formed by chemical means, and also the protoxide, and many of its salts. These papers were not very readily affected by iodine, or influenced by light during short exposures.

Silver is revived from its solutions by hydrogen gas; consequently, nothing is more easy than by washing a paper with nitrate of silver in solution, to procure a fine silver paper, by passing a current of hydrogen gas over it.

A picture of a peculiarly delicate character may be produced on this kind of paper; but it has not the required sensibility, and there is a great want of contrast in the lights and shadows. It may be interesting to state, that the yellow-brown phosphate of silver is as readily acted on by iodine as the oxides, and is quite as sensitive to luminous influence. Phosphuretted hydrogen gas effects the revival of metallic silver, and the surface produced by means of this gas, used as the hydrogen was in the former case, is of a fine steel-blue, which colour arises from a portion of phosphorus having entered into combination with the silver. These kinds of paper comported themselves in every respect as the metallic tablets—were equally sensitive, and produced pictures as delicately beautiful. Unfortunately, however, owing to the spontaneously inflammable nature of the phosphuretted hydrogen gas, it is not safe to operate with it. After various ineffectual contrivances to overcome this difficulty, I was obliged to abandon the use of this gas entirely—warned of the danger I incurred, by several violent, but fortunately, harmless explosions. The vapour of phosphorus and of sulphur was also tried, and many very beautiful effects were produced. At length, however, I stopped at sulphuretted hydrogen, which answers in every respect. *

To prepare this paper, *soak* a paper of very firm texture, not too much glazed, in a weak solution of the muriate of ammonia. It must then be wiped with clean cloths, and carefully dried. The paper is then dipped into a weak solution of the nitrate of silver, and the small bubbles which form on its surface are carefully removed with a camel's hair pencil. When the paper is nearly, but not quite dry, it must be exposed in a closed vessel to sulphuretted hydrogen gas, slowly formed from the sulphuret of antimony and hydrochloric acid; in a few minutes it will become of an iron-brown colour, having a fine metallic lustre. It is again to be passed through a solution of silver, somewhat stronger than the first, and dried, taking care that no shadow falls on the paper whilst it is drying. It is then a second time submitted to sulphuration,

---

* A very interesting account of the revival of gold and silver from their solutions, by these gases, will be found in a tract on Combustion, published by Mrs. Fulhame.

and, by careful management, the process is now generally completed. If, however, the paper is not considered to be sufficiently dark, it must be once more washed in the solution of silver, and again subjected to the action of sulphuretted hydrogen.

If the above paper be allowed to remain in the sulphuretted hydrogen gas after the maximum blackness is produced, it is again whitened with some quickness. This may be accounted for in two ways; the gas may be mixed with a portion of muriatic acid vapour, or, a quantity of chlorine sufficient to produce this effect may be liberated from the preparation on the paper, to react on the sulphuret of silver.

The perfection of these papers consists in having a deep black ground to contrast with the mercurial deposit, by which means the pictures have the advantage of being seen equally well in all positions, whereas Daguerre's pictures on the metal plates, can only be seen to advantage at certain angles.

The sulphuretted paper may be rendered sensitive, in the same manner as the plates, by exposure to the vapour of iodine. I, however, prefer drawing the paper *over* a solution thus formed:—A saturated solution of any hydriodic salt is made to dissolve as much iodine as possible, and of this liquid two drachms are mingled with four ounces of water. Care is required that one side only of the paper is wetted, which is by no means difficult to effect, the fluid is so greedily absorbed by it; all that is necessary being a broad shallow vessel to allow of the paper touching the fluid to its full width, and that it be drawn over it with a slow steady movement. When thus wetted, it is to be quickly dried by a warm, but not too bright fire; of course daylight must be carefully excluded. Papers thus iodidated do not lose their sensitiveness for many days, if carefully kept from light.

On examining the sheet, after the Daguerréotype processes in the camera, and of mercurialization have been completed, a very perfect picture is found upon it: but it is still capable of vast improvement, which is, by the following simple plan, accomplished in a way which is at once magical and beautiful.

Dip one of the Daguerréotype pictures, formed on the sulphuretted paper, into a solution of corrosive sublimate: the drawing instantly disappears, but, after a few minutes, it is seen unfolding itself, and gradually becoming far more distinct than it was before; delicate lines, before invisible, or barely seen, are now distinctly marked, and a rare and singular perfection of detail given to the drawing. It may appear, at first sight, that the bichloride of mercury dissolves off the metal, and again deposits it in the form of chloride (calomel). But this does not account for the fact, that if the paper has been prepared with the nitrate of silver, the mercury disappears, and the drawing vanishes, the deposit taking place only on those parts upon which light has acted but feebly; as, for instance, on the venations of leaves, leaving those portions of surface which were exposed to full luminous influence, without a particle of quicksilver. When the paper has been either a

chloride or iodide, the effect is as above, and the thickness of the deposit is as the intensity of the light has been; consequently, the semi-tints are beautifully preserved.   If the drawing remains too long in the solution, the precipitate adheres to the dark parts and destroys the effect.  The singularity of this operation will be more striking if the picture has been soaked some time in a solution of the hyposulphite of soda, and then dipped into the bichloride of mercury.   As the drawing disappears, a series of circles, formed of a white powder, appear to arise from the paper, generally commencing at the centre, and slowly extending over the whole surface: the powder is afterwards deposited, and the sheet is buried in the precipitate; but on taking the paper from the liquid, and passing a stream of water over it, the precipitate is entirely removed from all the parts, except the lights of the picture.   I have also found the invisible photographic image becomes evident, without the aid of mercurial vapour, by simply soaking for some time in a solution of corrosive sublimate.

When these papers are prepared with due care, they are extremely sensitive, and if used for copying engravings during bright sunshine, the effect is *instantaneous.*   The great difficulty is to present the paper to the sun, and withdraw it with sufficient celerity.   In the weak light of the camera a few minutes during sunshine, is quite sufficient for the production of the best effects.   One great advantage of these pictures over those procured on the plated copper is, that the mercury does not lie loosely as on the tablets, but is firmly fixed, being absorbed by the paper; therefore these pictures may be kept without injury in a portfolio.

If, instead of immersing the paper in a vessel full of sulphuretted hydrogen gas, a stream of the gas is made to play upon it, it assumes a most richly irridescent surface; the various colours are of different degrees of sensibility—but for surface drawings, they may be used— and in copying of leaves or flowers, beautiful pictures, which appear to glow with the natural colours, are procured.

----

## 2.—PHOTOGRAPHIC PROCESSES WITHOUT ANY METALLIC PREPARATION.

THERE are many preparations, which are effected by light in a similar manner to the salts of silver.   Several have been tried as photographic materials, but as yet without much success, with the exception of the bichromate of potash, which was first announced as a useful photographic agent, by Mr. Mungo Ponton, in the Edinburgh New Philosophical Journal, from which I quote Mr. Ponton's own account.

When paper is immersed in the bichromate of potash, it is powerfully, and rapidly acted on by the sun's rays.   When an object is laid in the usual way on this paper, the portion exposed to the light speedily becomes tawny, passing more or less into a deep orange, according to

the strength of the light. The portion covered by the object retains the original bright yellow tint which it had before exposure, and the object is thus represented yellow upon an orange ground, there being several gradations of shade, or tint, according to the greater or less degree of transparency in the different parts of the object.

In this state, or course, the drawing, though very beautiful, is evanescent. To fix it, all that is required is careful immersion in water, when it will be found that those portions of the salt which have not been acted on by the light are readily dissolved out, while those which have been exposed to the light are completely fixed on the paper. By the second process the object is obtained white upon an orange ground, and quite permanent. If exposed for many hours together to strong sunshine, the colour of the ground is apt to lose in depth, but not more so than most other colouring matters. This action of light on the bichromate of potash differs from that upon the salts of silver. Those of the latter which are blackened by light, are of themselves insoluble in water, and it is difficult to impregnate paper with them, in a uniform manner. The blackening seems to be caused by the formation of oxide of silver.

In the case of the bichromate of potash, again, that salt is exceedingly soluble, and paper can be easily saturated with it. The agency of light not only changes its colour, but deprives it of solubility, thus rendering it fixed in the paper. This action appears to consist in the disengagement of free chromic acid, which is of a deep red colour, and which seems to combine with the paper. This is rendered more probable from the circumstance, that the neutral chromate exhibits no similar change. The best mode of preparing paper with bichromate of potash, is to use a saturated solution of that salt; soak the paper well in it, and then dry it rapidly at a brisk fire, excluding it from daylight. Paper thus prepared, acquires a deep orange tint on exposure to the sun. If the solution be less strong, or the drying less rapid, the colour will not be so deep. A pleasing variety may be made by using sulphate of indigo, along with the bichromate of potash, the colour of the object and of the paper being then different shades of green. In this way also, the object may be represented of a darker shade than the ground.

Paper prepared with the bichromate of potash, though as sensitive as some of the papers prepared with the salts of silver, is much inferior to most of them, and is not sufficiently sensitive for the camera obscura. This paper, however, answers quite well for taking drawings from dried plants, or for copying prints. Its great recommendation is its cheapness, and the facility with which it can be prepared. The price of the bichromate of potash, is about two shillings per pound, whilst the nitrate of silver is five shillings the ounce.

As the deep orange ground of these pictures prevents the permeation of the chemical rays of light, it is very easy to procure any number of fac-similes of an engraving, by transfer from the first negative photograph. The correct copies have a beautiful sharpness, and, if carefully managed, but little of the minute detail of the original engraving is lost.

The colour of these photographs may be very agreeably varied, by soaking the finished drawing in a weak solution of the nitrate of silver, by which the chromate of silver is formed,—a salt of a bright red colour—or in a solution of the bichloride of mercury, by which a chromate of mercury is formed, which is of a rich purple colour. When the drawings are again dry, they must be washed in water having a very small portion of common salt in it, to remove the silver or mercury from the white parts of the paper.

The most interesting variety of photographic paper, prepared with the bichromate of potash, is a kind described by M. E. Becquerel. He states,—It is sufficient to steep a paper prepared in Mr. Ponton's manner, and upon which there exists a faint copy of a drawing, in a solution of iodine in alcohol, to wash this paper in alcohol, and then dry it; then the parts which were white become blue, and those which were yellow remain more or less clear.

M. E. Becquerel has pursued his investigations into the action of the chromic acid on organic compounds, and has shown that the mode of sizing the papers influences their colouration by light, and that with unsized paper, colouration is effected only after a long time. Perceiving that the principal reaction resulted from the chromic acid contained in the bichromate of potash, on the starch in the size of the paper, it occurred to M. E. Becquerel, that, as starch has the property of forming with iodine a combination of a very fine blue colour, it should produce deep shades of that tint, whilst the lights still remained an orange-yellow.

His method of proceeding is to spread a size of starch, very uniformly over the surface of the paper. It is then steeped in a weak alcoholic solution of iodine, and afterwards washed in a great quantity of water. By this immersion it should take a very fine blue tint. If this is uniform, the paper is considered fit for the experiment: in the contrary case it is sized again. It is then steeped in a concentrated solution of bichromate of potash, and pressed between folds of blotting paper, and dried near the fire. To be effective, it should be very dry.

It is now fit for use. When the copy is effected, which requires in sunshine about five minutes, the photograph is washed and dried. When dry, it is steeped in a weak alcoholic solution of iodine, and afterwards, when it has remained in it some time, it is washed in water, and carefully dried in blotting paper, but not at the fire, for at a little below 100° Fah. the combination of iodine and starch discolours.

If it be considered that the drawing is not sufficiently distinct, this immersion may be repeated several times ; by this means may be obtained the intensity of tone that is desired, which intensity cannot be changed at will by employing a more concentrated solution of iodine.

When the paper is damp, the shades are of a very fine blue, but when it is dry, the colour becomes deep violet. If while the drawing is still wet it be covered with a layer of gum arabic, the colour of the drawing is greatly preserved, and more beautiful when it is dry. When a paper

is thus prepared, at first it loses a little of its tone, but it afterwards preserves its violet tint.

An interesting variety of photographic drawings may be formed by purely vegetable preparations. These are not equal in point of beauty or delicacy to any of those varieties before mentioned, but they form a very satisfactory series of examples of the well known influence of solar light upon some of our beautiful dies and colours. The subject is replete with interest to the dyer and the artist, and is certain of being useful to many of our most refined processes of manufacture.

Amongst the vegetable colours which are readily affected by light, may be named the alkaline tincture of many of the lichens, particularly of the *Lichen Rocellus*—the tincture of gum guaiacum, and of ·the common heart's-ease, *Viola Tricolor*—together with several of the alcoholic solutions of the colouring matter of many of the dahlias. It will be found in most instances that the vegetable colour is bleached out ; consequently the object is of the original colour, and darker than the ground. No means of fixing these drawings have yet been discovered.

A very speedy way of taking a copy of any object, when we have no ordinary photographic paper at hand, is to take a piece of the best blue demy paper, and dip it in either a weak solution of muriatic acid, or of any of the hydriodic salts—the object being placed upon it, it is then exposed wet to sunshine, and the uncovered parts are soon completely whitened. With some kinds of demy the effect is very rapid. Simple washing in a large quantity of cold water is all that is required to render the drawing secure.

---

### 3.—DR. SCHAFHAEUTL'S PROCESS ON CARBONISED PLATES.

METALLIC plates are covered with a layer of hydruret of carbon, prepared by dissolving pitch in alcohol, and collecting the residuum on a filter. This, when well washed, is spread as equally as possible over a heated even plate of copper. The plate is then carbonised in a closed box of cast iron, and, after cooling, passed betwixt two polished steel rollers, resembling a common copperplate printing press. The plate, after this process, is dipped into a strong solution of nitrate of silver, and instantly exposed to the action of the camera. The silver is, by the action of the rays of the sun, reduced into a perfect metallic state, and the lights are expressed by the different density of the milk-white deadened silver ; the shadows by the black carbonized plate. In a few seconds the picture is finished, and the plate is so sensitive, that the reduction of the silver begins even by the light of a candle. For fixing the image, nothing more is required than to dip the plate in alcohol mixed with a small quantity of the hyposulphite of soda, or of pure ammonia.

This process, from its description, might be considered easy of ac-

complishment; and from its extreme sensibility, complete in all the details of picturesque effect. It is neither the one nor the other. The preparation of the plate requires the skill of an artist, combined with the knowledge of a chemist; and even these are not always sufficient to ensure a perfect surface. The revival of the silver is not to be depended on: sometimes it does form a continuous sheet over the parts acted on by the light, but often it is only spangles; and frequently a metallic arborescence will commence in the light parts, and run rapidly into the portions in shadow. The fact is, that light has the property of effecting the revival of the silver spread upon any carbonaceous body, but caloric having the same effect, and being indeed rather more active in the operation than light is, any slight increase of temperature produces a revival of the metal over the parts in shadow.

Reference to the early volumes of Nicholson's Journal will afford ample evidence of these facts, which I have also recently proved. These volumes contain some papers by Count Rumford on the revival of gold and silver from their solutions, by light, when spread upon charcoal or carbonaceous earth. This philosopher has conclusively shown, that this revival is more dependent on the action of heat than light, which accounts, in some measure, for the apparent effect of candle light. It is, however, possible, that this process may, with some modifications, become of importance.

----

#### 4.—A NEW CONSTRUCTION OF THE PHOTOGRAPHIC CAMERA OBSCURA.

A PHOTOGRAPHIC camera should possess, according to Sir John Herschel, " *the three qualities of a flat field, a sharp focus at great inclinations of the visual ray, and a perfect achromaticity.*" There can be no doubt but these qualifications are very essential,—the two first particularly are indispensable, and there is but one objection to the latter. We can only produce perfect achromaticity by a combination of glasses, and my experiments go to prove that by increasing the thickness of the object-glass, and the number of reflecting and refracting surfaces, we interrupt a considerable portion of light, and consequently weaken the action on the photographic material, whatever it may be. It is with considerable reluctance that I express myself somewhat at variance with so high an authority as Sir John Herschel, gifted as he is with the highest power of physical research; I am however satisfied, that we may to a considerable extent get rid of the difficulties of chromatic dispersion, without having recourse to a combination of glasses of different refracting powers. I have long used myself, and constructed for others, a camera obscura, which appears to answer remarkably well. It is but right I should acknowledge that I am indebted to the suggestions of Dr. Wollaston, for part of my lenticular arrangement. *a*, Figure 26, represents the aperture of the lens; *i i'*, a box sliding into an outer

Fig. 26.

case, *h h'*; *k k*, a third division, containing a ground glass at the back, and a door which can be raised or lowered by the screw *g*, the whole fitting into the frame *h h'*.

Figure 27 is a section of the camera. *a*, is a lens of a periscopic form, whose radii of curvature are in the proportion of 2 to 1. This

Fig. 27.

meniscus is placed with its convex surface towards the plane of representation, and with its concavity towards the object.

The aperture of the lens itself is made large, but the pencil of rays admitted is limited by a diaphragm, or stop, constructed as in the figure at *b*, between it and the plane of representation, at about one tenth of the focal length from the lens. By this arrangement objects are represented with considerable distinctness over every part of the field, but little difference being observable between the edges and the centre. *c* is the plate of ground glass at the back, which serves to adjust the focus, and also to lay the photographic paper on, when we desire to copy any object; *d*, a door to shut off the light from the paper or plate, until the moment we desire to expose it to luminous agency. Figure 28 represents this screen or door more perfectly, in the act of falling; *e* is a door at the back, through which the picture formed on the opaque glass is examined; *f*, a pin, keeping the door, *d*, in its place.

Fig. 28.

With the kind of lens here recommended, and the light thus stopped off, and adjusting the camera to the focus of the violet ray, it will be found that most of the advantages of the achromatic lens are obtained, and we get rid of some of its defects. A camera of this description, capable of forming a picture 12 inches by 10, may be constructed for from thirty to forty shillings, which is about the expense of a good achromatic lens.

---

### 5.—On the possibility of producing Photographs in their Natural Colours.

Few speculations are more replete with interest, than that of the probability of our succeeding in the production of photographic images in their local colours. M. Biot, a great authority, says,—" substances of the same tint may present, in the quantity, or the nature of the radiations which they reflect, as many diversities, or diversities of the same order, as substances of a different tint; inversely, they may be similar in their property of reflecting chemical radiations, when they are dissimilar to the eye; so that the difference of tint which they present to the eye may entirely disappear in the chemical picture. These are the difficulties inherent in the formation of photographic pictures, and they show, I think, evidently, the illusion of the experimenters who hope to reconcile not only the intensity, but the tints of the chemical impressions produced by radiation, with the colours of the objects from which these rays emanate." It may be remembered that two years since, Sir John Herschel succeeded in procuring upon photographic paper *a coloured image* of the solar spectrum; and that eminent enquirer has communicated to me a recent discovery of great interest, which I have his permission to publish. " I have got specimens of paper," says Sir John Herschel, " *long kept,* which give a considerably better representation of the spectrum in its *natural colours,* than I had obtained at the date of my paper, (February, 1840,) and that *light* on a *dark ground;* but at present I am not prepared to say that this will prove an available process for coloured photographs, *though it brings the hope nearer.*" Here we have the speculations of one philosopher representing the production of such°pictures as hopeless, while ˌthe experiments of another prove these to be within the range of probabilities.

My own experiments have in many instances given me coloured pictures of the prismatic spectrum, *dark* upon a *light ground,* but the most beautiful I have yet obtained, has been upon the Daguerréotype iodidated tablets, on.which the colours have, at the same time, had a peculiar softness and brilliancy. Daguerre himself has remarked, that when he has been copying any red, brick or painted, building, the photograph has assumed a tint of that character. I have often observed the same thing in each variety of photographic material, *i. e.,* where a salt of

silver has been used.   In the *Philosophical Magazine* for April, 1840, will be found a paper,—" Experiments and Observations on Light which has permeated Coloured Media,"—in which I describe some curious results, on some of those photographs which are prepared with the hydriodic salts, exposed to luminous influence with coloured fluids superimposed; permitting, as distinctly isolated as possible, the permeation of the violet and blue,—the green, the yellow, and the red rays, under each of which a complementary colour was induced.   During January of the present year, I prepared some papers with the bichromate of potash, and a very weak solution of nitrate of silver; a piece of this paper was exposed behind four coloured glasses, which admitted the passage respectively of, 1st, the violet, indigo, and blue rays; 2d, the blue, the green, and a portion of the yellow rays; 3d, the green, yellow, and orange rays; and, 4th, the orange and red rays.   The weather being extremely foggy, the arrangement was unattended to for two days, being allowed to lie upon a table opposite a window having a southern aspect. On examining it, it had under the respective colours become *tinted*, of a blue, a green, and a red;—beneath the yellow glass the change was uncertain, from the peculiar colour of the paper,—and this without a solitary gleam of sunshine.   My numerous engagements have prevented my repeating the observations I desire on this salt, which has hitherto been considered absolutely insensible to light.

The barytic salts have nearly all of them a peculiar colourific effect; the muriate, in particular, gives rise to some most rich and beautiful crimsons, particularly under the influence of light which has permeated the more delicate green leaves; and also in copying the more highly coloured flowers, a variety of tintings have been observed.   We may always depend on producing a photographic copy of a leaf of a green colour by the following arrangement:—Having silvered a copperplate, place it in a shallow vessel, and lay thereon the leaf of which a copy is desired, maintaining it in its position by means of a piece of glass; pour upon it, so that the plate beneath the glass may be covered, a solution of the hydriodate of potash, containing a little free iodine—then expose the whole to sunshine.   In about half an hour one of the most beautiful photographic designs which can be conceived is produced, of a fine green colour.   The fluid is yellow, and cuts off nearly all the "chemical" rays, allowing only of the free passage of the less refrangible rays—the most abundant being the yellow.   This retards the process of solarization; but it produces its complementary colour on the plate.

These facts will, I think, prove that the *possibility* of our being enabled to produce coloured photographs is decided, and that the *probability* of it is brought infinitely nearer, particularly by Sir John Herschel's very important discovery, than it was supposed to be.

### 6.—Invisible Photographs, and their Reproduction.

It was first noticed by Sir John Herschel, that any of the ordinary photographic drawings were completely obliterated by being immersed in, or washed over with, a solution of corrosive sublimate, and the paper restored to its original whiteness, in which state it might be kept any length of time; but the drawing is to be reproduced at pleasure, by washing it in a solution of the hyposulphite of soda.

About the same time, and being then perfectly unacquainted with what Sir John Herschel had done, I fell upon the same phenomenon, but on the hydriodated papers, instead of the simple muriated. These are changed yellow by the corrosive sublimate, but present no trace of the original picture, which exists, but is invisible, and may be restored by the same means as before mentioned. Either of these photographs may thus be obliterated, and rendered again visible as frequently as we please, affording an extremely curious illustration of the action of chemical reagents.

After we have *completed* a picture on a Daguerréotype plate, by a little brisk rubbing with the hand or a leather, we entirely obliterate it; place it again in the mercurial vapour, and the design will be reproduced; or plunge it into a solution of iodine, and the picture again appears very defined, but with reversed lights and shadows.

The effect of these solutions of bichloride of mercury and the hyposulphite of soda, may be very strikingly shown on one of the papers which, after having been darkened by light, are exposed to the Daguerréotype processes. The effect of the bichloride of mercury is to whiten the dark parts of the picture, and, of course, produce a negative drawing, which is rapidly rendered positive by immersion in the solution of hyposulphite of soda. We have it thus in our power to produce upon the same sheet the two distinguishing varieties of photographic drawing.

The corrosive sublimate may be employed for painting on the darkened photographic paper, by drawing in the lights with it. The processes named above may also be used for secret correspondence.

---

### 7.—On the Spontaneous Darkening of the White Photographic Papers.

Great annoyance often arises from the rapid discolouration of the more sensitive kinds of photographic drawing paper, independent of the action of light, which appears to arise from the action of the nitrate of silver on the organic matters of the *size*. Unsized paper is less liable to this change. If we spread a perfect chloride of silver over the paper, it may be kept for any length of time without any change of its white-

ness taking place in the dark. Wash it over with a very weak solution of nitrate of silver, and, particularly if the paper is much sized, a very rapid change of colour will take place, however carefully we may screen it from the light. From this it is evident that the organic matter of the size is the principal cause of the spontaneous darkening of photographic papers prepared with the salts of silver.

The most curious part of the whole matter is, that in many cases this change is carried on to such an extent, that a revival of metallic silver takes place, to all appearance in opposition to the usual force of the affinities. I have now some packets of paper prepared two years since, which have been carefully kept in the dark. Over many of these there is a perfect revival of the metal. This is very difficult to deal with. Chemistry has not yet made us acquainted with any organic body, which would separate either chlorine or nitric acid, from their metallic combinations. I can only view it in this light:—the nitric acid liberates a quantity of carbonaceous matter, which, acting by a function peculiarly its own, will at certain temperatures effect the revival of gold and silver, as we have seen in the case of Dr. Schafhaeutl's process and Count Rumford's experiments.

Having been informed that the paper-makers are in the habit of bleaching their sizes with sulphur and the sulphites, I have recently submitted a considerable quantity of the browned papers which I happened to have by me, to analysis. In all cases where there has been a revival of the silver, or where the paper has *blackened*, I have detected the presence of sulphur. Consequently, when the darkening goes on rapidly, we may, I think, correctly attribute it to the formation of a sulphuret of silver, rather than to the causes above named. Where the darkening process is slow, these will, however, be found to be tolerably near to the truth.

---

### 8.—On the Use of the Salts of Gold as Photographic Agents.

It is well known that gold is revived from its etherous solution by the action of light, and that the same effect takes place when the nitro-muriate of gold is spread on charcoal.

Considering it probable that the required unstable equilibrium might be induced in some of the salts of gold, I was induced to pursue a great many experiments on this point. In some cases, where the paper was impregnated with a mordant salt, the salt of gold was darkened rapidly, without the assistance of light; in others, the effect of light was very slow and uncertain. By washing paper with muriate of barytes, and then with a solution of the chloride of gold, a paper, having a slight pinky tint, is procured; by exposing this paper to sunshine it is at first *whitened*, and then, but very slowly, a darkening action is induced. If, however, we remove the paper from the light, after an

exposure of a few minutes, when a very faint impression, and oftentimes not any, is apparent, and hold it in the steam of boiling water, or immerse it in cold water, all the parts which were exposed to the light are rapidly darkened to a full purple brown, leaving the covered portions on which the light has not acted, a pure white, producing thus a fine negative drawing. If, while such a paper, or any other paper prepared with the chloride of gold, is exposed to the sun, we wash it with a weak solution of the hydriodate of potash, the oxidation is very rapidly brought on, and the darkness produced is much greater than by the other method; but this plan is not often applicable. I have not yet been enabled to produce with the salts of gold, any paper which should be sufficiently sensitive for use in the camera obscura.

------

### 9.—On the Action of Heat on the Hydriodic Photographic Papers.

I HAVE before alluded to some remarkable effects on these papers, produced by the "calorific" rays. It is therefore necessary to notice the analogous action produced by artificial heat, under similar circumstances. If a piece of darkened photographic paper, washed with an hydriodic solution, be pressed into close contact with a dark engraving, or a printed page, by means of a piece of metal, which is kept moderately warm, a very faithful copy is in general obtained; but not always. There are some circumstances, not yet detected, which sometimes prevent a change. All the dark parts of the engraving are copied in lights, i. e., we have a negative picture. Much appears to depend upon the composition of the ink used in printing; with some kinds I have never failed—with others I have seldom succeeded in producing this kind of drawing.

------

### 10.—On Copying Letter-Press, &c., on the Photographic Papers, by means of Juxtaposition.

THERE are numerous instances in which copies are effected by mere juxtaposition, in a very remarkable manner:—Allow a piece of white muriated photographic paper to lie between the leaves of a book for a few weeks, nothing will be observed upon the paper if we then remove it; but if we plunge it into sulphuretted hydrogen gas, the letters are all brought out in metallic silver, the other parts of the sheet becoming the black sulphuret of silver. If a sulphuretted paper is placed in the same way in a book, in a few days the printing is faintly copied. By passing the paper then through a solution of iodine, it becomes much more visible, the letters being, if viewed in one position, the darkest parts of the paper, while in another they appear the lightest. Many kinds

of pencil marks are readily copied on photographic papers, and gold printing soon leaves its impression on the chloride of silver. Sir John Herschel states, this effect is not produced by all pencils on the same paper; as a preparation of the paper, nitrate of silver over borax seemed to succeed best; this possibly arises from the sulphur in the pencil. The gold leaf may act on the silver, in all probability, from its containing a small alloy of copper. These facts are curious, and may eventually be turned to some important uses.

---

### 11.—On the Use of Photographic Paper for Registering the Indications of Meteorological Instruments.

There are so many advantages attendant on self-registration, as to make the perfection of it a matter of much interest to every scientific enquirer. The first who suggested the use of photographic paper for this purpose was Mr. T. B. Jordan, who brought the subject before a committee of the Royal Cornwall Polytechnic Society, on the 18th of February, 1839, and exhibited some photographic registers on the 21st of March of the same year. The plan this gentleman adopted was to furnish each instrument with one or two cylinders containing scrolls of photographic paper. These cylinders are made to revolve slowly by a very simple connection with a clock, so as to give the paper a progressive movement behind the index of the instrument, the place of which is registered by the representation of its own image.

The application of this principle to the barometer or thermometer is most simple; the scale of either of these instruments being perforated, the paper is made to revolve as close as possible to the glass, in order to obtain a well defined image. The cylinder being made to revolve on its axis once in forty-eight hours, the paper is divided into forty-eight parts by vertical lines, which are figured in correspondence with the hour at which they respectively arrive at the tubes of the instruments. The graduations on the paper correspond to those on the dial of the barometer or scale of the thermometer, and may be printed on the paper from a copperplate, or, what is much better, may be printed by the light at the same time from opaque lines on the tube, which would of course leave a light impression on the paper; by this means we should have all that part of the paper above the mercury darkened, which would at the same time be graduated with white lines, distinctly marking the fluctuations in its height for every minute during daylight, and noting the time of every passing cloud.

Mr. Jordan has also published an account of his very ingenious plan of applying the same kind of paper to the magnetometer or diurnal variation needle,* and several other philosophical instruments; but as

---

* See the Sixth Annual Report of the Royal Cornwall Polytechnic Society.

these applications have not been entirely successful, owing principally to the difficulty of finding a suitable situation for so delicate an instrument, it is thought unnecessary to occupy these pages with any particular description of the arrangements adopted, the more so, as this is a subject which can scarcely be said to come within the meaning of a popular treatise.

One subject, however, which, at the same time that it is highly philosophical, is of a more popular character, must not pass unnoticed. The registration of the ever varying intensity of the light is so important a subject, that it has occupied the attention of several eminent scientific observers. Sir John Herschel and Dr. Daubeny have applied their well known talents to the inquiry, and have, both of them, devised instruments of great ingenuity for the purpose. The instrument constructed by Sir John Herschel, which he has named an *actinograph*, not only registers the *direct* effect of solar radiation, but also the amount of general illumination in the visible hemisphere, which constitutes daylight. One portion of the apparatus being so arranged that a sheet of sensitive paper is slowly moved in such a direction, that the direct rays of the sun, when unobscured, may fall upon it through a small slit made in an outer cylinder or case:—while the other is screened from the incident beam, the paper being fixed on a disc of brass, made to revolve by watch work, is affected only by the light which " emanates from that definite circumpolar region of the sky to which it may be considered desirable to limit the observation," and which is admitted, as in the other case, through a fine slit in the cover of the instrument.

Mr. Jordan has devised an instrument for numerically registering the intensity of the incident beam, which appears to have some peculiar advantages, a description of which I shall take the liberty of transcribing. Figure 29 is an elevation of the instrument; it consists of two

Fig. 29.

copper cylinders supported on a metal frame, the interior one is fixed to the axis and does not revolve, being merely the support of the prepared paper; the exterior cylinder is made to revolve about this once in twenty-four hours by a clock movement. It has a triangular aperture cut down its whole length, as shown in the figure, and it carries the scale of the instrument, which is made to spring closely against the

prepared paper. This scale or screen is composed of a sheet of metal foil between two sheets of varnished paper, and is divided into one hundred parts longitudinally, every other part being cut out, so as to admit the light to the prepared paper without any transparent medium intervening. The lengths of the extreme divisions, measuring round the cylinder, are proportioned to each other as one to one hundred, consequently the lower division will be one hundred times longer passing over its own length, than the upper one over its own length, and the lines of prepared paper upon these divisions will, of course, be exposed to the light for times bearing the same proportion to each other.

Now, as the sensitiveness of the paper can readily be adjusted, so that the most intense light will only just tint it through the upper division during *its passage* under the opening, and the most feeble light will produce a similar tint through the lower division during *its passage*, the number of lines marked on the paper at any given time, will furnish a comparative measure of the intensity of solar light at that time, and may be registered as so many degrees of the *Heliograph*, the name Mr. Jordan has given his instrument, just as we now register the degrees of the thermometer.

Of course, it is essential for these registrations, that the photographic paper should be always of the same kind. The manufacture of such paper is not so difficult as it may, in the first instance, appear to be. Provided a perfectly uniform paper, which shall be invariable in its composition, can be procured from the manufacturers, by attending strictly to the rules prescribed in the former part of this treatise, there will be no difficulty in producing sheets of any length, and in any number, which shall act in all respects similarly under the influence of radiation.

---

### 12.—THE INFLUENCE OF CHLORINE AND IODINE IN RENDERING SOME KINDS OF WOOD SENSITIVE TO LIGHT.

HAVING on many occasions subjected the simply nitrated photographic paper to the influence of chlorine and iodine in close wooden boxes, I was often struck with the sudden change which light produced on the wood of the box, particularly when it was of deal, changing it in a few minutes from a pale yellow to a deep green. This curious effect frequently occurring, led me to observe the change somewhat more closely, and to pursue some experiments on the subject. These produced no very satisfactory result. They proved the change to depend much on the formation of hydrochloric, and hydriodic acids, and the decomposition of water in the pores of the wood. I found well baked wood quite insusceptible of this very curious phenomenon. The woods of a soft kind, as the deal and willow, were much sooner influenced than the harder varieties, but all the light-coloured woods appeared more or less capable of

undergoing this change.  All that is necessary is, to place at the bottom of an air-tight box, a vessel containing a mixture of manganese and muriatic acid, and fix the piece of wood at some distance above it. Different kinds of·wood require to be more or less saturated with the chlorine or iodine, and consequently need a longer or shorter exposure. The time, therefore, necessary for the wood to remain in the atmosphere of chlorine, can only be settled by direct experiment.  Wood is impregnated very readily with iodine, by putting a small portion in a capsule a few inches below it.  It does not appear to me at present, that any practical result is likely to arise out of this peculiar property: it is only introduced as a singular fact, which is perhaps worthy a little more attention than my numerous engagements have left me time to devote to it.

---

### 13.—PROCESS FOR PREPARING THE HYPOSULPHITE OF SODA.

As the solution of this salt is found to be the best fixing agent yet recommended, and as it is not commonly kept by the retail chemist, I insert the following directions to enable any person to prepare it for himself :—

Form, in the first instance, a solution of caustic soda, by dissolving a pound of soda in a quart of boiling water, and mixing it, while hot, with half-a-pound of fresh burnt lime, slacked with another quart of boiling water.  The mixed solution is to be carefully covered from the air until cold.  The clear liquor is then to be poured off, and made to dissolve, by boiling in an earthen vessel, as much sulphur as possible.  The deep yellow solution formed is to be decanted off into a deep vessel, and a current of sulphurous acid gas passed through it until it becomes quite colourless.  This is very easily done by mixing, in a retort with a long beak, some linseed oil and sulphuric acid.  On applying a little heat, the sulphurous acid gas is given off in great abundance.  By plunging the beak to the bottom of the vessel, it passes through, and is rapidly absorbed by the solution.  If it is desired to crystallize the hyposulphite, the fluid should not be allowed to become quite free of colour.  Whilst still a little yellow, it should be filtered and evaporated in a porcelain or earthen vessel, over a quick fire, to the consistence of a syrup.  The liquid thus evaporated is mixed with half its volume of alcohol, and well shaken.  The alcohol takes up all the sulphuret, and floats above ; the lower solution is left to cool under the alcoholic one.

The hyposulphite of soda must be preserved in well stopped glass bottles, and never be exposed to any bright light.  It is best to keep it in small bottles, as the action of the oxygen of the atmosphere has a tendency to form a sulphate and precipitate the sulphur.

## CONCLUSION.

HAVING now completed my description of all the *published* photographic processes of any real value, and my own observations on each of them, nothing more remains to be done, but to draw attention to the importance of the art, both practically and philosophically considered. A great number of important considerations press themselves upon me, but I shall only remark on those which have the most popular tendency.

We have seen that the beams which proceed from the sun, in the form of white light, are each one of them a combination of distinct rays, not only differing in colour, but having very opposite powers. Formerly these rays were divided into three classes, and called the " calorific," the " luminous," and the " chemical," under an impression that these particular functions were confined to the particular parts thus named. Recent observations have shown that the calorific action is not confined to the red or " calorific" rays, but that it extends over the greater part of the spectrum. The " luminous," or yellow rays, have long been considered as being destitute of any chemical action ; but Sir John Herschel, in a communication he has been kind enough to make to me, and which I have his permission to publish, says, " I have obtained photographic actions on certain papers, not argentine, which are limited not to the ' chemical,' not to the ' calorific,' *but to the ' luminous* ' *rays, i. e.* which seem to be produced exclusively, or nearly so, by those rays which affect the organ of sight. These papers are prepared with substances of *vegetable* origin ; and though at present I do not see how this can become serviceable in the arts, it strikes me as scientifically of considerable importance." This fact is to me singularly interesting, the more so, that in my experiments on the effects of light on vegetation, I have detected powers in the " luminous" rays which are highly destructive to the germination and the growth of plants. This inquiry I am now pursuing, and I hope the coming summer will enable me to add something to the many very remarkable discoveries recently made by Sir John Herschel and others.

The chemical action of light, so far from being confined to the most refrangible rays, we now know extends over the whole spectrum, *visible and invisible*, the action only being shifted from one ray to another, according to the substance upon which its peculiar functions are exerted. It is extremely difficult to explain many of the phenomena of light by either of the rival theories; and as we proceed in our inquiries, the question of the materiality or immateriality of light becomes more and more complicated. A matter of much interest arises out of these considerations, which is, are the different rays in similar electrical states, or do they vary in this respect with their refrangibility ? Those philosophers who have adopted the undulatory theory of light, put the

question aside with a smile, or show how completely the electrical notion is at variance with their theory. There exists many very great difficulties in solving the problem, but although a good theory will often aid us in discovering the truth, we must not allow our researches to be stopped, because they may appear inconsistent with the received notion. If we could establish the fact of peculiar electric action existing in the different rays of light, we should then have the means of reducing to something like system, the many anomalous features which come under our notice in prosecuting our studies into the character of the solar light. " In this instance," says M. Arago, " it is upon the *unforeseen* that we are especially to reckon," and every new discovery goes to prove the correctness of this.

Few words need be expended to show the utility of the photographic art to manufactures. We may expect in a few years to find the designs with which we ornament our porcelain, and the beautiful fabrics of the loom, infinitely superior to those with which they are at present adorned, and if not directly formed by the operations of light, they will be copied from those incomparably faithful pictures which photographic processes enable us to obtain. From the first publication of the photographic operations we may date an improvement of taste. No one who has accustomed himself to the exquisite finish of these productions, will be enabled to endure any artistic design which is not of superior excellence. Hence will be created a new era in the arts, and I have little doubt but the effects of photography will soon be apparent by improvements in linear perspective, and the general disposition of light and shadow in the productions of modern painters. It has been said that photographic drawings fail in *artistic effect*. That they fail in producing those exaggerated effects which are found no where in nature, but on the canvass of some modern artists of eminence, is most true. But nature in her rudest forms is more beautiful than any human production; and in her choice arrangements, how infinitely beyond us. If the photographic art does nothing more than teach our artists to subdue the violence of contrasts in which they have of late indulged, under a mistaken idea of producing a superior effect, it will have been of great service to all that relates to refined taste. Of all effects, the most untruthful is the modern *artistic effect*.

I shall conclude with a few words from the speech of M. Arago.

" To copy the millions and millions of hieroglyphics which completely cover the great monuments of Thebes, Memphis, Carnac, &c., would require scores of years, and legions of artists. With the Daguerréotype a single man would suffice to bring to a happy conclusion this vast labour. Arm the Egyptian Institution with two or three of Daguerre's instruments, and on many of the large engravings in their celebrated work, the fruit of our immortal expedition, vast assemblages of real hieroglyphics would replace fictitious or purely conventional characters.

Again, these photographic delineations having been subjected, during their formation, to the rules of geometry, shall enable us, with the aid of a few simple data, to ascertain the exact dimensions of the most elevated parts, and of edifices the most inaccessible."

Beyond this, what need be said of the vast importance of Photography?

*March* 17*th*, 1841.

# SUPPLEMENTARY CHAPTER.

---

A new Photographic Process by the Author, for procuring Pictures with the Camera Obscura in a few Seconds.

On referring to the section in which I have treated of the application of the Daguerréotype to paper, it will be seen, that I was the first to show, that both iodine and mercury could be used in the same way with papers properly prepared, as with the prepared silver tablets. I have been lately induced to extend my inquiries, and particularly to examine the manner in which chlorine and bromine would act on papers prepared as I have before directed. Many extremely curious results, which are omitted from their not having any practical bearing, led me to examine the effect of the mercurial vapour on the pure precipitated iodides and bromides. I was long perplexed with some exceedingly anomalous results, but being satisfied from particular experiments, that these researches promised to lead to the discovery of a most sensitive preparation, I persevered in them. Without stopping to trace the progress of the inquiry, I may at once state, that I have the satisfaction of being enabled to add to the present treatise, an account of a process which serves to prepare *papers* that are much more sensitive than Daguerre's iodidated plates. The exquisite delicacy of these new photographic papers may be imagined when I state, *that in five seconds in the camera obscura, I have, during sunshine, obtained perfect pictures; and that, when the sky is overcast, one minute is quite sufficient to produce a most decided effect.* The action of light on this preparation, does indeed appear to be instantaneous. On several occasions I have procured, in less than a second, distinct outlines of the objects to which the camera has been pointed, and even secured representations of slowly moving bodies. With this great increase of sensitiveness, we of course secure greater sharpness of outline, and more minute detail. It should be understood that the process is a negative one, from which positive pictures may be procured on the ordinary photographic paper by transfer.

To prepare this very sensitive paper, we proceed as follows:—Select the most perfect sheets of well glazed satin post, quite free from specks of any kind. Placing the sheet carefully on some hard body, wash it over on one side by means of a very soft camel's hair pencil, with a solution of sixty grains of the bromide of potassium in two fluid ounces

of distilled water, and then dry it quickly by the fire. Being dry, it is again to be washed over with the same solution, and dried as before. Now, a solution of nitrate of silver, one hundred and twenty grains to the fluid ounce of distilled water, is to be applied over the same surface, and the paper quickly dried in the dark. In this state the papers may be kept for use. When they are required, the above solution of silver is to be plentifully applied, and the paper placed *wet* in the camera, the greatest care being taken that no day-light, not even the faintest gleam, falls upon it, until the moment when we are prepared, by removing the screen, to permit the light, radiated from the objects we wish to copy, to act in producing the picture. After a few seconds, the light must be again shut off, and the camera removed into a dark room. It will be found, on taking the paper from the box, that there is but a very slight outline, if any, as yet visible. Place it aside, in *perfect darkness*, until quite dry, then place it in the mercurial vapour box described in the former pages, and apply a very gentle heat to the bottom. The moment the mercury vaporizes, the picture will begin to develope itself. The spirit lamp must now be removed for a short time, and when the action of the mercury appears to cease, it is to be very carefully again applied, until a well defined picture is visible. The vaporization must now be suddenly stopped, and the photograph removed from the box. The drawing will then be very beautiful and distinct; but much detail is still clouded, for the development of which it is only necessary to place it cautiously in the dark, and allow it to remain undisturbed for some hours. There is now an inexpressible charm about the picture, equalling the delicate beauty of the Daguerréotypes; but being still very susceptible of change, it must be viewed by the light of a taper only. The nitrate of silver must now be removed from the paper by well washing in soft water, to which a small quantity of salt has been added, and it should be afterwards soaked in water only. When the picture has been dried, wash it quickly over with a soft brush, dipped in a warm solution of the hyposulphite of soda, and then well wash it for some time in the manner directed for the ordinary photographs, in order that all the hyposulphite may be removed. The drawing is now fixed, and we may use it to procure positive pictures, many of which may be taken from one original. The transfers procured from this variety of negative photographs, have more decision of outline, and greater sharpness in all their minute detail, than can be procured by any other method. This is owing to the opacity produced by the curious combination of mercury and the bromide of silver, which is not, I believe, described in any chemical work.

This very beautiful process is not without its difficulties; and the author cannot promise that, even with the closest attention to the above directions, annoying failures will not occur. It often happens that some accidental circumstance, generally a projecting film, or a little dust, will occasion the mercurial vapour to act with great energy on one part of the paper and blacken it, before the other portions are at all

affected. Again, the mercury will sometimes accumulate along the lines made by the brush, and give a streaky appearance to the picture, although these lines were not at all evident before the mercurial vapour was applied.

The action, however, of this new photographic preparation is certain; and although a little practice may be required to produce finished designs, yet very perfect copies of nature may be effected with the greatest possible ease and certainty.

I have stated that the paper should be placed wet in the camera: the same paper may be used dry, which is often a great convenience. When in the dry state, a little longer exposure is required, and instead of taking a picture in four or five seconds, two or three minutes are necessary.

I cannot conclude without remarking, that it appears to me that this process, when rendered complete by the improvement of its manipulatory details, will do much towards realising the hopes of those who were most sanguine of the ultimate perfection of photography; and will convince others who looked upon the art as a philosophical plaything, that the real utility of any discovery is not to be estimated from the crude specimens produced in its infancy, ere yet its first principles were evident to those who pursued it with an eager hope.

FALMOUTH, *April* 19, 1841.

BELL AND BAIN, PRINTERS, GLASGOW.